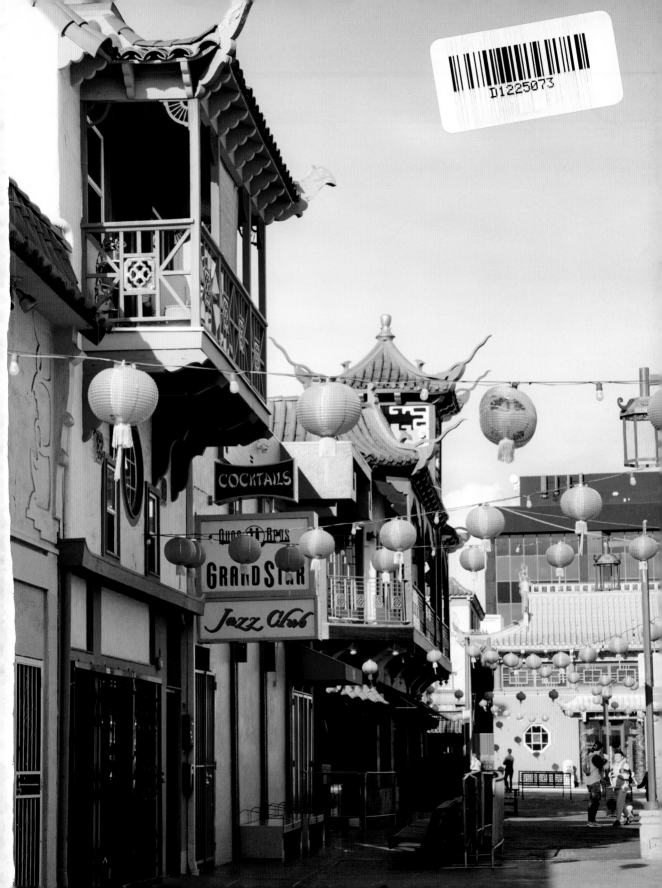

華埠 靚靚

Fashion and Wisdom from

CHINATOWN

Chinatown's Most Stylish Seniors

PRETTY

ANDRIA LO

CHRONICLE BOOKS
SAN FRANCISCO

VALERIE LUU

Library of Congress Cataloging-in-Publication Data

Names: Lo, Andria, author, photographer. | Luu, Valerie, author, photographer.
Title: Chinatown pretty : fashion and wisdom from Chinatown's most stylish seniors/ by Andria Lo and Valerie Luu.
Description: San Francisco, California : Chronicle Books, 2020. | Includes bibliographical references.
Identifiers: LCCN 2019056169 | ISBN 9781452175805 (hardcover)
Subjects: LCSH: Older Asian Americans—Portraits. | Beauty, Personal. | Chinatowns—United States—Pictorial works. | Street photography—United States.
Classification: LCC TR681.A75 L6 2020 | DDC 779/.2—dc23
LC record available at https://lccn.loc.gov/2019056169

Manufactured in Hong Kong.

Design by Rachel Harrell.

Rose logo design by Valerie Shagday.

Typesetting by Howie Severson.

10 9 8 7 6 5 4 3 2 1

Chronicle books and gifts are available at special quantity discounts to corporations, professional associations, literacy programs, and other organizations. For details and discount information, please contact our premiums department at corporatesales@chroniclebooks.com or at 1-800-759-0190.

Chronicle Books LLC
680 Second Street
San Francisco, California 94107
www.chroniclebooks.com

This project is dedicated to all the grandmas and grandpas who took time to talk to two strangers who were so curious about their clothes that they needed to stop them on the street.

What would start out with us waving and smiling or exclaiming *"pòh poh hóu leng!"* (pretty grandma) would lead to personal conversations about their life journeys and immigration stories, their joys and their pains.

These seniors taught us not only how to dress with joy and abandon, but also how to live a meaningful life. This book is for them.

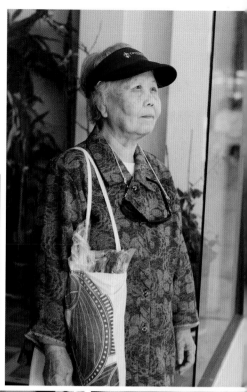

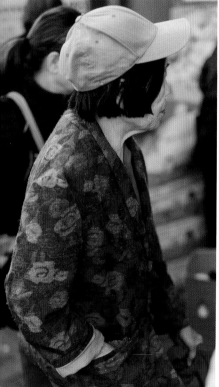

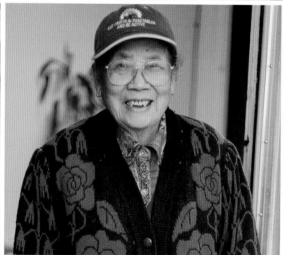

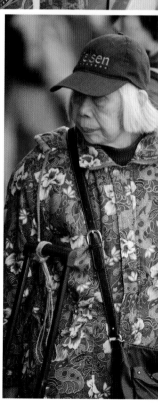

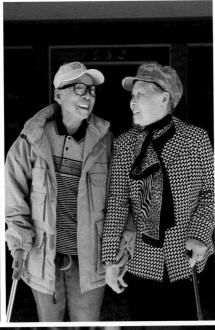
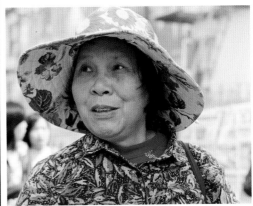

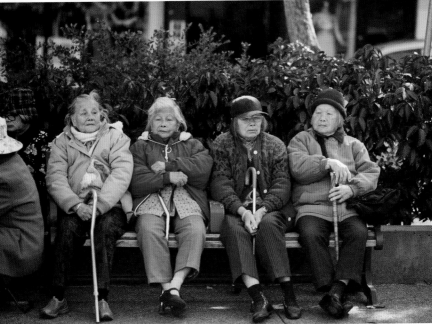

CONTENTS

San Francisco / 12

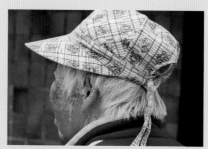

Oakland / 72

Los Angeles / 102

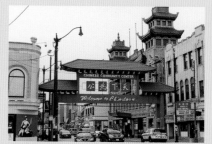

Chicago / 126

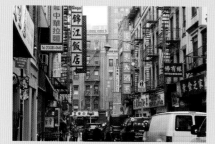

Manhattan / 150

Vancouver / 176

WHAT IS CHINATOWN PRETTY?

Spotted in Chinatown: a tightly trimmed silver bob and an '80s print two-piece suit paired with jade green sneakers. Vintage painter's cap worn askew, large tortoiseshell glasses, and a plaid fleece jacket layered over a houndstooth vest. Oversize black beanie, square-rimmed glasses, red Fair Isle sweater juxtaposed with a blue plaid shirt.

Sounds like a window display at Urban Outfitters, but it's just a few of the outfits we've encountered on China-town *pòh poh*s (grandmas) and *gùng gung*s (grandpas). These seniors cause us to do a double, sometimes a triple take when we pass them in the crosswalks on Stockton Street, the catwalks of San Francisco China-town. Our hearts race when we see their inventive outfits and melt at the sight of the tender details—found ribbons tied onto walking canes and shopping carts, worn clothes that carry so much obvious history.

Chinatown Pretty—the term we coined to describe this unique style—is a delightful mix of modern and vintage, high and low, bold patterns and colors, and contem-porary streetwear—like Nike sneakers or a Supreme hat—that takes the outfit to a whole new level. There are layers of knit sweaters and puffy coats (even in the summer) as well as five iterations of purple or florals—sometimes all in one outfit. These Chinatown fashion icons share some of the same aesthetic sensibilities as hipster bloggers—except they're eighty years old! The seniors combine urban utilitarianism with unexpected sartorial selections that set our hearts aflutter.

These outfits weave together the seniors' diaspora: where they came from, what they did for a living, how they made the best of their circumstances. Like handmade items using fabric from the sewing factory where they worked, or hand-knit or hand-me-down clothing from friends and family. Their style speaks to their values: Why buy new clothes when you can wear gifted ones? Or custom clothes from Hong Kong, thirty years old but perfectly preserved? Combined with tender personalized touches, Chinatown seniors' style contains so much ingenuity, flair, and beauty.

HOW WE STARTED

We started Chinatown Pretty out of admiration for this overlooked community, for both their fashion blog–worthy outfits and their active and independent lifestyles. We often asked ourselves, "What is this grandma's story—and where did she get her shoes?" (Specifically Jade Shoes, pg. 20, our Chinatown Cinderella story.)

Andria and I met in 2009 through the San Francisco food community—she was photographing the burgeoning street-food scene as I was starting Rice Paper Scissors, a Vietnamese pop-up restaurant.

Our friendship began on dim sum outings in San Francis-co's Chinatown; we bonded over a shared love of China-town fashion. Whenever we saw a *pòh poh* pairing floral prints with plaids or a *gùng gung* wearing a baseball hat embroidered with an unexpected catchphrase like "All I Do Is Party," we would look at each other in astonish-ment, like "Did we really see that?"

There was a certain *je ne sais quoi* about their style, so Andria and I started approaching seniors on the street to learn more about their outfits. Our conversations became as much about where they came from as where they got their clothes. Their stories reflected some of our own history through their diasporas, humble beginnings, and struggle to create better opportunities for them-selves and their children. As second generation Asian Americans, we saw this project as a way to connect to our families' histories: Andria's parents came from Boston Chinatown and Hong Kong; my family were Viet-namese refugees, and my stepfamily came from Hong Kong. The Chinatown seniors' dress and demeanor also reminded us of our own grandparents—their permed hair, their sock-and-sandal combinations, and the way their expressions could switch between extremely tough (and intimidating) and overwhelmingly affectionate.

Over the past five years, we've learned that we're not the only ones obsessed with Chinatown street style. In the comments on our blog and Instagram, many Asian Americans have told us that these photos and stories also reminded them of their own grandparents and expressed gratitude for seeing this generation repre-sented. We've also heard from other city dwellers excited to learn more about neighborhood characters, and fashion enthusiasts who are now looking to their elders for style inspiration.

Chinatown seniors' outfits serve as portals to heart-warming and inspirational life stories, and through

interviews with them, we hope to share their insight on how to live and dress during the golden years.

CHINATOWN HISTORY

We didn't know much about Chinatown history before starting this project. After interviewing hundreds of seniors, we've seen the rhythms and reasons emerge for their journeys from China to Chinatowns. This history is the pattern from which Chinatowns are cut.

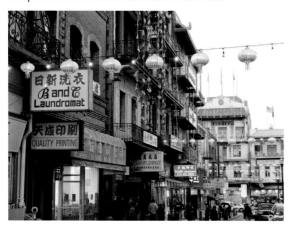

Due to famine, war, natural disasters, political instability, and economic opportunities overseas during the mid-to-late 1800s, 370,000 laborers (mostly men) left Cantonese-speaking regions in Guangdong Province in search of work. Since Guangdong Province had been a hub for foreign trade for centuries due to the numerous ports in the region, the locals knew the opportunities that lay abroad. This awareness, combined with a strong sense of kinship between family and village members, created a community of people who immigrated to the United States and would support and encourage friends and relatives to migrate over throughout the next century. Many of these immigrants came to San Francisco in 1848 for the Gold Rush, thus creating the first Chinatown. It was a place for Chinese people to live, work, and provide services for each other. After the Gold Rush, another wave of immigrants were recruited as cheap labor to build the Transcontinental Railroad.

Once the railroad was completed, the demand for labor decreased. Racial tensions grew because white laborers felt that Chinese immigrants were taking away their jobs. Politicians capitalized on this sentiment and passed a series of unjust and racist laws that restricted the ability of the Chinese to immigrate and assimilate into mainstream society. The Chinese Exclusion Act of 1882 denied Chinese living in America a path to citizenship and naturalization, the first and only time a federal law prohibited immigration based on nationality.

(Canada enacted the Chinese Immigration Act, a similar ban, in 1885 and 1923.) The Page Act made it nearly impossible for Chinese women to immigrate, and other laws prohibited Chinese in America from marrying people of other ethnicities. Together these factors resulted in a mostly male, bachelor society.

Across the United States, Chinatown residents also faced arson, boycotts, and other violence from angry white laborers. Unjust alien land laws that barred Chinese from buying property, as well as the overwhelming hostility, made Chinatowns the only safe places for immigrants to live and work. Family and village associations became a social support network where people who shared similar last names or came from the same village could find jobs, housing, and loans. These mutual-aid organizations continue to exist today.

Due to the immigration bans, some people forged documents and claimed to be the offspring of United States–born Chinese Americans (who received automatic citizenship)—a phenomenon known as "paper sons." Many birth certificates were lost in the 1906 San Francisco earthquake, which gave "paper sons" the opportunity to claim they were born in the United States (even if they weren't), since there was no other path to naturalization.

Immigration laws opened up once China and the United States became allies in World War II. The next big wave of immigrants came in 1965, when immigration quotas were lifted. The exclusion acts in the United States and Canada were also repealed in 1943 and 1947 respectively. Chain migration allowed family members to sponsor relatives, which continues to bring a steady stream of Chinese to America.

Another big wave occurred from the 1960s through the 1990s, as middle-class people in Hong Kong started to immigrate to North America in droves, since the Communist government of China was scheduled to take back control of Hong Kong in 1997 (it had been operating as a British Crown colony). For this group of immigrants, moving to Canada and the United States wasn't so much about prosperity as it was about escaping Communism and retaining their personal and financial freedom.

Chinatown populations have ebbed and flowed over the past few decades. Second-generation Chinese Americans and new immigrants (many of whom are working professionals) have moved from the cities to the suburbs, leaving a smaller community consisting mostly of seniors and the "bachelor society" in historic Chinatowns. Suburban homes and Chinese mini-malls in

satellite Chinatowns—in Monterey Park, Los Angeles, and Flushing, Queens, in New York—have become another way of life for Chinese Americans.

More recently, Chinatowns are experiencing gentrification, with upscale businesses and luxury housing displacing the older Chinese residents and businesses. In cities like San Francisco, Vancouver, Los Angeles, and New York, residents, activists, and nonprofits are working hard to protect their vision of Chinatown.

Even though Chinatowns are changing, they remain an important hub for many different people. For new immigrants, Chinatowns still serve as a landing pad as they start their search for economic mobility. For second- and third-generation Chinese Americans, it's a cultural touchstone, a place to visit for groceries or dim sum with their family. For locals and tourists, it's a place to get immersed in the vibrant culture and architecture.

And for many of the people in this book, it's the place they call home. The seniors we've met have come to Chinatowns for various reasons. Each conversation has given us a sliver of history, which is often tinged with the fatigue and heartbreak that comes from having to start over. Despite these hardships, many count their blessings and continue to be resilient. Our project is not only a celebration of their style, but also a documentation of their immigration journeys, their values, and their ability to adapt and overcome.

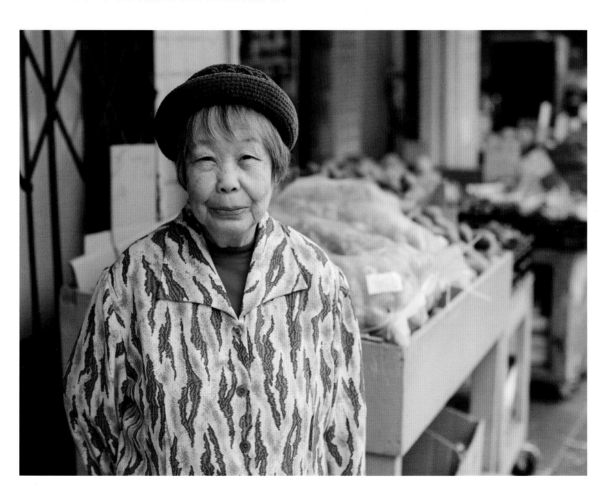

SAN FRANCISCO

Home is where the heart (and fashion) is

San Francisco's Chinatown is one of the most iconic, magical, and historical Chinatowns in the world. We're not just saying that because it's our home base.

During the past five years, we have taken hundreds of laps around the same twenty-four blocks in hopes of bumping into Chinatown's Next Top Model. The alleyways always hint at a possibility of a visual discovery, like a van being loaded with floral arrangements, a lion dance troupe practicing stunts, or a *pòh poh* shuffling home after a day of errands, gray hair lit by golden-hour sunlight.

Over that time, we've encountered a wide range of souls and styles on the busy streets and in the enchanting alleyways. Like Buck Chew, dressed in dapper tailored suits from Hong Kong and colorful ties, who never lets us forget how old he is. "I'm ninety-six!" he'll yell, since he's a bit hard of hearing. Or Mei Ha Wong, who sells flower arrangements (and sometimes zippers) on the corner of Powell and Jackson in her flower-adorned bucket hat.

San Francisco's Chinatown is the oldest in the United States. It has served as a landing pad for immigrants since the mid-1800s, when laborers came to join the Gold Rush and work in accessory businesses like laundries, restaurants, and grocery stores. With California's abundant resources, agriculture and fishing were also major industries for the new immigrants. Since then, people have migrated over to build the Transcontinental Railroad, or to find political freedom or the American Dream, or to enjoy their retirement.

Within this neighborhood outlined by Broadway, Powell, Bush, and Kearny Streets, buildings are in various states of old and new and hundreds of Chinese businesses serve tourists and locals. Chinatown bumps up against Italian restaurants and third-wave coffee shops in North Beach, San Francisco's Little Italy, and gray high rises in the

Financial District. It's a wonder to see how neighborhood lines blur and how many different demographics intersect: Chinese residents, international tourists, and young professionals on their way to work downtown. Chinatown also features one of San Francisco's most iconic features: rolling hills that leave us breathless—partly because of the steep climb, but also because of the epic views they reward us with.

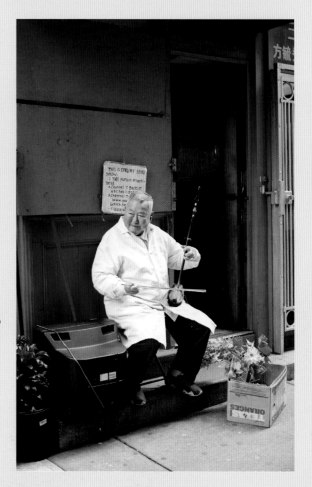

Paul's Jewelry Co

San Francisco Chinatown is still mostly inhabited by a monolingual Chinese community of seniors. Living in Chinatown allows these seniors an independent life where they can easily go downstairs to get groceries, socialize with friends at the park, or step out for a walk and not depend on a car (or relative) to get around. The majority of seniors live in single room occupancy buildings (SROs) and affordable residential buildings like the I-Hotel, Ping Yuen, or YWCA. Because some of these residential buildings can be small, public space is utilized to the fullest.

After traveling to Chinatowns around the world, we've come to understand what makes San Francisco the hotbed of Chinatown Pretty fashion: The secret is in all the layers.

Layering is key, since seniors spend so much time out in the city. They have to prepare for all the different climates that can characterize a single day in San Francisco—sunshine, fog, and a reliable afternoon wind—and they do so with a mix of color, patterns, and texture as well as a combination of modern streetwear with clothes from China that they've owned for decades.

There is a San Francisco adage that says you should never leave home without a jacket. In the case of Chinatown, it's never leave home without a few jackets.

Chinatown seniors are the ultimate urban dwellers. They *really* inhabit this place by taking advantage of the neighborhood's parks, playgrounds, and plazas. At Portsmouth Square, also known as Chinatown's living room, groups of grannies in floral hats of every brim size sit on pink plastic stools no more than a foot high, throwing down cards on makeshift cardboard tables. Men in monochrome outfits claim the steps near Kearny Street, where they play games of Chinese chess or spectate with their hands clasped behind their backs or cigarettes between their lips. We usually admire their looks from afar, since they don't like it when we interrupt their game, even if it's to pay them a compliment.

At Washington Park, seniors host a consistent schedule of exercise classes from morning till night—tai chi on the east, social dance between the trees on the south side, and Luk Tung Kuen on the north side, where seniors use parking meters as ballet bars.

People also pass time at a variety of businesses: dim sum joints, Hong Kong–style cafes, and Chinese bakeries, where men in fisherman's vests and baseball caps sit for

hours chatting and mulling over a Chinese newspaper and a cup of dollar coffee.

If seniors don't live in Chinatown, they take the bus from the Sunset and Richmond Districts or Portola Valley, San Francisco's satellite Chinatowns, to exercise at the park, play mahjong, visit doctors, and, of course, go grocery shopping.

Grocery stores open as early as seven a.m. every day, and by nine a.m. Stockton Street is packed with shoppers filling up their rolling backpacks and metal shopping carts. This is where they can stock up on fresh produce, chickens butchered on-site, and dry goods—ranging from Chinese herbs to dried shrimp. Market time is when Chinatown thrives. Grandmas slowly scan the streetside produce stands, meticulously scrutinizing the jujubes, bok choy, and whatever's in season with the seriousness of a diamond appraiser (while we are admiring their outfits like fangirls).

We often meet these *pòh pohs* after their grocery runs, with their day's hauls hanging heavy in plastic reusable bags. Although single-use plastic grocery bags are banned in San Francisco, they still flourish in Chinatown—seniors often collect and reuse plastic pink Thank You bags, which add an extra pop to a *pòh poh*'s outfit. We've seen a *gùng gung* napping on a park bench, a bag positioned on his head to block out the midday sun, while others tie them around their walkers in case they eye some citrus on their walk home. Anything that can be reused often is in Chinatown, which speaks to the seniors' resourcefulness and results in the delightful details in their outfits.

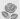

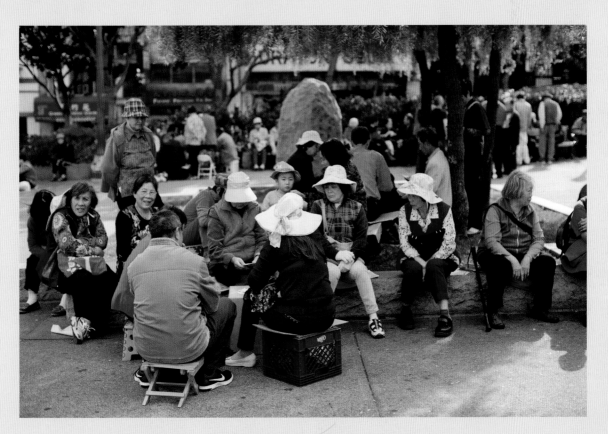

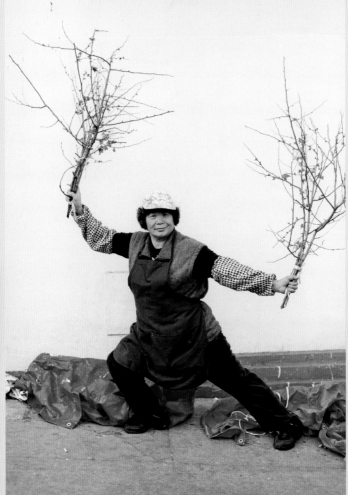
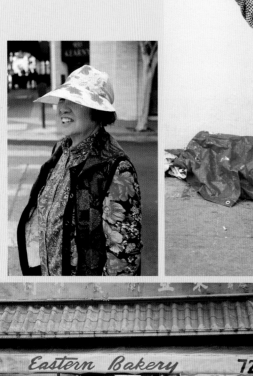

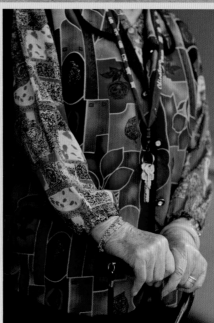

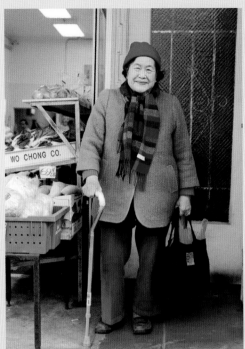

What we love most about San Francisco Chinatown is how unchanged it is—it's still utilized and inhabited by Chinese seniors and recent immigrants.

Conversely, there are Chinatowns across the United States where Chinese populations are dwindling and culturally relevant stores are closing up shop. Manhattan and Vancouver Chinatowns have declined as first- and second-generation Chinese Americans move out to the suburbs. "Making it is getting out" is something many children of Chinese immigrants tell us. The results are empty storefronts and apartment buildings that are sometimes redeveloped as luxury housing and businesses that don't serve the Chinese community.

San Francisco's Chinatown thrives because of the numerous organizations, such as the Chinatown Community Development Center, that protect the neighborhood's look and livability by operating affordable housing for seniors and promoting businesses that benefit the community.

The threat of the Financial District creeping into Chinatown has been a battle for decades, but the neighborhood continues—with its own rhythm, language, and architecture. San Francisco Chinatown is a place where every nook and cranny is lived in: clothes hang-dry on balconies next to homemade dried fish and Chinese sausage; herb shops and home goods stores pack Powell Street along with renegade retailers that sell garden-grown vegetables on the sidewalk.

San Francisco Chinatown is where serendipitous street style awaits at every corner. It's where seniors live, socialize, shop, and thrive.

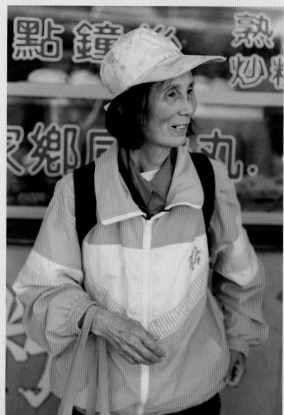

JADE SHOES

JACKSON STREET, 2014

When I lived in Chinatown, I would spend my mornings at Reveille Coffee, located at the intersection of Chinatown, the Financial District, and North Beach. While I did my morning journaling at the cafe, I would watch people get off the bus on Columbus Avenue. Week after week, I saw a woman's jade shoes as she stepped off the bus.

They were bright green with a speckled '80s print; they looked like shoes you'd find at Anthropologie, not on an older lady on Columbus Street. I never saw her face—just her bright green sneakers—as she walked up Pacific Street into Chinatown. Whenever I saw the Woman with the Jade Shoes, I would point her out to whomever I was sitting next to. "Doesn't she look amazing?" I'd say to the person next to me. "Where did she get those shoes?"

She was my fashion missed connection.

That is, until Andria and I crossed paths with her in Chinatown one fateful day during the Lunar New Year and interviewed her about her life (and sneakers).

Manning Yeung Tam bought her jade-colored shoes at a store on Stockton Street. "I liked them so much I bought ten pairs," she said. "I wear them until they break."

She's been in Chinatown for the past nineteen years, long enough to see that shoe store on Stockton come and go.

Jade was a recurring theme in her outfit. She pulled back her bob to reveal a pair of jade earrings she received when she got married at age sixteen back in China. She also wears a jade ring with the stone turned around toward her palm, most likely to ward off unwanted attention, or have it be her own private luxury.

We parted ways after twenty minutes of conversation, feeling like we had all made a new *páhngyáuh*, or friend. Whenever we see her in Chinatown, she holds our hands and says hello, right before she hurries off to catch a bus, groceries in hand and green shoes on her feet.

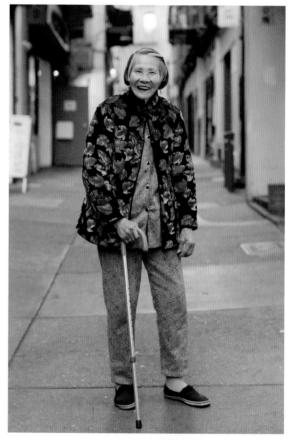

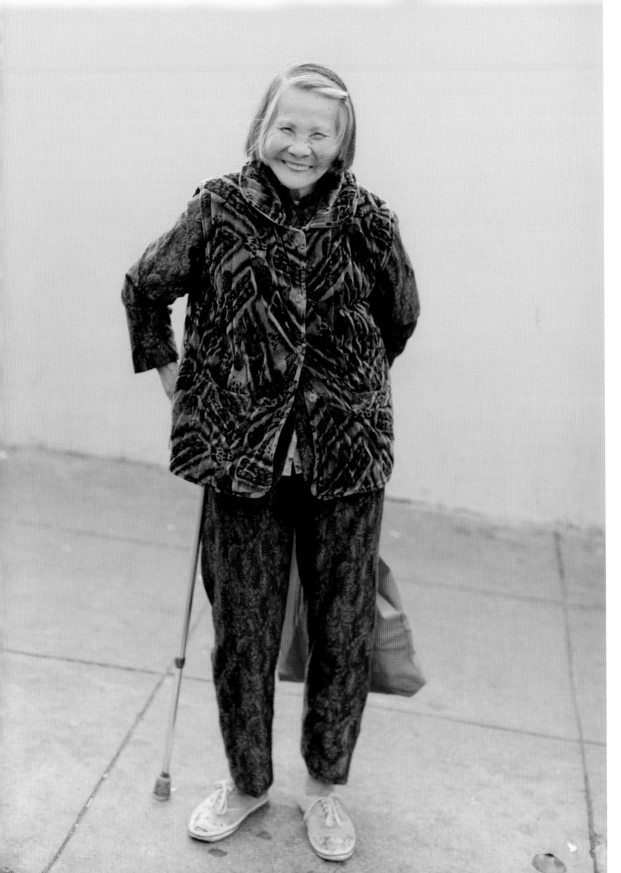

TWO HATS

We bumped into Huitang Deng, seventy-five, as he was enjoying a cigarette one crispy cold day.

We were impressed by his style—his posture, the way the smoke swirled around him as he exhaled, and how he tucked his pack of cigarettes in his vest pocket. And the fact that he had on not one, but two hats—a gray beanie underneath a gray ivy cap. "I got this hat in Chinatown," he said, taking off the cap. "You can have it if you like it."

He also had on seven layers of shirts, which included a seafoam green mock turtleneck smartly layered with a marbled black-and-tan vest (one of the ten his sister has knitted for him) and a worn-in cargo vest topped with a gray fleece sweater.

"I live in the Sunset, near the ocean," he said. "Sometimes when it's really cold out there, I wear eleven layers."

But today in Chinatown, he had on just two hats, seven shirts, and four pairs of pants—which made for one warm and impressive outfit.

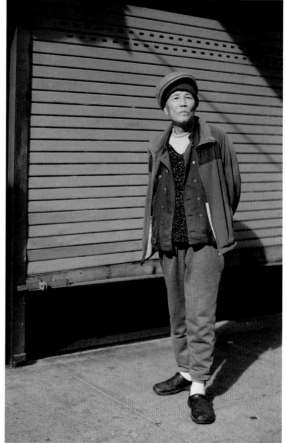

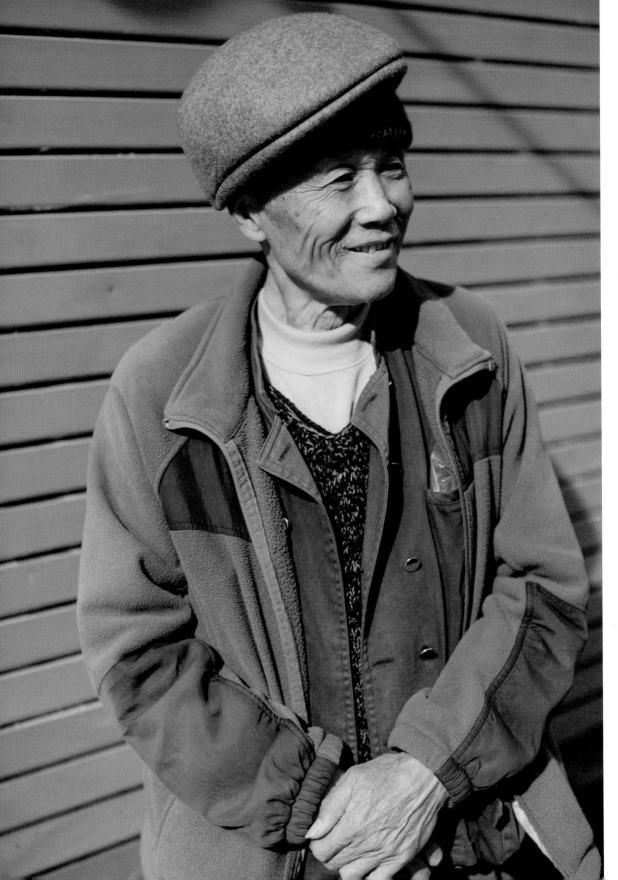

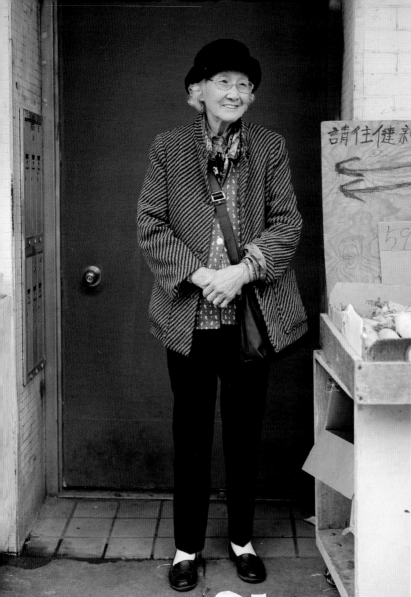

THREE SILKS

We approached Yok Lan Chung, ninety, outside a grocery store. She was a bit taken aback at first by the three of us, a group of women complimenting her on her tweed coat and layers of silk: a jade blouse with a purple paisley shirt and a black and gold paisley scarf around her neck.

We loved the silk on silk on silk. Her daughter, who's lived with her in Chinatown for forty years, was a little less impressed when I asked her for some insight on Chinatown fashion. "What is there to write about?" she grunted. "There's nothing special."

But if you notice details, like the silks in Ms. Chung's outfit, there is something very special about Chinatown style.

POWER GLOVES

PACIFIC STREET, 2018

Yee Song Hung, ninety-two, looked like a boss after a successful grocery run (also kudos to her for all those reusable bags!). She had on a velvet wallpaper-print jacket with a matching magenta zip-up poking out from underneath. Her tapered sweatpants, thick beanie, and red gloves showed she was prepared to take on the cold and her shopping trip. We were able to grab a quick picture before she rushed onto the bus with her haul.

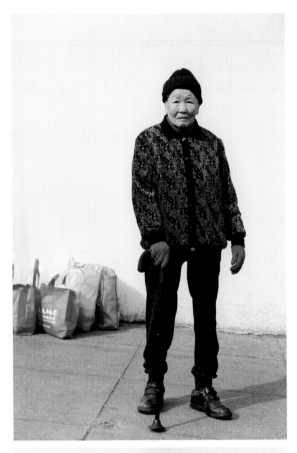

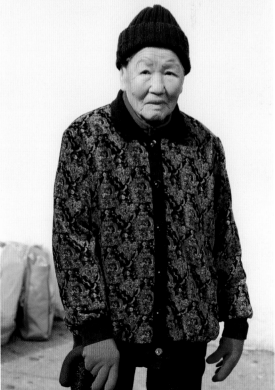

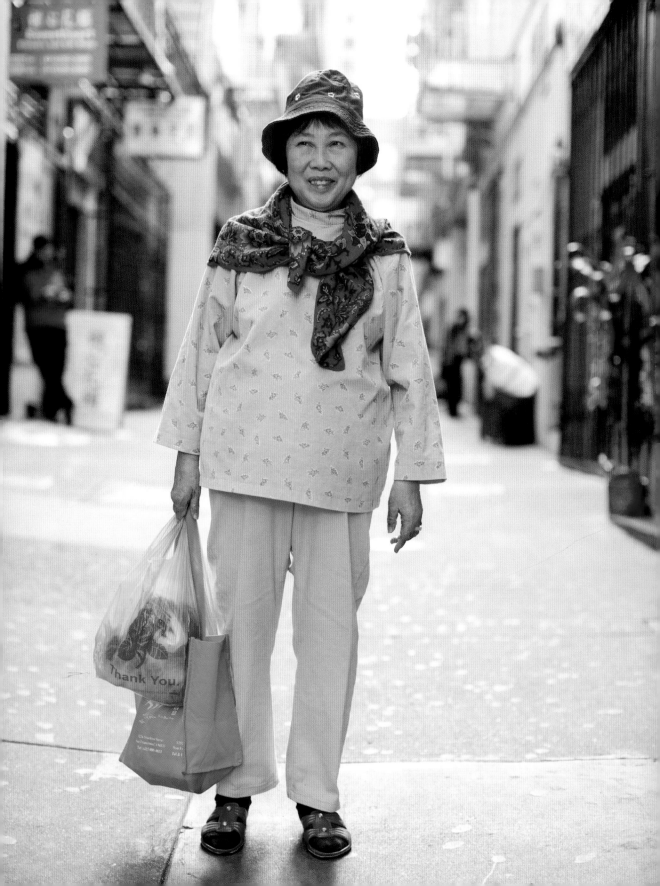

PRETTY
IN PINK

ROSS ALLEY, 2015

Julie Fong walked by 41 Ross as we were installing our first *Chinatown Pretty* photo exhibit. Although Julie wouldn't get specific about her age ("I'm over sixty," she kept repeating when we asked), she was open to sharing her life story. Born in Burma, she lived in Hong Kong and Taiwan before moving to Chinatown, where she's been for fifty years. Prior to retirement, she worked at Wells Fargo Bank. The day we met her, she was out getting groceries in a pink floral corduroy shirt that her sister-in-law made for her. "I picked the fabric at a store in the Serramonte Center a long time ago," she said. "I got five yards and my sister-in-law made three long-sleeve shirts and one short-sleeve." We asked her why she chose that fabric. "It's warm and it's bright—good for seniors," she said. "And it's warm."

27

NINERS FAN

GRANT STREET, 2015

We met Chuck Lee, eighty-three, while he was window-shopping at Kaye's Footwear. We were drawn to his old-school San Francisco 49ers beanie and how it popped against his monochrome outfit.

Mr. Lee was born in Guangzhou and moved to San Francisco in 1999 after a brief stint in Seattle. As we were talking, we noticed that his beige outfit contained fascinating patterns and gems: a furry paisley vest, fastened with a row of safety pins, and shimmering beads around his neck and wrists, an unexpected sparkly touch that he got on sale at a jewelry store on Jackson Street.

CLASSIC HONG KONG

STOCKTON STREET, 2015

At first glance, it was Joyce Wing's stylish oversize pink glasses that caught our eyes.

But then we saw a blue floral Mandarin-collar shirt peeking out of her San Francisco fleece jacket. When she pulled off the jacket, we were enamored by the details of her shirt: the modern Mandarin collar, the square hip pockets, the sharp cuffs.

Mrs. Wing, eighty-nine, lived in Boston for a few years. In 1963 she came to San Francisco Chinatown and worked in a Chinese grocery store, then in housekeeping at a hotel.

She also worked as a seamstress and had made the outfit she wore that day. Her look was very classic Hong Kong, which had more Western-style tailoring and fabrics due to the British influence. Many seniors we meet still wear the clothes they had custom made in Hong Kong in the '60s, though Mrs. Wing's subtle color combinations and pattern-mixing was something else (plus, she sewed it herself!).

Her calico shirt paired wonderfully with the red square-patterned pants. "I like pockets," she said. "I made my pants with pockets on the inside." She showed us: The pockets were made with a thin piece of fabric tucked on the interior, only accessible to her.

Many seniors like to create secret pockets on the inside of their pants or jacket to keep their cash and IDs safe. When I was growing up, my grandma always kept a few twenty dollar bills in her secret pocket, which she would gift to us grandkids on occasion, much to our delight.

After fawning over her outfit, we asked Joyce what was next in her day. In her bag was a whole chicken, which she was going to cook herself. "Nobody helps me, so I have to help myself," she said about living on her own in Chinatown. She sighed and looked a little sad, but stressed the importance of keeping active: "I have to walk around so my feet can still work good."

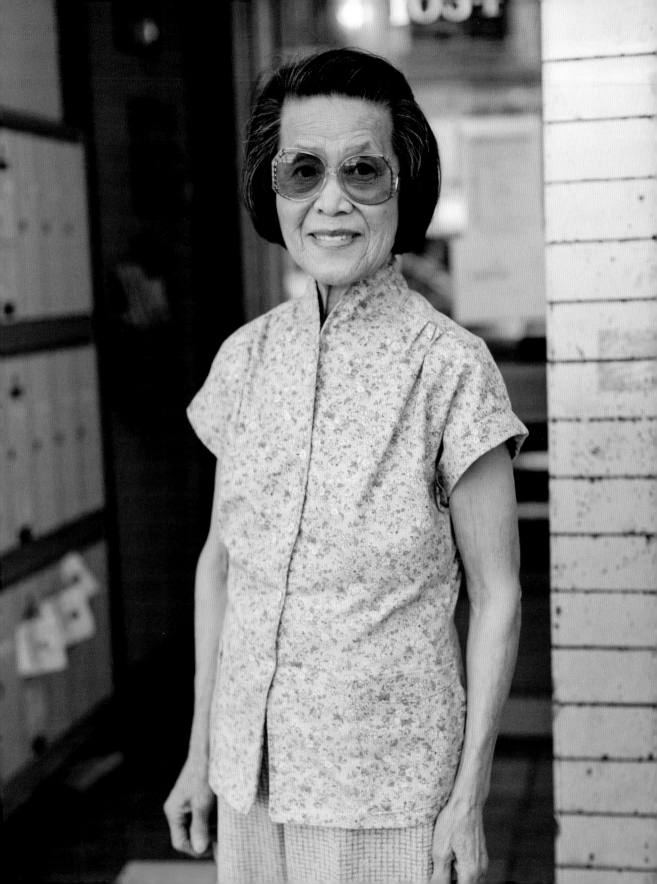

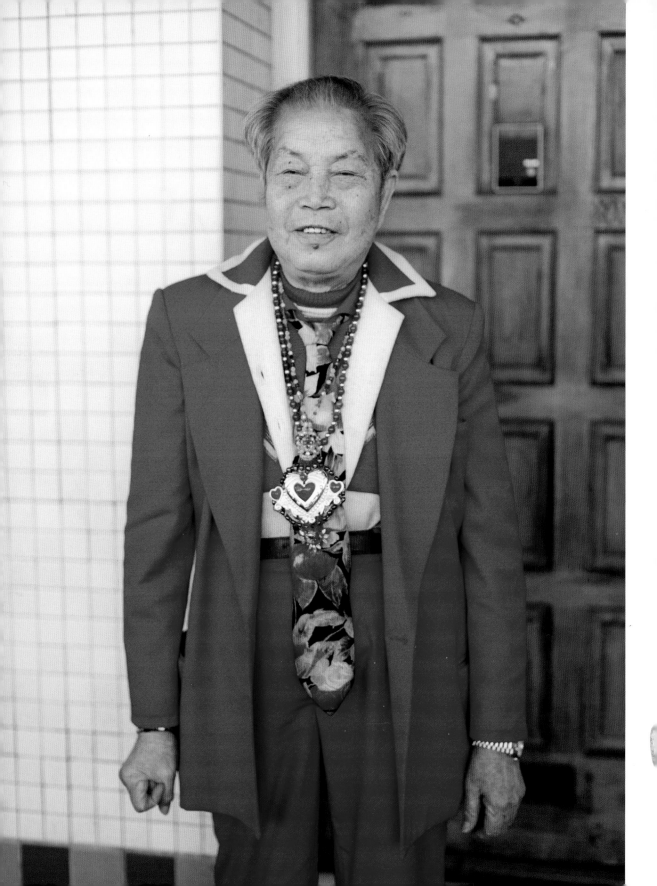

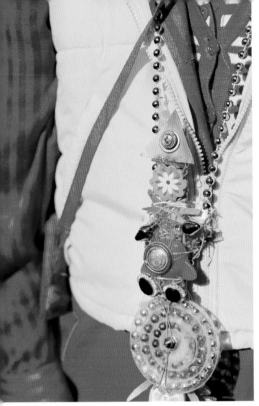

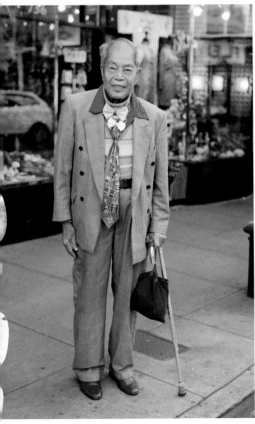

THE ONE

BROADWAY, 2014,
AND POWELL STREET, 2016

You Tian Wu's reputation preceded him. We came across Mr. Wu on Accidental Chinese Hipster, a blog that posts readers' submissions of Chinatown fashion. Someone had submitted a photo of Mr. Wu riding the Muni, which inspired the blogger to dub him "The One"—someone you may "tragically never unite with" but are "connected to by Fate."

Lucky for us, we got to meet him by chance. We went to a dim sum joint on Broadway after a long day of shooting and sat down next to him at a table. Our eyes grew wide when we realized he was "The One," clad in his signature red suit and a bolo tie fashioned out of old Mardi Gras beads.

We talked to Mr. Wu, eighty-two, about his fashion philosophy: "When you're young you don't have to care about fashion. But when you're old, you have to."

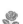

A LUNAR NEW YEAR ENCOUNTER

JACKSON STREET, 2016

We met Yu Tom, seventy-six, and her daughter Charmaine the weekend before the Lunar New Year, when everyone rushes to Chinatown to buy up fresh citrus, new year treats, and red envelopes. They had lived in Chinatown for thirty-five years but currently reside near Cow Palace.

Charmaine said her father had just passed away a month ago, and this was her mom's first outing since she lost her husband.

"My dad always liked bright colors," she said, when I asked her why her mom wore two different shades of purple, a popular color among *pòh pohs*. In a way, it seemed like Mrs. Tom's tribute to her husband.

Also on Mrs. Tom was a long-billed cap, because "she cannot stand the sun."

"Sometimes she wears it sideways, so it looks a little hip-hop," giggled Charmaine.

We asked her about the layering in Chinatown. "The elderly like vests to keep warm," she said, pointing out that it's not as bulky as a long puffy jacket. "The hat, the vest—it's all like a security blanket for her," she said.

THE CHEWS

PACIFIC STREET, 2015 AND 2016

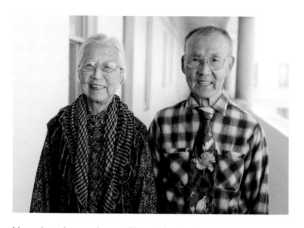

We first spotted Buck Chew, ninety-six, sitting on a bench in Portsmouth Square wearing a fedora, suit, and white gloves. He had a gentle, inviting smile. Though he didn't speak much English, he did know how to say, "Sorry, I don't know how to speak English" in *perfect* English. He also said it loudly, since he's a bit hard of hearing.

Instead, he let the photos do the talking. Mr. Chew always carries a little photo album with pictures of his younger self, looking just as stylish with patterned pant suits, trench coats, and hats. But his ties are where he really shines—in his photo album was a picture of him wearing one decorated with colorful parrots, one out of his collection of forty ties.

Before he moved to the United States in 1983, Mr. Chew worked as an accountant and abacus master in Macau (though he also considers himself a poet and calligrapher). Most of his clothes are from Hong Kong or Macau and he has owned them for a very long time.

Flipping through his photos, he proudly called out his grandchildren's professions as he pointed at them—"doctor," "engineer"—and reveled in his daughter's age—"She's seventy-two!" he laughed.

He pointed to a photo of his wife, Len Wuey, whom he referred to as his "wife-fu." Cantonese speakers sometimes alter English words by adding an extra syllable, which makes them sound more like words from their dialect. Over the years, he's become one of our Chinatown regulars. We can spot him a block away with his signature suits and white gloves. One day, we saw him on his way back from the grocery store but almost didn't recognize him because he was wearing a large women's sun hat. But once we saw his parrot tie, we knew it was our old friend. Since he was carrying a full load of groceries, we helped him bring his bags of ginger and bok choy home.

We met Len Wuey, his "wife-fu," for the first time at their one-bedroom apartment at the Ping Yuen housing complex. She wore a pink keffiyeh scarf with her knit sweater and floral shirt, all in the same color palette. The Chews treated us to snacks and hot water. We sat in the living room and held hands with Mrs. Chew, communicating with our smiles and hand squeezes. She didn't let us leave without taking an apple or orange.

The Chews are in their nineties, so we asked them about the key to longevity. "Cook at home and eat lots of fresh veggies, ginger, and fish," they said.

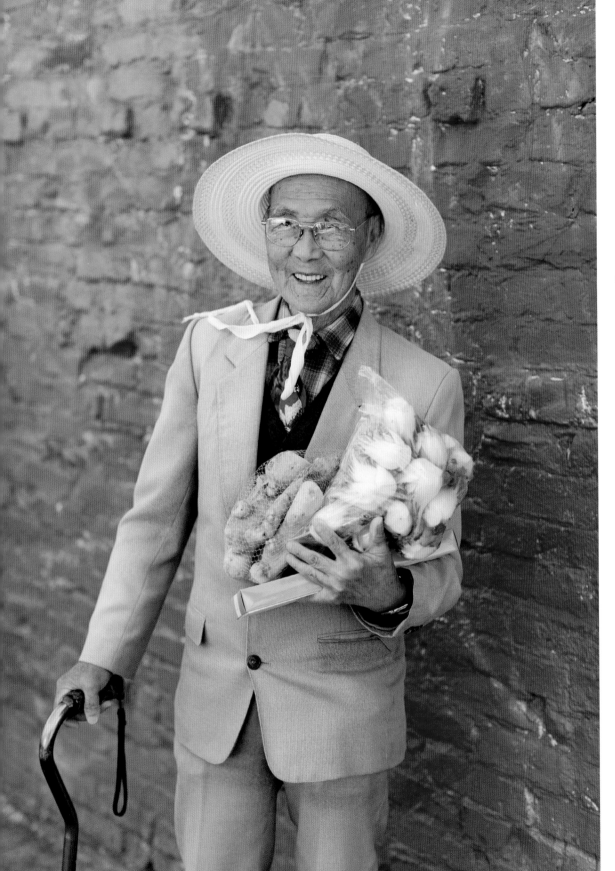

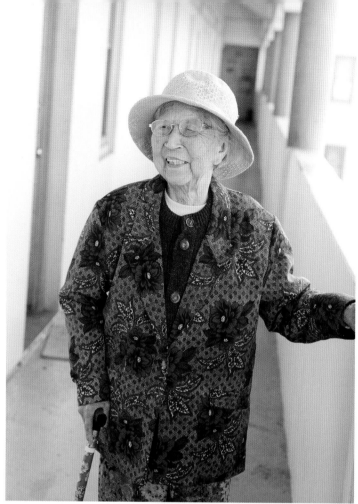

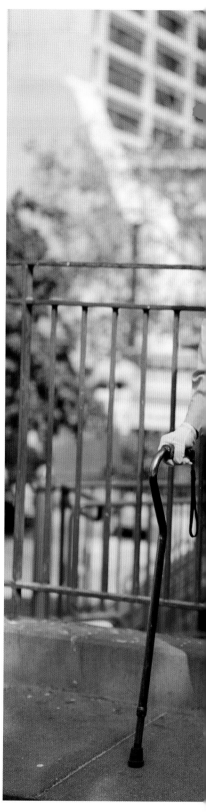

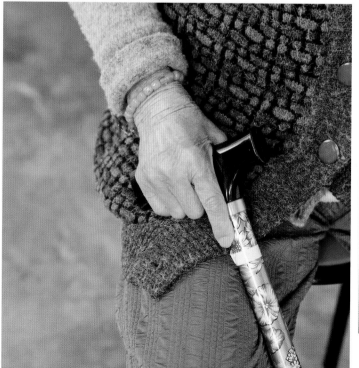

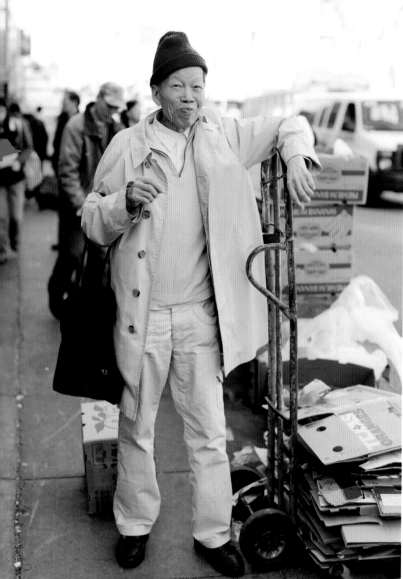

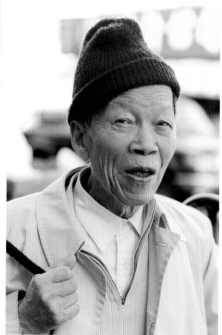

THE FOX

POWELL STREET, 2014

"I'm a real fox," said James Yang. His outfit is typical of many men in Chinatown: monochrome, either all beige, gray, or black. He prefers wearing suits and slacks instead of denim jeans like "young people."

He told us about his ties with Mayor Ed Lee, grand education in foreign countries, and ability to speak seventeen languages. But with that rascal smile, we just nodded and listened.

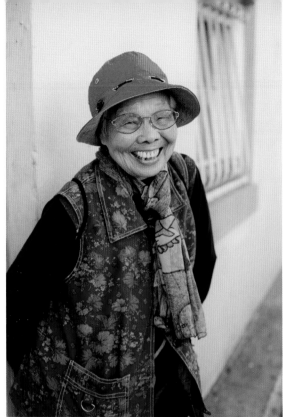

SMILEY

POWELL STREET, 2016

Wui Ying Zhou, eighty-six, was all smiles in her red bucket hat, floral fisherman's vest, and patterned scarf. We appreciated how one accessory could transform an outfit—in this case, it was the punch of neon green in her silk scarf that took her purple outfit to another plane. We dug those rose gold glasses too!

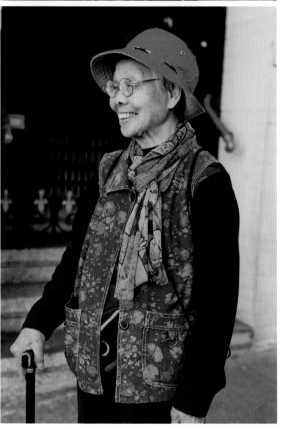

THE FLOWER VENDOR

JACKSON STREET, 2015

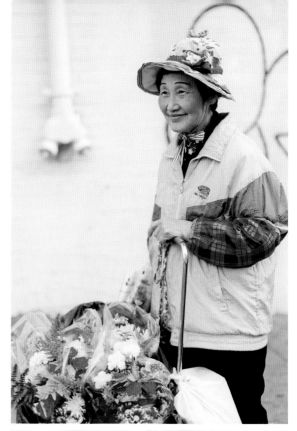

We spotted Mei Ha Wong, seventy, selling flowers one weekend morning. Her Édith Piaf–esque makeup, bright smile, and flowers popped against the white walls on Jackson Street.

Florals dominate the fashion scene in Chinatown and her outfit was no exception. Ms. Wong had a floral string tied to her cart, flowers embroidered on her Mandarin collar shirt, and a bucket hat with flowers she had sewn herself using gifted fabric.

We bought a bouquet for three dollars. "I take care of my dad, but sometimes I sell flowers too. My son buys the flowers wholesale and I arrange them," she said. "It's very easy."

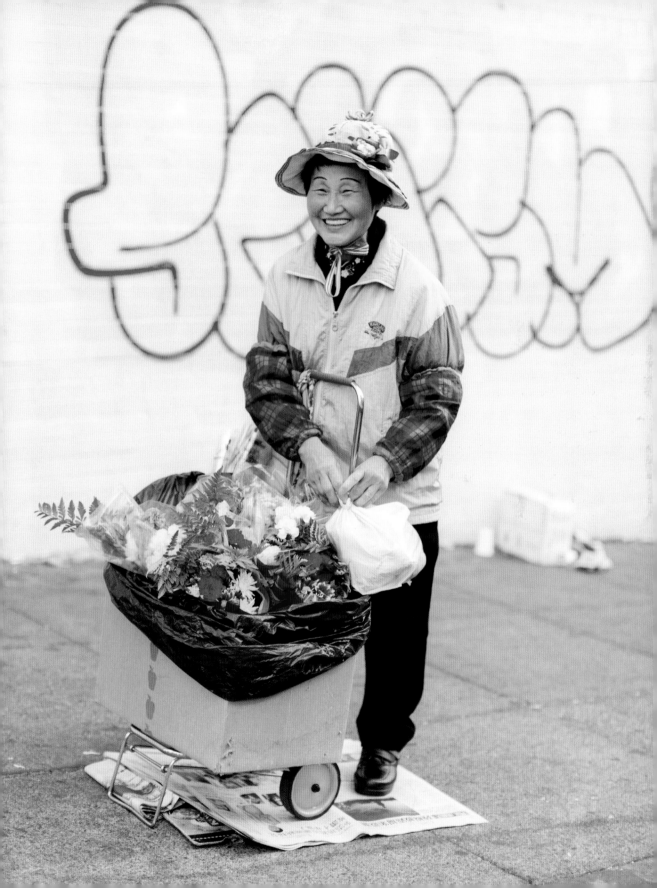

RANDOM ACTS OF KINDNESS

BROADWAY, 2015

Xianji Guan, eighty-two, moved from Canton to San Francisco Chinatown in 1997. His five-panel Obey hat was a gift from a stranger on a rainy day. He said he got off a bus and was on his way home when he was caught in the rain without an umbrella. A kind stranger gave him the hat to keep him dry.

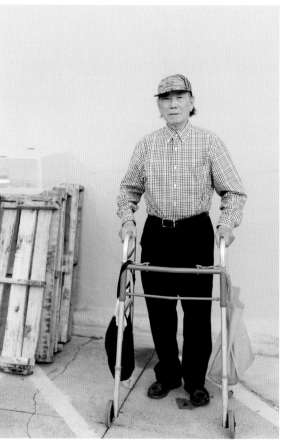

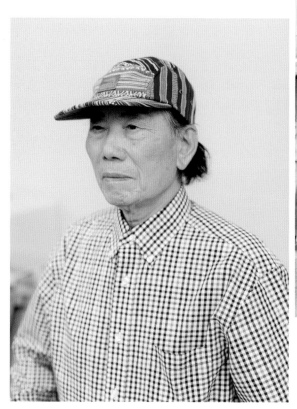

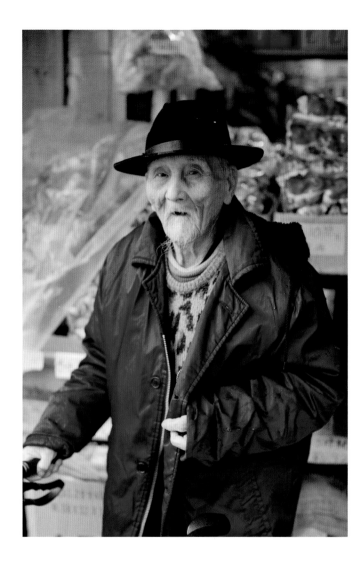

HEARTFELT FEDORA

STOCKTON STREET, 2014

We spotted Nam Ping Li on his way to tea with his son. Even at ninety-five, the former schoolteacher treks down from his house on Broadway to read the paper and relax over tea—a ritual he's enjoyed for the forty years he's lived in Chinatown.

We were enamored by his velvety fedora cap. "I've had it for the past twenty years," he said. When asked why he enjoyed the hat, he says he bought it because it spoke to him. "I felt it in my heart," he said, patting his chest.

When we asked him to describe his style, he said "warm." He had eight layers on that day, each one creating a Saturn-like ring around his neck.

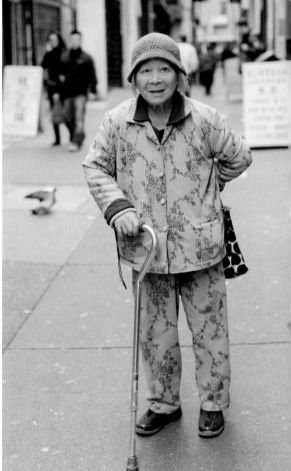

MY FAVORITE SALAD IS WINE

ROSS ALLEY, 2016

A Chinatown Pretty outfit is like a short story. There's a narrative, there are themes and references. And once you read through the whole outfit, you'll be delighted, amused, or inspired—maybe even all at once.

That's what happened when we met this woman while we were installing our first gallery show at 41 Ross, an art and community space in Chinatown. We like how certain elements show up several times in her outfit: jade jewelry, knitwear, fleece, and multiple pops of pink—like her socks.

Another time we ran into her at Ross Alley wearing a powerful outdoor pajama set with bold pink florals and mustard yellow buttons. This time, another surprise: She was sporting a pink froggy pinkie ring. Minds blown and hearts exploded—again.

The story of a Chinatown Pretty outfit sometimes leads to a punchline. In this case, the kicker was a pair of pink socks that read "My Favorite Salad Is Wine."

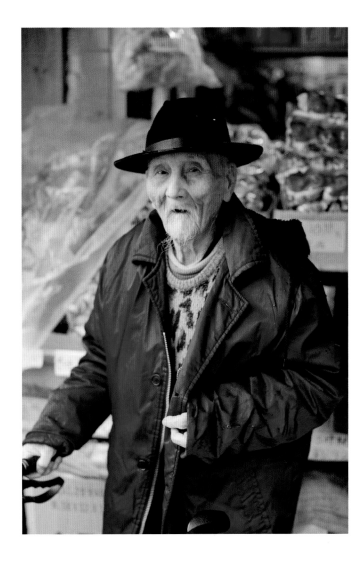

HEARTFELT FEDORA

STOCKTON STREET, 2014

We spotted Nam Ping Li on his way to tea with his son. Even at ninety-five, the former schoolteacher treks down from his house on Broadway to read the paper and relax over tea—a ritual he's enjoyed for the forty years he's lived in Chinatown.

We were enamored by his velvety fedora cap. "I've had it for the past twenty years," he said. When asked why he enjoyed the hat, he says he bought it because it spoke to him. "I felt it in my heart," he said, patting his chest.

When we asked him to describe his style, he said "warm." He had eight layers on that day, each one creating a Saturn-like ring around his neck.

MY FAVORITE SALAD IS WINE

ROSS ALLEY, 2016

A Chinatown Pretty outfit is like a short story. There's a narrative, there are themes and references. And once you read through the whole outfit, you'll be delighted, amused, or inspired—maybe even all at once.

That's what happened when we met this woman while we were installing our first gallery show at 41 Ross, an art and community space in Chinatown. We like how certain elements show up several times in her outfit: jade jewelry, knitwear, fleece, and multiple pops of pink—like her socks.

Another time we ran into her at Ross Alley wearing a powerful outdoor pajama set with bold pink florals and mustard yellow buttons. This time, another surprise: She was sporting a pink froggy pinkie ring. Minds blown and hearts exploded—again.

The story of a Chinatown Pretty outfit sometimes leads to a punchline. In this case, the kicker was a pair of pink socks that read "My Favorite Salad Is Wine."

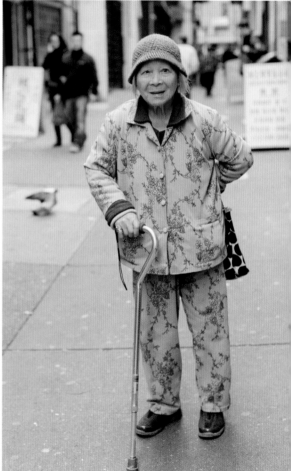

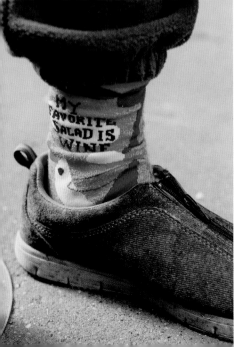

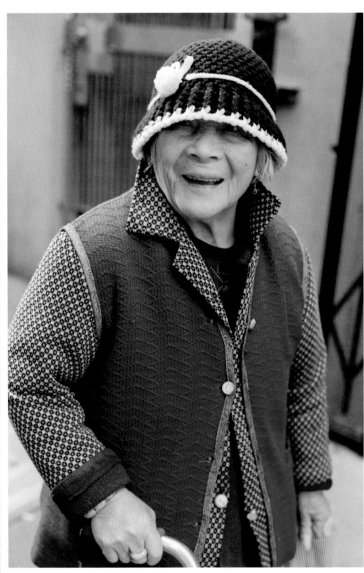

GREAT IN GRAPE

PACIFIC AVENUE, 2015

After scouting for a few hours (without much success), we turned a corner and saw the pop of color that was Feng Luen Feng, a seventy-seven-year-old San Francisco resident. She doesn't live in Chinatown, but like a lot of people in her cohort, she comes to buy groceries. She was picking out grapes while wearing a grape-colored jacket that she's had for twenty-one years.

"Going out is dressing up," she said.

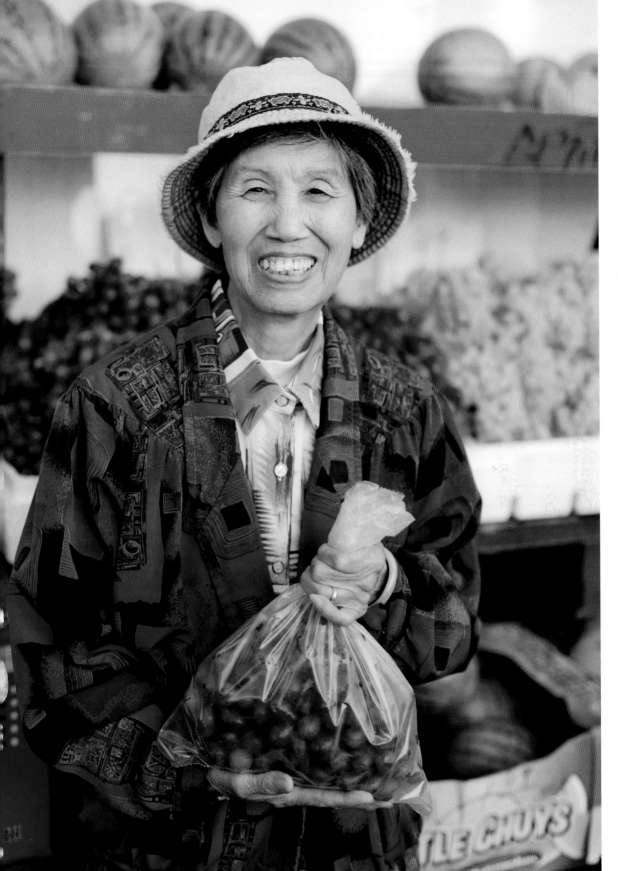

SHI PING

JACKSON STREET, 2014, AND MISSION
STREET, 2017

When we first met Shi Ping Tang pushing her cart down
Jackson Street, she had on three different prints: a yel-
low Tropicana floral blazer, a checkered blue scarf, and
a burgundy checkered vest. She unbuttoned her jacket
and revealed a purple plaid shirt.

"All my clothes are gifted," she said. "My friends give
me all my clothes. I never have to buy anything."

She had such a sweet look, it's no wonder people
want to give her things. We loved her gray bob with
bangs she'd freshly trimmed herself. "People give me
food too," she said. The previous day she had been
walking down the street when a stranger petted her
on the head. "Normally people don't like that, but I
didn't mind," she said. "I smiled and he gave me a
big juicy peach."

A few years later, we caught up with her in her Mission
Street apartment. Ms. Tang, then eighty-two, had
experienced health complications and now had a
caretaker. She was once a caretaker herself: When she
was in China, she worked as a nurse at a pen factory.
When she immigrated to the United States twenty
years ago, Ms. Tang worked at a nursing home in
Chinatown before she retired.

She shared her approach to health care: "Treat every-
one equally and with love."

SUITS AND ÁO DÀIS

ROSS ALLEY, 2016

Meet my *bà ngoại* (grandma in Vietnamese)—Hoa Thi Nguyen, eighty-one years old and a resident of San Jose, California.

I convinced her to come up for Senior Portrait Day at 41 Ross, because after all this is a project documenting grandmas and their style, and it was only fitting that I profile my own.

I had never really given thought to my grandma's style until my cousin's wedding a year ago. At the beginning of the night, my grandma wore a beautiful *áo dài* (traditional Vietnamese dress), but after all the photo-ops were done, she changed into a dress shirt and trousers.

It was unexpected: the drastic transition from feminine to masculine, the realization of what my grandma considered "slipping into something a little more comfortable." She reminded me of a photo (or perhaps a wax figure at Madame Tussauds) I'd seen of a young Liza Minnelli, looking at home and very handsome in a suit.

"I like that it's simple," my grandma said of her uniform of a dress shirt and slacks. She said she wore a dress once in the States and didn't like it, so she decided to only wear *áo dàis* during Vietnamese celebrations. "My legs are so white—it doesn't look right!" she said.

I have sworn off certain fashion items as well. No skirts (how else am I going to squat down with a fortune-teller without any issues?) and no heels (because of San Francisco hills). Like my grandma, I also commit to a uniform—in my case, T-shirts and jeans—six days out of the week, not just because I have to dress for the kitchen, but because I enjoy its simplicity.

It wasn't until Andria took this photo that I realized my grandma and I are cut from the same cloth.

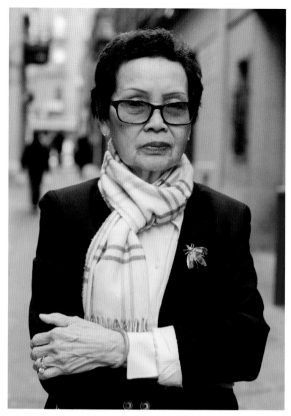

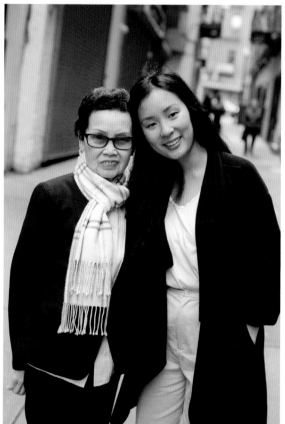

OLD AND CAREFREE

POWELL STREET, 2016 AND 2018

Run Jin Ou Yang, eighty-three, lives at the YWCA, an affordable housing building designed by the famous Californian architect Julia Morgan. She was out on a walk with her daughter wearing a freshly trimmed bob that she'd cut herself, an oversize plaid blazer, emerald green elastic-waist pants, and a fun floral silk shirt.

We interviewed her in her apartment, where she told us about her thirty-year teaching career in a rural village in Guangdong Province. "As a teacher, you need to have a lot of love," she said. "Treat them like your own kids. Don't treat them like students."

After she retired in her sixties, she moved to the United States. When we tried to get more details about her immigration, she told us she has Alzheimer's. "It's hard to remember the past," she said.

But she reassured us that she's living happily—she spends her time going out for dim sum and keeps in touch with family and friends. "I have no cares. I have nowhere I need to be," she said. "The kids and grandkids are OK, so there's nothing to worry about."

She said she was a perfectionist when she was younger. "Now I'm carefree. If I remember, I remember. If I don't, I don't."

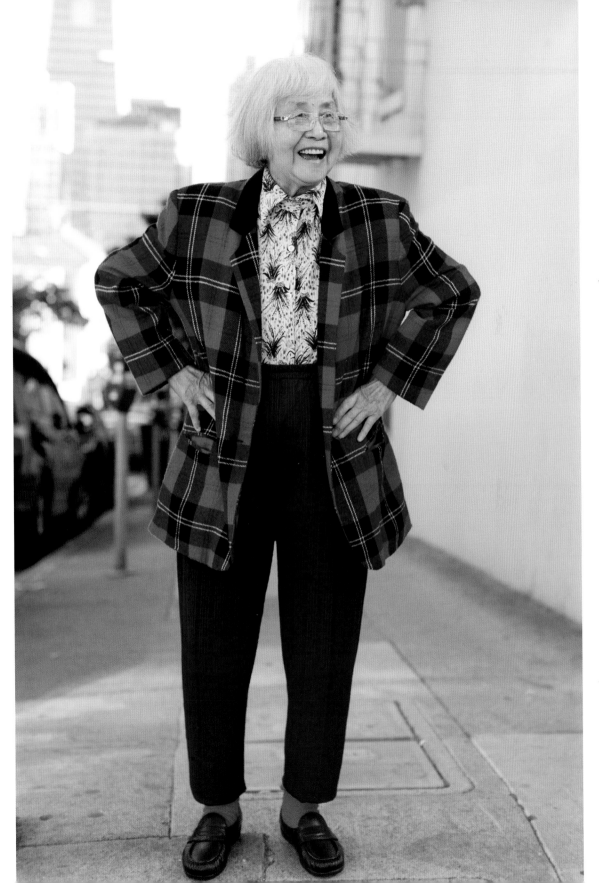

ELENA

We met Elena Lai at the Chinatown Community Devel-
opment Center's Thursday food pantry. She was fiery
and flexible. When we asked for a photo, she busted
out tai chi moves and hand kicks to demonstrate her
dexterity. "There are still trophies that I won in the hall
of fame back in China," she said. After surprising us
with her moves, she shared a bit of her backstory: She
came to the United States after having to leave a war-
torn South American country (she didn't specify which
one). Wartime scarcity forced her to make clothes, like
the ones she wore when we met her: a cotton floral
button-down shirt and purple trousers.

Her outfit was a delight upon closer inspection—the
seafoam green windbreaker picked up on the jade
floral details, both of which paired perfectly with the
purple pants. (We also loved how she cuffed them.)
The Chanel sneakers were worn but still wonderful.

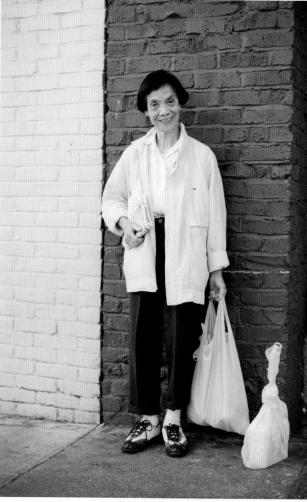

LILAC AND BURGUNDY

PORTSMOUTH SQUARE, 2015

Her subtle color combinations are what makes this woman unique. Like many seniors in Chinatown, she hangs out in Portsmouth Square, often sitting on the park benches watching the world go by. We loved her smart color combinations: a subtle lilac shirt paired with a similar quilted vest. Her accessories: a burgundy corduroy baseball cap and tortoise-rimmed sunglasses, worn at the tip of her nose.

Combined with dark burgundy pants (which she wore the day we first met her), it made for a color combo none of us had ever considered. When we commented on her brilliant matching, she disagreed, saying that it didn't match. We begged to differ.

We squatted at the park bench to stay at eye-level, and chatted with her for ten minutes about her life and clothes. "My daughter-in-law keeps buying me clothes from Hong Kong," she said. "I tell her I live in an SRO and I have no room!"

Afterward, we asked to take her photo. She said no. "I will tell you stories all day, but no pictures," she said. We begged, but she didn't budge. But we knew we would see her again, and we often did, in and around Portsmouth Square. Finally, one afternoon she agreed to a picture; luckily she was wearing her signature outfit.

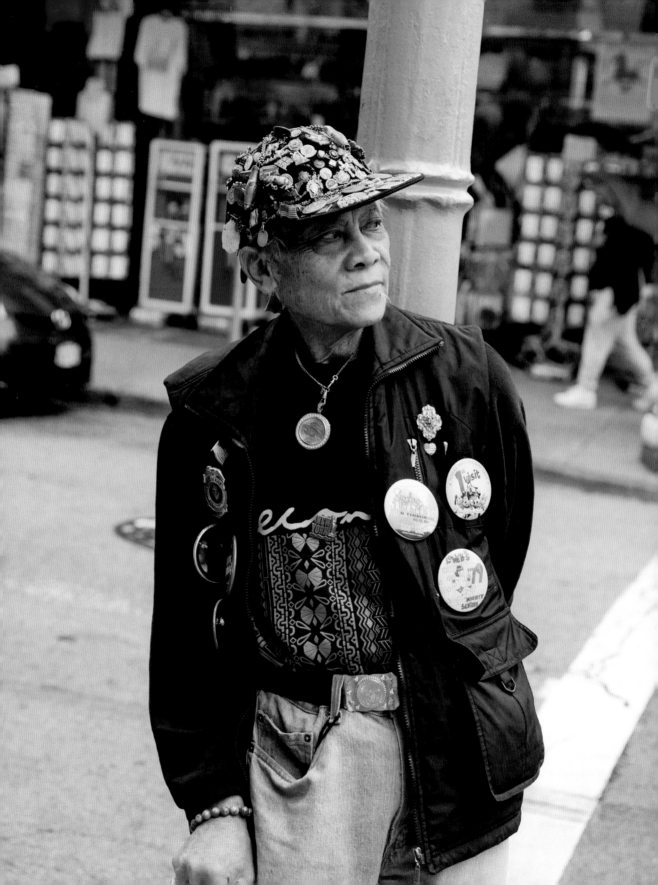

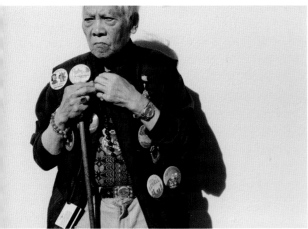

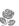

ANGIE NO GOOD

GRANT STREET, 2017, AND PACIFIC
STREET, 2018

We couldn't believe we hadn't met this character and San Francisco Chinatown resident before, but there he was one afternoon, casually leaning up against a light pole on Grant Street, wearing a cap encrusted with enamel pins from his travels around the world.

"What's your name?" we asked.

"Angie," he said. "Angie No Good."

His punk name matched his punk attitude. When we saw him again a year later, he was wearing the same outfit, except with a few more Cache Creek Casino pins and gold jewelry. This time we had more time to chat before he caught the 12 Folsom bus on Pacific Street.

As for the bling, he wore a watch, belt, bracelet, ring, pin, necklace, keychain, and a sphinx-topped walking cane all covered in gold—and even a gold coin in his pocket. He says gold's feng shui properties give him life (and perhaps fortune).

"I like to play roulette," he said when we asked him about his casino game of choice. "I won twenty thousand dollars once."

THE FORTUNE-TELLER

We met Ms. Li on the corner of Pacific and Grant, where she can be found on most days sitting on her plastic bucket-shaped stools, faded pink, waiting to read fortunes for passersby.

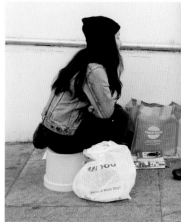

Her little pink corner caught our eye—the stools, the faded red cap, the set of purple outdoor pajamas. Ms. Li paired her purple outfit with a striped mock turtleneck underneath and stylish gold sunglasses.

"How's business?" we asked.

"When there's people there's people," she said matter-of-factly. "When there's no people, there's no people."

"Do you want your fortune read, or not?" she asked. We asked for a trade—a paid fortune reading for a portrait. She sort of agreed.

"How much?" I asked.

"How much do you want to pay?" she rebutted.

I handed her two fives and she switched her sunglasses out for reading glasses and started singing a song.

She asked me to choose two cards from her deck, cut-outs from Marlboro cartons with fortunes inside, written in Chinese characters. They were worn and smooth from many years of swishing around and handling.

In response, she said that I was born on a good birthday; currently things are hard, but overall things look pretty good. "Twenty-eight and twenty-nine will not be good years," she said. "You need to pray—a lot." She assured me that thirty will be a better year.

She also took a call during the session on her hot pink flip phone that lasted for five minutes.

Once her call was finished, she asked me if I drove a car. "Why, yes," I said—I had just gotten a car earlier in the week. "Well, you need to put two safety banners. One in the car and one in the purse." She pulled out a thin yellow paper that had been folded into a triangle—good-luck banners, she said. "How much?" I asked. This time she named the price, "three dollars each." I bought two of them for good luck.

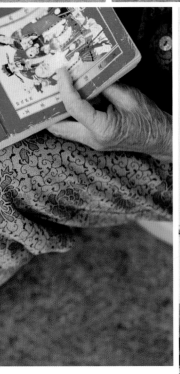

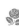

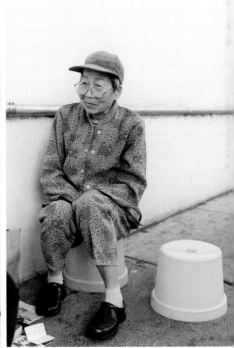

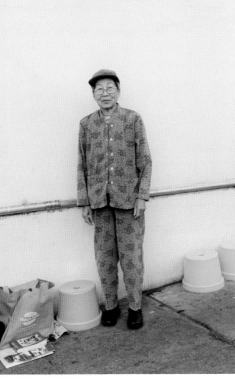

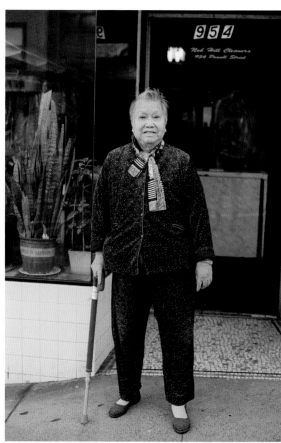

BOSS LADY IN BLUE

POWELL STREET, 2016

Hoa Tran Lu, eighty-three, looked powerful in her navy patterned outdoor pajama set, topped with an orange print scarf. Both were strong statement pieces, which added to her bold aura. She had thoughtfully accessorized her walking cane with a colorful knit sleeve to make it more comfortable. Different colored silk ribbons wrapped around the cane gave it an extra few pops of color, another personal touch.

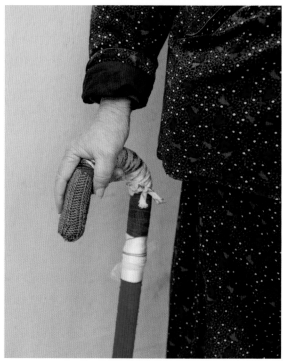

CHERRY
TOMATO SOCKS

POWELL STREET, 2016

Meet Li Su Qin, eighty-three, representing San Francisco
with her maroon hat. Also, three words: *happy tomato
socks*. Or are they cherries? Amazing either way.

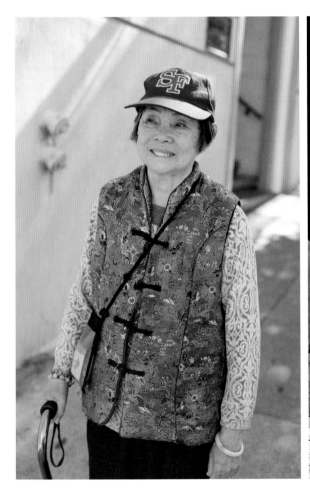

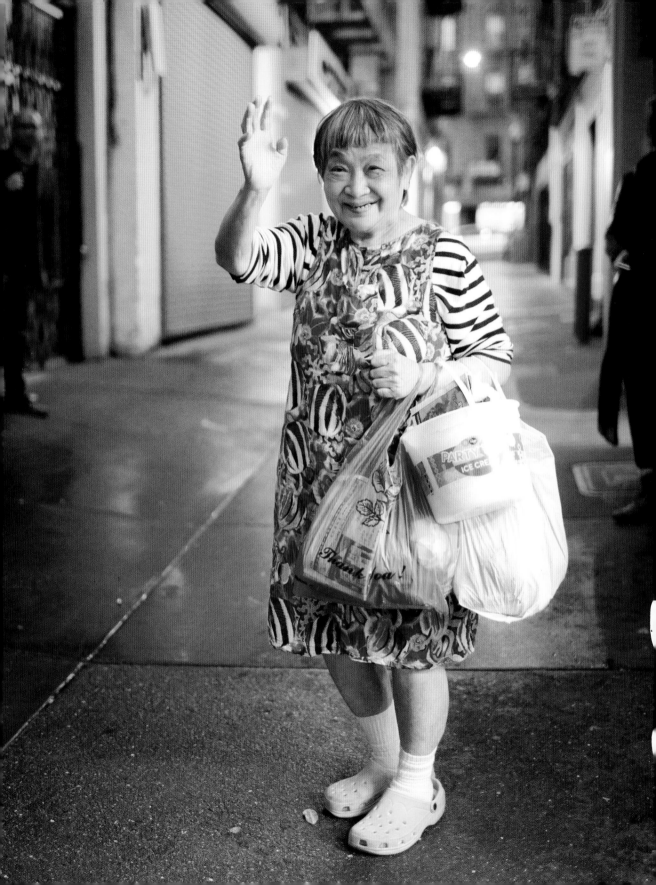

LIFE AQUATIC

ROSS ALLEY, 2016

We met Betty Yee at the opening and closing parties for our first Chinatown Pretty photo exhibit at 41 Ross.

She was walking down the alleyway and stopped to peer inside the space, curious about what was going on. We waved her in and became fast friends—she wanted to show us her house and requested that we save our beer cans from the opening party for her to recycle.

At the closing party, she showed up in this great outfit. She had just finished swimming laps at the Chinatown YMCA and appeared in an aquatic look consisting of yellow Crocs and a tropical ocean print dress with a striped shirt underneath.

She grabbed our arms and insisted that we Irish-exit our event. "Come with me to the church—there's free food!" she said.

"But, Betty, we can't leave!" we cried.

"Sure you can," she replied.

We didn't leave, but we exchanged mailing addresses instead, imagining it wouldn't be long till we ran into her again.

POLKA DOT

CAMERON HOUSE AND WAVERLY PLACE,
2017 AND 2018

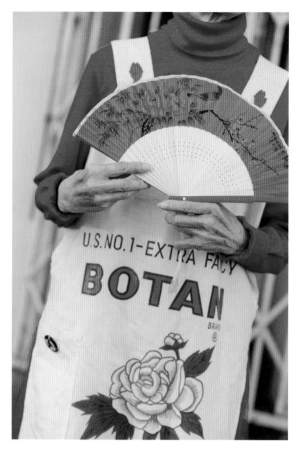

We met Dorothy G.C. Quock, better known as Polka Dot, at an opening party for Eat Chinatown, a photo exhibit we produced that chronicled longtime restaurants in the neighborhood. She brought in an old matchbook from a long-gone restaurant to contribute to our wall of vintage restaurant menus and ephemera.

Living up to her name, she wore a pink raincoat studded with white polka dots. She got her nickname at Donaldina Cameron House, a Presbyterian family and youth organization in Chinatown. There was another person named Dorothy, so the executive director nicknamed her Polka Dot, and it stuck. At the time, she didn't wear polka dots much, but now it's her signature look.

We met her one day at the Cameron House rooftop basketball court, where Polka Dot demonstrated her tai chi moves, which she practices daily. She wore an all-red outfit with a polka dot turtleneck underneath a ruffled shirt. Her accessories included a hair clip with Guatemalan worry dolls (a gift from her daughter) and cotton Mary Janes, to the tips of which she had affixed pom poms to patch up a hole.

"I grew up here," she said of Cameron House. Polka Dot was in the first group of teens to join the youth program in 1947, when she was thirteen years old. She spent most of her youth at Cameron House until she moved away for college, so much so that her mother quipped, "Why don't you move your bed there?"

On Friday nights they held socials, where teens would learn about "the birds and the bees." Polka Dot also learned about civic responsibility and politics through the youth program. Although she's no longer active in the religious aspect of Cameron House, it taught her the importance of social change and community work.

Polka Dot has shown us what it means to be community-minded. One afternoon we were at her apartment in Chinatown, which she moved back to in 2003 after spending forty-one years in Livermore. "It was a once-in-a-lifetime opportunity to get this apartment," she said.

Her front door, which is mostly made of frosted glass, was covered in posters and stickers that advocated for universal health care, "Impeach Bush and Cheney" signs, and a flyer that said "Bring the Troops Home—Bay Area United Against War."

Her political hero is Ralph Nader, who's run for president four times. During his run in 2000, Polka Dot campaigned for him—referring to herself as a "self-appointed campaign manager of Nader in the Fremont-Newark area." Since there wasn't a campaign office in her town, she formed her own nucleus of Nader supporters—they registered voters and campaigned for him at BART stations and college campuses. One of her bucket list items is to take him on a walking tour of Chinatown.

Polka Dot thinks globally, but acts locally by taking care of her neighbors. On Mondays, she receives a delivery from the food pantry. She keeps a list of her neighbors and "what they can eat or what they like to eat" on her fridge—and distributes her bounty to them accordingly. Because our city is susceptible to earthquakes and fires,

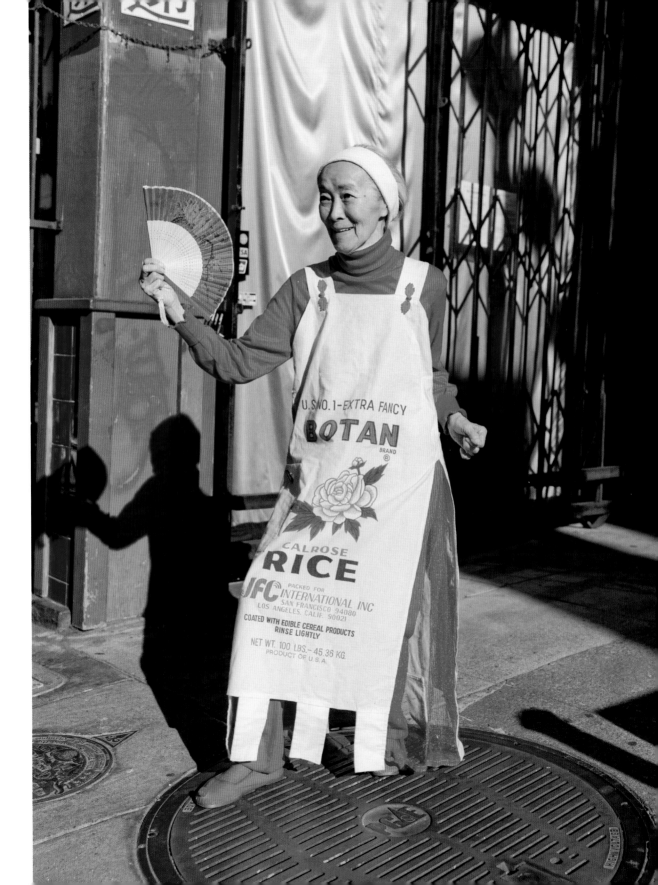

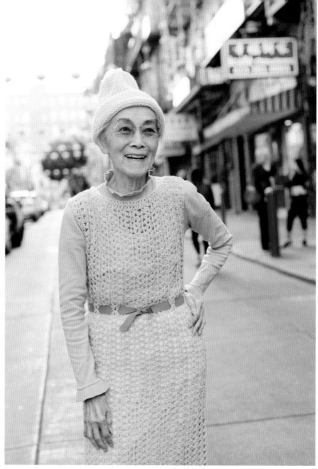

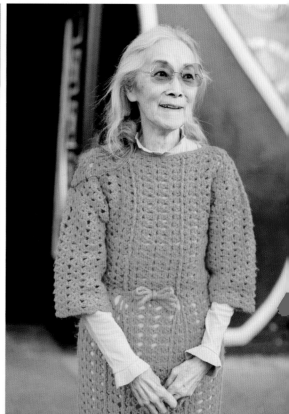

Polka Dot has initiated an emergency response plan for her apartment building, which she created after receiving training through Neighborhood Emergency Response Team (NERT), a San Francisco Fire Department program. Although Polka Dot hasn't experienced an emergency, there've been plenty of false alarms. "There's old ladies that burn their rice every so often," Polka Dot said with a laugh.

Recently, Polka Dot's building was purchased by new landlords who increased her rent by three hundred dollars. As someone with limited income, she applied for a hardship waiver and also formed a group of residents, who dubbed themselves "The Gang of Five," to appeal to the San Francisco Rent Board. She got her first rent increase waived, but no longer qualifies for a reduction. Community organizations like Chinatown Community Development Center (CCDC) and the Community Tenants Association helped advocate for Polka Dot at the rent board meeting. "I was so troubled after the hearing that I told CCDC 'If you need a poster senior for tenants' rights, let me know—I'll consider it!'"

Nowadays, new tenants pay around three thousand dollars a month for a one-bedroom apartment, significantly more than what she paid when she moved there sixteen years ago. She said that there's only "half of us" left in the building—people she refers to as "the old doors," a reference to the people with the frosted glass doors, as opposed to the newer solid wood doors that replace the glass ones once an older tenant moves out. We asked where have they gone. "People have died; been evicted," she said.

Polka Dot is a portal to what Chinatown is and was. On our first walk around the neighborhood with her, Polka Dot—wearing a five-piece cheetah-print outfit she had made herself—had a story to share every time we turned a corner. "See that building? I was a house girl for a well-to-do engineer. My sister had the job first, but when she moved away I took over. He had these outfits he'd want us to serve in—Chinese brocade blouses. I learned how to mix martinis for dinner parties," she said, recalling one of her many Chinatown memories.

After working as a secretary for three institutions, she's established her most recent career based on her longtime connection to Chinatown: She works as a guide for Wok Wiz Chinatown Walking Tours and also as a researcher for filmmaker James Q. Chan.

Polka Dot was born in 1934 in Chinatown, as one of eight kids. They lived in single-room occupancy housing (SROs) and houses all over Chinatown—at times with ten of them in one room. Before she graduated high school, they'd moved eleven times. "With so many of us, my mom probably got into arguments with neighbors," she said.

Her father had arrived in San Francisco as a crew man on a freighter sometime between 1916 and 1918 and remained in the United States illegally. He delivered rice for work, dropping off fifty- and hundred-pound sacks to Chinatown businesses and residences. For a film premiere in 2016, Polka Dot took one of the heirloom cotton rice bags and turned it into a dress.

Her mother worked at the sweatshops that produced Levi's, where she would bring Polka Dot and her siblings. Polka Dot described it as a crowded, dirty, and dimly lit place where the shades were always drawn so that people could not look in. As a preschooler, she got her first experience trimming thread ends. In second grade, she learned how to use an embosser to stamp the Levi's logo onto the leather tag. At age ten, she mastered the buttonhole, five of which appeared on Levi's before zippers became the norm. "We got two cents for every buttonhole we made, so it was very lucrative," she said.

Child labor laws were not strongly enforced back then, so kids worked next to their mothers. There was always someone in front to keep watch for an inspector. "They'd yell *'baahk gwái lai le'* [the white ghost is coming] whenever a white guy came in and we would run into the toilet and hide until someone told us it was safe to come out," she said. (*Baahk gwái* is a Toisanese derogatory term for someone of European descent.) "It usually wasn't a labor law inspector; it was usually a new Levi-Strauss driver that had come to pick up the finished jeans." She says those were scary times for the children.

On another day, we toured Chinatown with Polka Dot while she modeled a few knit dresses that her late sister Fann had knitted for her over the years, paired with Sophia Loren–style eyeglasses she's had since 1990. We stood in front of 842 Washington, her parents' first rental, where Fann, the eldest sibling, was born. Fann started knitting for her in the 1980s. "She would constantly knit or crochet," Polka Dot said. "And since she had three sons, the knitting didn't go very far." Therefore, Polka Dot was the main recipient of Fann's original designs—dresses, vests, decorative collars, and scarves.

During the Great Depression, Fann and her dad would walk around the corner to Sam Wo, a local institution, around two a.m. to fill two big pots with leftover *jook* (rice porridge), noodles, and Chinese doughnuts, which they would eat for breakfast the next morning. "Otherwise, we would've gone hungry," she said. Of Fann, Polka Dot said: "She was my surrogate mother. As the oldest, by default, she had to take care of us younger ones."

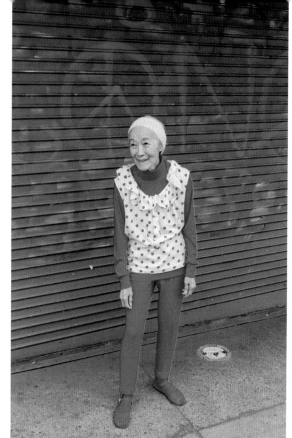

We ducked into Impressions Orient, a gift shop that's a regular stop on Polka Dot's walking tours, so she could change into another outfit. She modeled her combination on Waverly Avenue: a beige crocheted dress with a ruffled turtleneck underneath, the mellow colors contrasted with a citrus yellow knit pom-pom beanie and green ribbon at her waist. On her feet were a pair of black flats gifted to her by the 1948 Miss Chinatown Pageant winner, Penny Lee Wong; she added an elastic band across the top to secure the slippers. The outfit wasn't just fashionable—it felt like a unique product of Fann's familial love and Polka Dot's artistic engineering.

Over the years, Polka Dot has become a role model and a friend. She came to our photo exhibit at Legion, an art gallery in Nob Hill. The event at the gallery unfolded into an after-party at the Tonga Room, a legendary tiki bar inside the Fairmont Hotel and one of Polka Dot's old haunts, a place for special date nights. Her last visit was twenty years ago; she was happy that it's basically remained the same.

She joined us on the dance floor, while a cover band played Rihanna's "Umbrella" on a floating stage atop the bar's indoor pool. When our friend Pete Lee motioned to her that he was ready to walk her home, she said, "Can you wait five more minutes?" so she could squeeze in one more song.

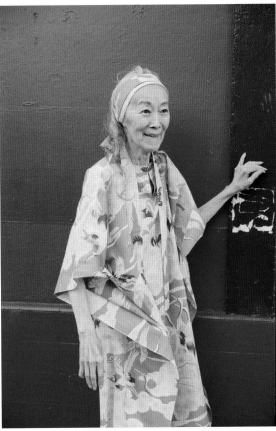

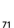

OAKLAND CHINATOWN

The Chinatown across the Bay

When San Francisco has gotten too cold (as in, the locals have had enough of us), we cross the Bay Bridge to sunny Oakland Chinatown, where seniors are more relaxed and warmed by the climate. We usually begin our scouting in the heart of things, on the corner of Webster and Eighth Streets, near Downtown. As we wait at the diagonal crossing, our eyes scan the dozens of passersby wearing floral wide-brimmed hats and pulling rolling metal shopping carts, ready to get their grocery shopping on. We'll scan the line that snakes around the corner of Gateway Bank before it opens or peek into the Pacific Renaissance Plaza to scout seniors sitting on benches that circle the water fountain. After a few hours of lapping around Harrison, Webster, and Franklin Streets, we always pay a visit to Tian Jin Dumplings, which sells *jianbing guozi*, a street-food breakfast made of a long crisp Chinese fried doughnut wrapped in a thin omelet.

The markets are the pulse that keeps Chinatown busy and beating—whether it's brick and mortar stores or the Old Oakland Farmers' Market on Fridays. Ms. Wong, our favorite grocer at New Hop Lung Market, is always greeting customers outside the market, prepared for rain or shine with her assortment of hats. The employees at

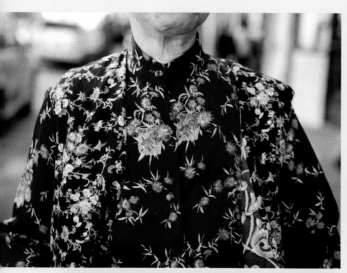

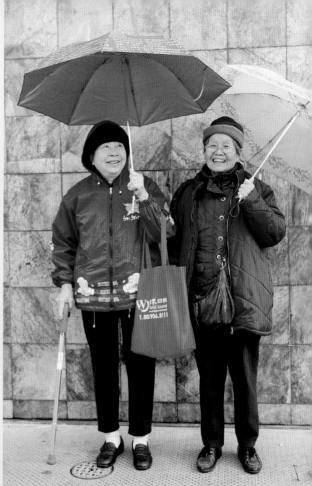

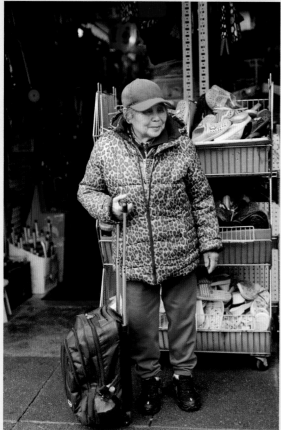

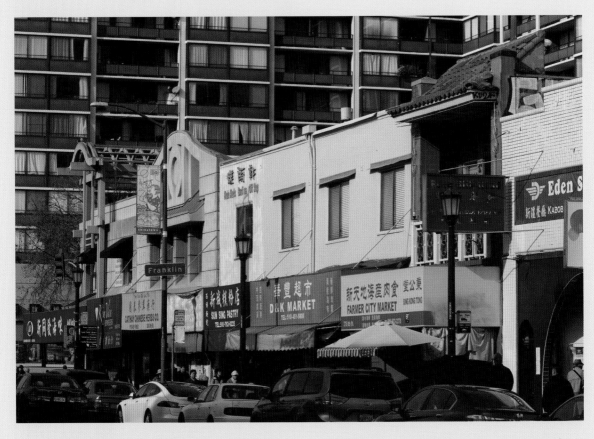

LG Supermarket grocery don minimal brown baseball caps with the store's name as they hurriedly unpack deliveries to restock the outdoor stalls. Renegade produce and plant peddlers occupy street corners with their bounty of home-grown goods laid out on blankets—and interesting outfits to go along with them.

Oakland Chinatown was established in the 1850s, around the same time as San Francisco Chinatown. The first Chinese settlers in Oakland lived near the waterfront and established shrimp fisheries. There were dozens of these fishing encampments along the San Francisco Bay until many were forced to close because their traditional bag fishing methods were outlawed in 1911. China Camp in San Rafael is one of the few that remains standing, though it functions now only as a state park and historical landmark. In addition to fishing, the Chinese in Oakland worked on building the dams that, in 1868, created Lake Chabot and Lake Temescal.

The population increased by thousands after the 1906 earthquake, when many displaced Chinese left San Francisco for Oakland. Over the decades, different waves of Asian immigrants—Japanese, Korean, and Vietnamese—have also settled or opened businesses in Oakland Chinatown, creating a multicultural Asian community.

ELEPHANT HAT

EIGHTH STREET, 2017, AND FRANKLIN STREET, 2018

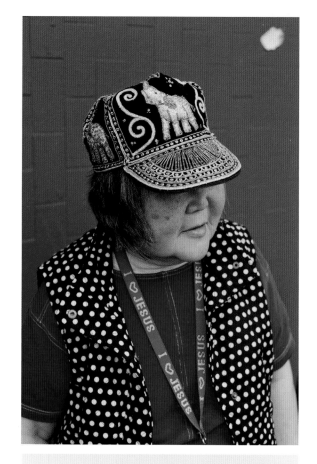

Ms. Chen, seventy-five, exuded a certain kind of cool and command—we immediately wanted to call her "boss." We loved her mix of colors topped off with a sparkly embroidered cap, which she bought in Thailand nearly two decades ago and recently rediscovered in her closet.

Originally from Jiangxi (where they make "best porcelain in the world"), Ms. Chen spent many years moving around China—Guangzhou, Nanking, and four other cities, eventually ending up in Taiwan in 1949. "That's why I understand different dialects," she said.

Her final move was to the United States, where she worked at an immigration office in Oakland before retiring. She picked up Cantonese and English on the job. She called to thank us upon receiving her prints in the mail. "I think these are the sharpest photos I've ever had taken of me," she said. "Very, very super!"

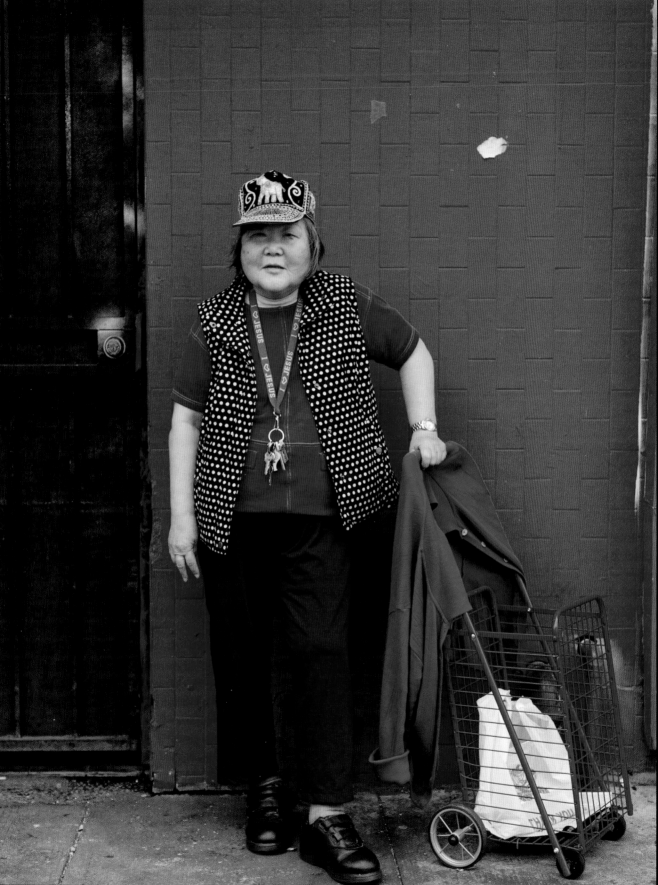

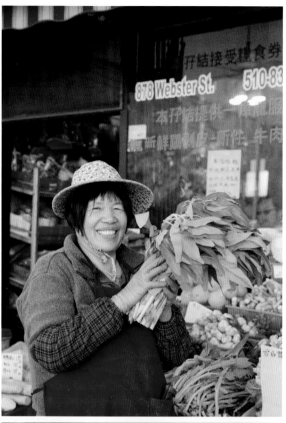

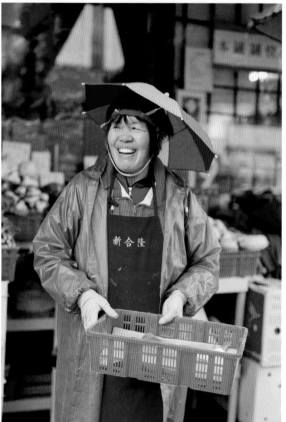

THE GROCER

Ms. Wong is a friendly familiar face whenever we make our rounds in Oakland Chinatown. We always find her outside of New Hop Lung Market in a unique hat, fleece sweater, maroon apron, and sleeve covers—always dressed appropriately for the weather. When it's bright out, she sports super sun hats in floral patterns. On rainy days, she wears an umbrella hat, which looks like it was constructed using a children's umbrella.

THE VOLUNTEER

ELEVENTH STREET, 2018

Ying S. Geng, eighty-two, was part of a group of volunteers at Lincoln Square Recreation Park Center picking up trash for Earth Day. One of them said to us that since they receive Social Security benefits, they want to be able to give back.

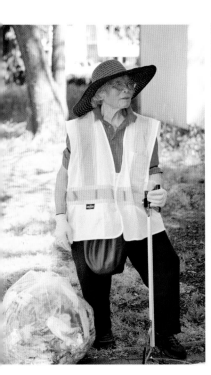

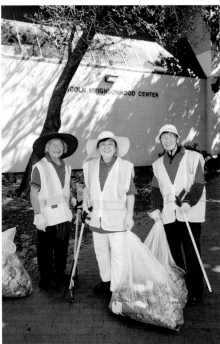

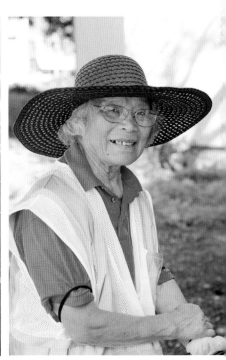

THE BEARDED BUTCHER

FRANKLIN STREET, 2017, AND NINTH
STREET, 2017

We met Sidney Yuen, seventy-three, as he was headed home with full bags of fresh produce and groceries. He's now retired after working for thirty-six years as a butcher at Berkeley Bowl, a popular East Bay grocery store. He has always worked in markets—first at the Sheung Wan Market in Hong Kong, where he grew up, and then in Hawaii where he landed in the '70s upon immigrating to the United States.

When he moved to the Bay Area, his friend connected him to the job at Berkeley Bowl, where he remained for the rest of his career. We asked him about his distinctive hair, which he said he only began growing out a few years ago. "Everywhere I go, people say they recognize me [from the grocery store]," he said. "They call me Mr. Miyagi or Ho Chi Minh."

Now in his retirement, Mr. Yuen stays active by tending to his backyard garden, practicing tai chi, and learning Chinese dance at local parks.

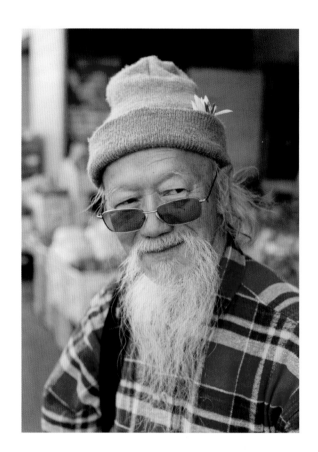

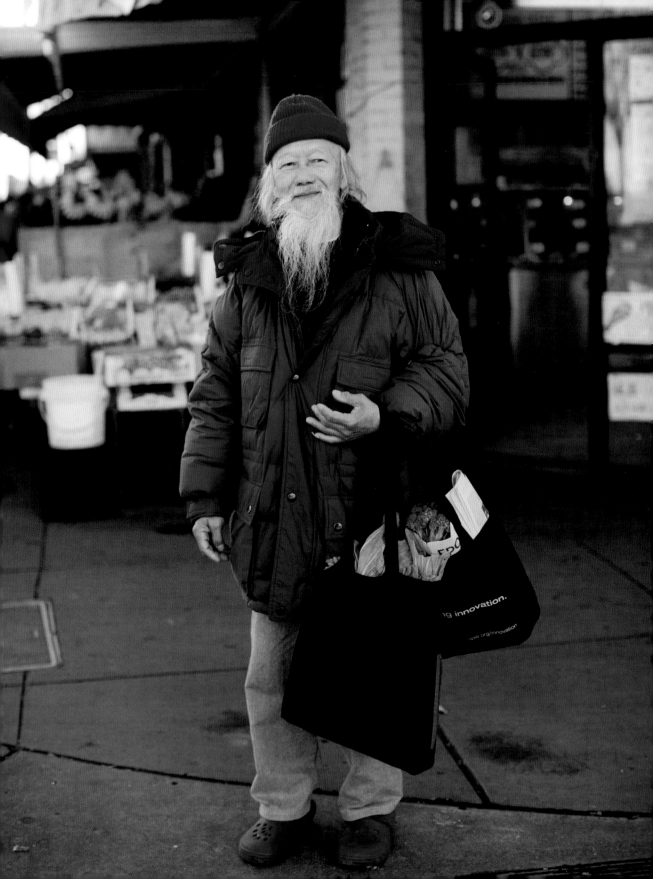

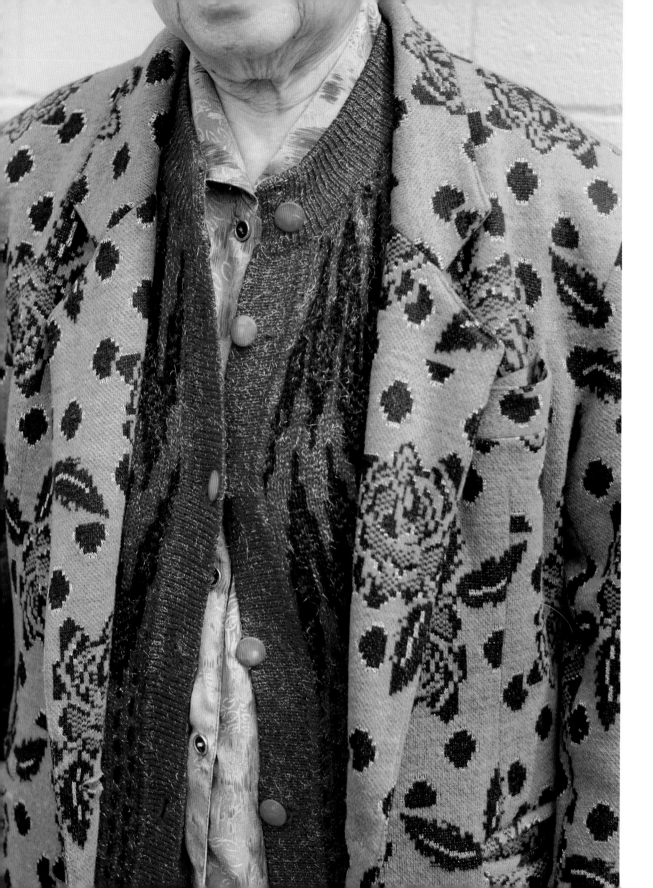

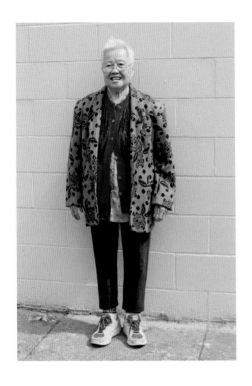

MUSTARD BLAZER

SEVENTH STREET, 2016

Shui P. Wong, ninety, has a knack for color. We met her when she was on her way to dim sum, wearing a mustard yellow blazer on top of a rose patterned cardigan and a watercolor print blouse. The knits looked cozy and coordinated; the pastel shirt offered a fun break. She paired it with thick brown sweatpants that revealed her "USA" socks.

Ms. Wong claims she just wears "whatever," but her "dozen or so" grandkids beg to differ—they said she's always been a pro at color coordinating her clothes, many of which they've given to her as gifts.

Before immigrating to the States, Ms. Wong worked in a metal factory for twenty-one years in Guangdong Province. In the United States she worked at a textile factory and as a babysitter. Nowadays, she's retired and enjoys at least twelve rounds of mahjong every day.

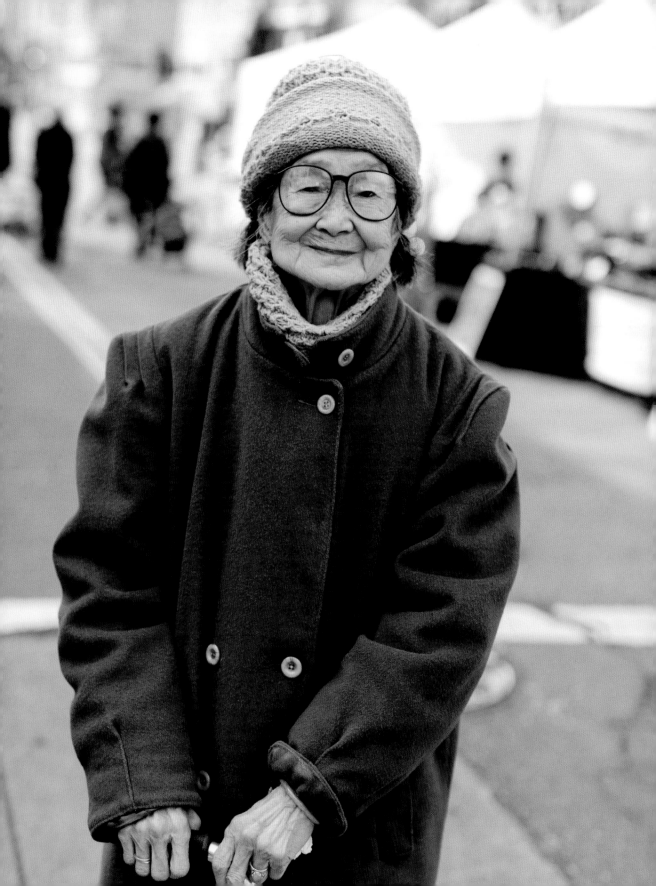

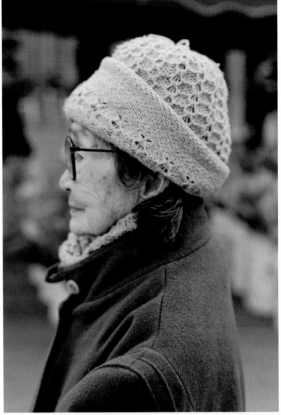

ELEGANT EARTH TONES

OLD OAKLAND FARMERS' MARKET, 2017

To Hon Ng Fan, eighty-nine, looked elegant in earth tones when we met her on her daily walk. We loved her coat's fit and unique tailoring, along with her textured knit beanie. Her jade jewelry radiated beautifully against her brown outfit.

She immigrated with her family to Vietnam by foot when she was three to escape flooding in their hometown, her mom carrying her in her arms during the journey. Then in 1995, Ms. Fan immigrated to the United States to be with her children. Most of her clothes are gifts from them, along with the wonderful glasses she was wearing.

We asked her how many children she had. She replied, "You won't believe it, but get this—I have twelve children! Eight daughters and four sons."

To keep healthy, Ms. Fan makes sure to walk around the neighborhood every day and picks up a few dollars' worth of vegetables if she sees something she likes. Her children come over to make her favorite foods and her "heart stays happy."

Before we parted ways, Ms. Fan expressed how fortuitous it was that we met each other. She was flattered we liked her style. We felt pretty lucky too.

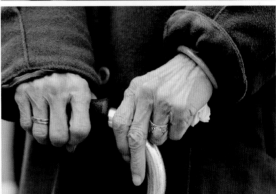

THE LEMON VENDOR

Ma Ui Sha's outfit was just as powerful as her merchandising: handfuls of homegrown lemons laid out on a leopard print blanket.

Ms. Sha immigrated from Michoacán, Mexico, where she lived for eighteen years; she's been in Oakland for fifteen. She said her lemons are organic, and she sometimes also has bok choy and tomatoes. The police come once a week to regulate the street vendors and tell them that they need a license to sell. "I just pack up and leave," she said. "And when they're gone, I come back."

Her ensemble evoked a lot of questions. Did she make the shirt? The unconventional mix of thick stripes and a vibrant floral fabric made us think so. What did the letters KNIF next to the swoosh on her track pants mean? Was it a spelling of Nike gone awry?

She confirmed that her shirt was handmade by her eighty-year-old friend, who tailored the garment for her. Her animal print blanket was also a gift from a friend. "I have many good friends," she said.

A Google search told us that KNIF is an acronym for a German saying, *kommt nicht in Frage*, which means "out of the question."

Ms. Sha's outfit showed us that nothing is out of the question—neither stripes with florals, nor reappropriated logos, nor lemons shrouded in leopard, for sale on the street corner.

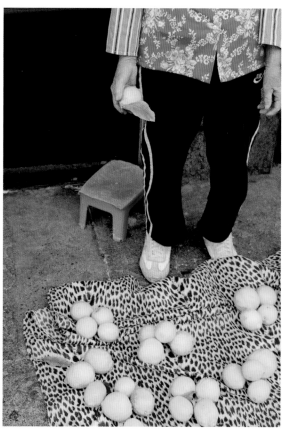

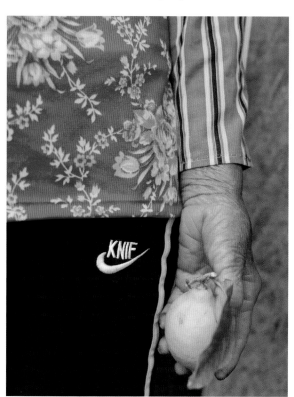

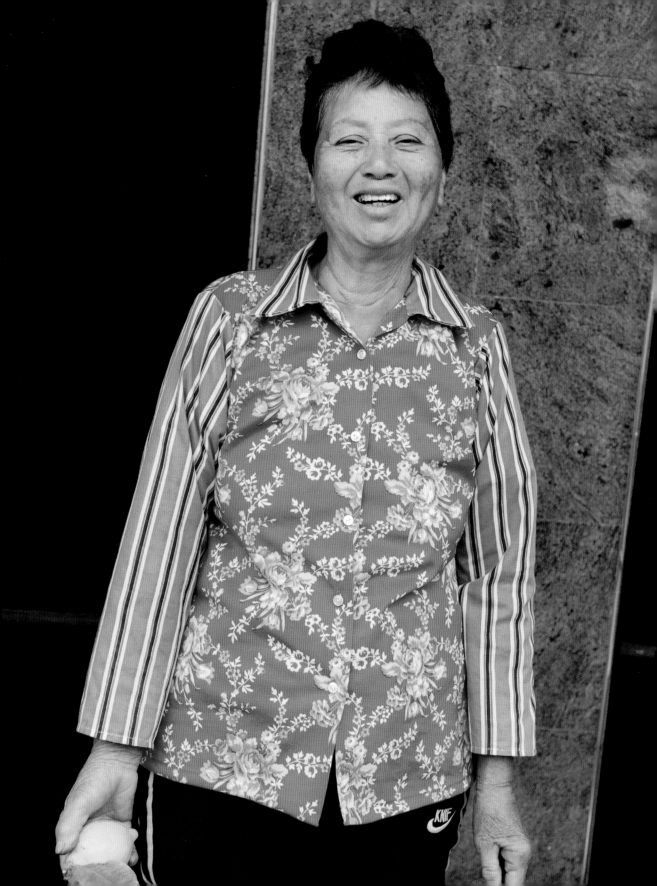

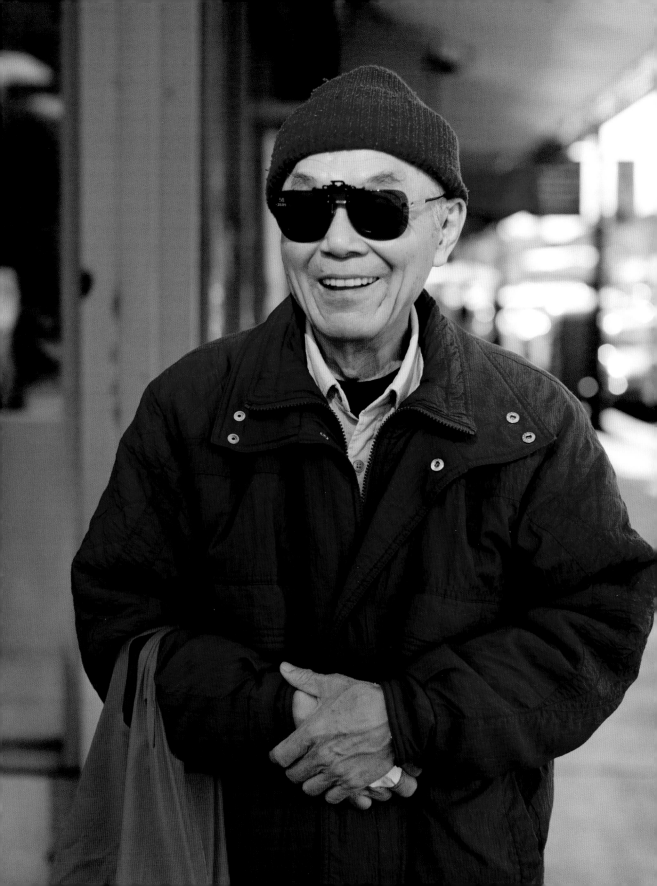

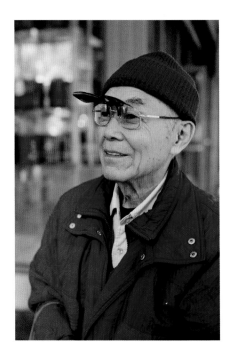

MERLOT MAN

FRANKLIN STREET, 2017

We met Wai Ping Lam, eighty, while he was on his way to church, where he attends classes on how to use the internet and iPads.

Mr. Lam was sporting a matching merlot beanie and jacket, along with clip-on shades from Walgreens. Though the shades were a more recent purchase, he says he's not much of a shopper. "I have not been shopping for clothes for the past twenty years," he said.

Prior to immigrating to the United States, he worked in construction in Hong Kong. While in the States, he worked in an electronics assembly line until he retired at sixty-five.

An Alameda resident, Mr. Lam only comes to Oakland about once a week. He says he keeps young by waking up at five fifty a.m. and walking around the neighborhood for an hour a day. His hobbies include baking bread at home.

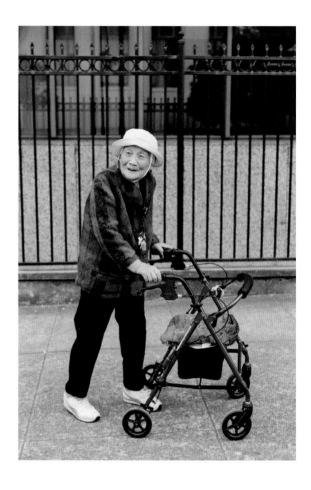

ON THE GO

THIRTEENTH STREET, 2017

Leung Tai Shen, eighty-nine, was walking in Down-town Oakland wearing a handmade seersucker hat, a rich-colored angora sweater, and teal Puma sneakers. We loved how her baby pink hat was decorated with a rich maroon grosgrain ribbon, which tied together the accessory with the outfit. She smartly added an elastic band so her hat wouldn't fly away.

For safety, Ms. Shen wore a whistle and two gourd charms on her lanyard. In Chinese culture, gourds are believed to keep away bad spirits and illness.

Although she was happy to smile for us, she was too busy to stop for a photo, so most of our photographs of her were taken while she was moving along with her walker, which she modified by adding silk floral fabric on the seat—a delicate touch.

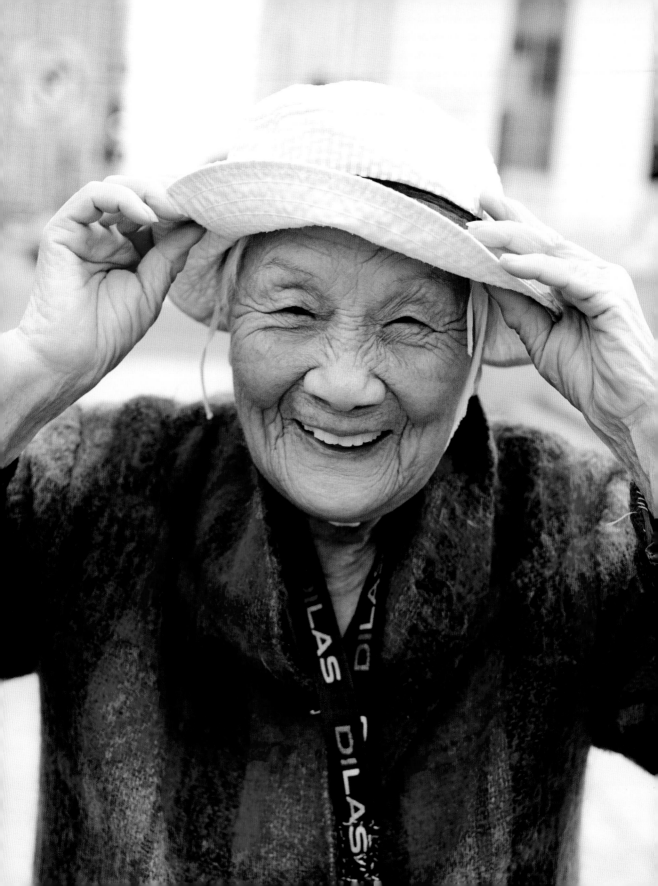

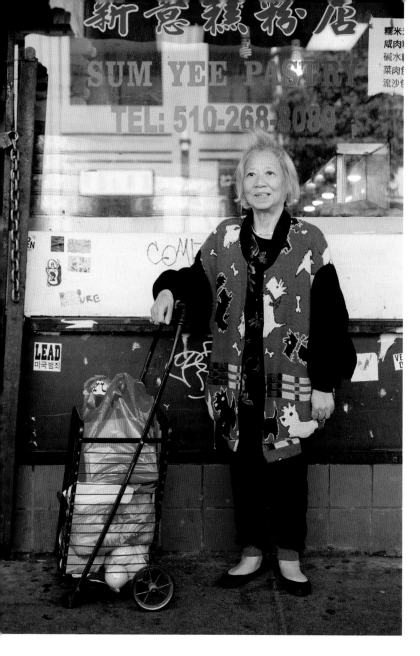

DOGS AND COWS

WEBSTER STREET, 2018

We spotted Judy Wang and her adorable cowlick and dog sweater when she was grocery shopping with her husband. They've been Berkeley residents for ten years.

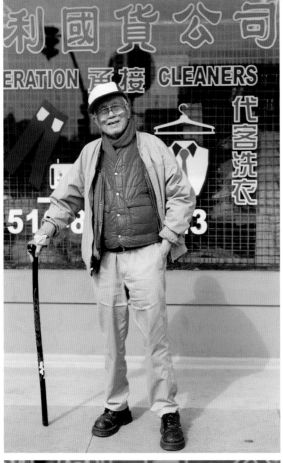

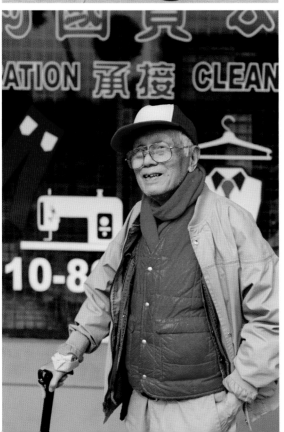

RED, WHITE, AND BLUE

HARRISON STREET, 2017

Jowh Tam, ninety, was sporting America's colors when we serendipitously crossed paths with him in front of a dry cleaner with all the same color scheme. He had on three jackets—a red down vest, a fishing vest, and a bomber jacket.

Mr. Tam is Chinese-Vietnamese—one of the many ethnic Chinese who lived in Saigon. As a result, he is fluent in Cantonese, Vietnamese, French, and English.

He was on his way to buy bok choy, which he was going to cook for his wife. "I walk a lot and watch my diet to stay healthy," he said.

He bought his cane three months ago from a ninety-nine cent store in San Leandro. "For safety," he said.

SONNY

PACIFIC RENAISSANCE PLAZA, 2018

We liked Sonny Huey's oversize jacket and perfectly folded beanie. We were so impressed that, at ninety-eight, he was out and about. Our interview didn't go very far since he couldn't hear us very well. "I will put in my earpiece next week," he said.

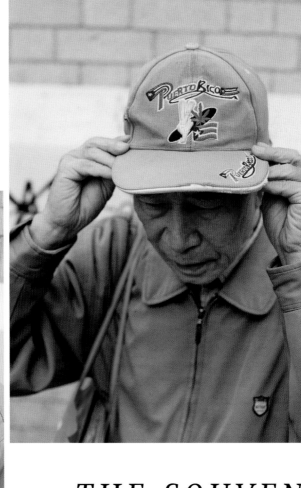

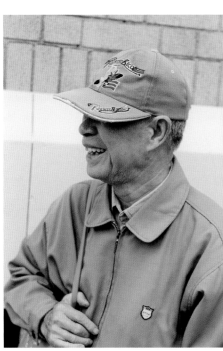

THE SOUVENIR

WEBSTER STREET, 2017

"Did you go to Puerto Rico?" we asked. Hong Xi Liang said, "No, I went to a travel agency and they gave me this hat."

COOL CAT

This woman's style and demeanor was such that she didn't even need to say a word.

When we first approached her, her daughter said no to a photo. We ran into her outside a grocery store a few hours later, while her daughter was shopping inside. She leaned against a pole, gently blinked, and waved us in to say "go ahead, take a photo before my daughter comes out again."

The combo of her slicked back hair, black jacket with the leather flats, mustard vest, and twenty-four karat earrings exuded a striking balance between "greaser" and "grandma."

What a cool cat.

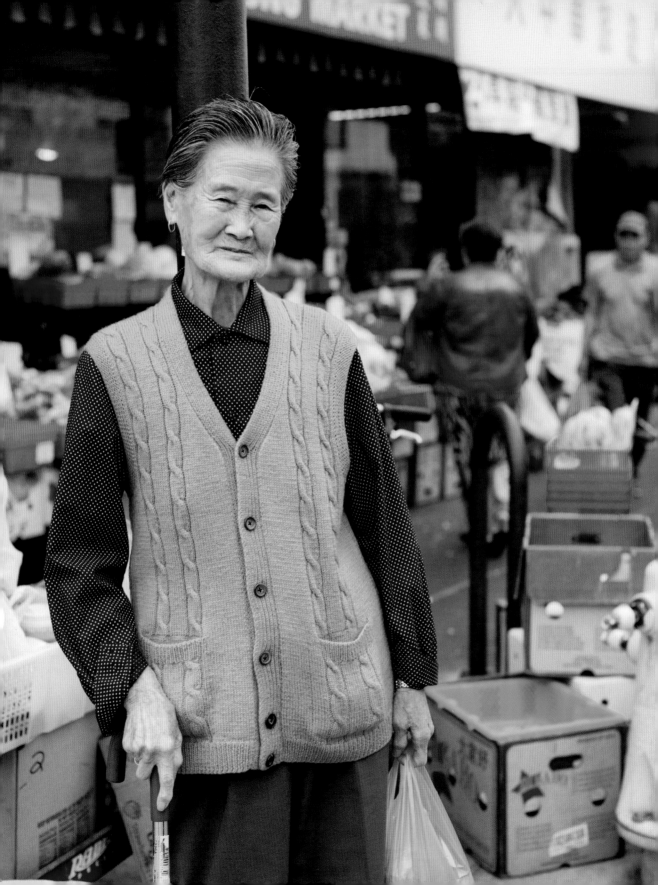

ESTELLE KELLEY

ROSS ALLEY, 2016, AND OAKLAND, 2019

A regal air preceded Estelle Kelley when she walked into a Senior Portrait Day we hosted at 41 Ross. She's Chinatown Pretty from a different time and place.

Her outfit was a mix of Chinatown Pretty with contemporary fashion. She had on a white plaid coat from Kohl's layered over a patterned zip-up and a color blocked outfit of green and blue that gave it a pleasurable mix of new and old.

"I don't dress like an old lady," she said. "I'm eighty-seven, but I don't feel like it."

Mrs. Kelley was born at the San Francisco Chinese Hospital in 1929. When she was still a baby, her family moved back to China.

In China, Mrs. Kelley lived in a big house with maids and servants. She went to school, but outside of that she didn't have much interaction with people. At one point, her parents had divorced and remarried ("It's a complicated story," she said) and neither parent wanted to bring Estelle and her sister, Eleanor, into their new lives. "We were like orphans," she said.

Her grandparents became her caretakers, but her grandfather was busy working and her grandmother was sick in bed all the time. "I have no sharp memories of that time," she said. "Everything's fuzzy. I was always by myself. I don't think anyone really cared what happened to me."

As the second Sino-Japanese war devastated China, she was sent back by boat at age nine, along with her sister, to live among her six aunts in San Francisco—"one or two nights at a time with whoever took us in," she said. "Every day was different. I didn't know where I was going to stay. We slept where we were told to sleep." For a year, she attended school at the old location of St. Mary's Cathedral Chinese Mission on Stockton Street. "They were teaching me English but I had no idea," she said. "I was just following my cousins." She only understood

Chinese, so she felt lost at school. "I wasn't learning," she said. Most of her life, Estelle felt like she had no idea what was being said, and no one ever explained what was happening to her—not in Chinese, not in English.

One day, at age eleven, she was taken to the Ming Quong Home, an orphanage for Chinese girls on Ninth and Fallon, where Lake Merritt BART station stands today. She remembered being driven over and dropped off at the home: "No one told me, 'This is where you are going to stay.'"

The orphanage, despite its shortcomings, provided her with structure: They ate breakfast, prayed, and then went to public school. "I was happy. Not happy,"—she corrected herself—"content." Her sister, whom she wasn't really close to, also ended up at the orphanage because she didn't get along with their stepmother, whom she'd been living with.

Even though Mrs. Kelley had lived in the Bay Area for years, she had never understood English. She overcame her language barrier unexpectedly, after spending six months at the home. "All of a sudden, I understood English," she said. "We were eating one morning, and someone said, 'Please pass the butter.' I understood what she said."

Ming Quong also served as a vocational training program. When girls turned fifteen, the home would "turn you out" and send girls to live with middle-class Oakland families as housemaids, all the while going to high school full-time. Mrs. Kelley was sent to live with three families. "The first one was bad"; the next couple had a six-year-old daughter and were always fighting.

She would wake up at six a.m., feed the kids, then get ready for school at Oakland Technical High School (which she attended with Clint Eastwood, she added). We asked how she balanced being a full-time nanny and student. "At school, they made me take a nap," she said. "They knew I was falling asleep." After school let out at three ten p.m., she reported back to her employer by three forty-five to cook dinner, take care of the kids, and clean. "If you're lucky, you get everything done by eight p.m.," she said. "By that time I was so tired, I just wanted to go to bed. From there, it was a nightmare until I was twenty-two."

She graduated from high school and got married, but her marriage was annulled once she found out that her husband already had a wife. Shortly after, she realized she was pregnant with her first child. She then got a job as a telephone operator and lived with her ex-husband's

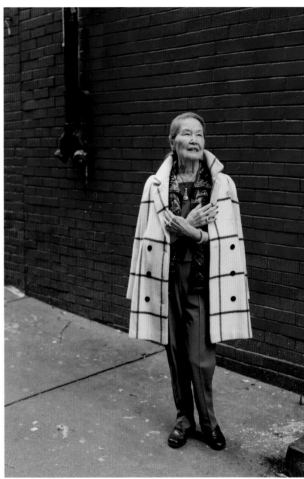

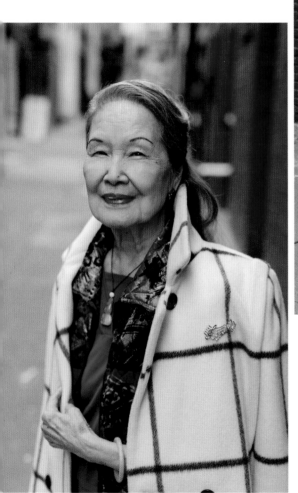

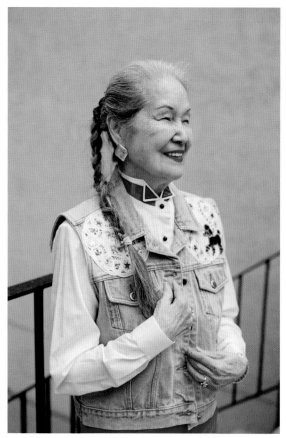

parents. At various points in time, she had to "board out" her daughter and have another family raise her child while she worked.

That's when she got started with her dancing career. When she was twenty-one, she met producers from Forbidden City, a Chinese nightclub and cabaret that operated from 1938 to 1970 on Sutter and Grant. It featured Asian singers, musicians, dancers—even acrobats and magicians. They were looking for a dancer and she tried out, even though she didn't have any experience. "You have rhythm," they told her, and she got the job.

Mrs. Kelley said that famous people would roll through Forbidden City whenever they were in town: Ronald Reagan, John Wayne, Bob Hope, and other celebrities of that era. She worked there for twelve years, leaving once in a while to work at other clubs. "I don't remember anything from when I was twenty-two to twenty-seven," she says. "I was a single mom, dancing in the 1950s. Everything was upside down."

There she met her second husband, who played string bass for the club band. "One night, I was foolish," she said. She had her second child, a boy. In her mid-thirties, she got out of dancing and worked at the Fireman's Fund Insurance Company for fourteen years until her retirement in 1978; the same year, she married Bob, her third husband, whom she is still with. "People shouldn't get married until after thirty-five," she said, reflecting back on her life. "At that time, you establish your work, what you want to do with your life."

A few years after our first meeting with Mrs. Kelley, we photographed her in her Oakland home. Her closet was filled with elastic-waist pants in every color; suitcases stuffed with sequin dance costumes. Although she retired from Chinese cabarets, she never gave up dancing. She still performs with seven others in her namesake group, the Estelle Kelley's Performing Arts Group; they sing and dance at retirement homes. "I like to sing and dance. I don't know what I'll be doing," she said. "It's a part of me."

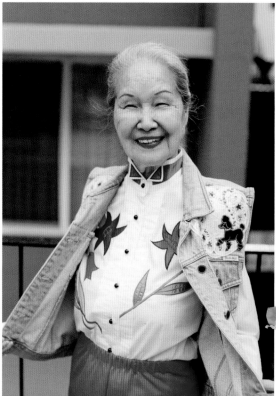

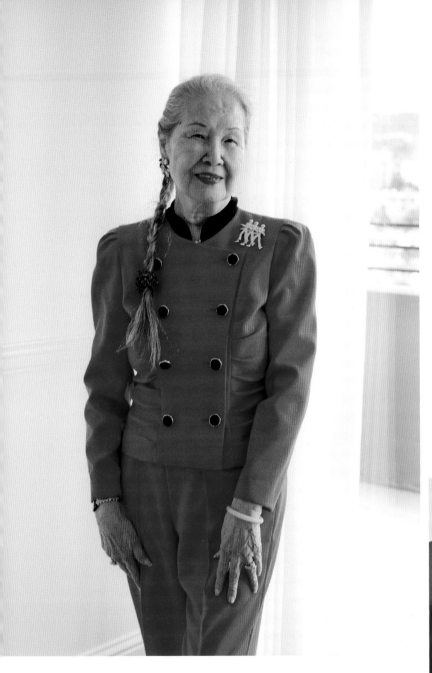

LOS ANGELES CHINATOWN

Where old is new

Los Angeles Chinatown's sunshine and spacious sidewalks make it a hot spot for meeting seniors on the street. Seniors seem more relaxed and willing to speak with us since they're not blocking a heavy flow of pedestrian traffic or having to go indoors because the wind has picked up. Seniors in Southern California can wear short-sleeve shirts, which would be a rare sight in San Francisco, where layers are key—even on the sunniest of days. Sunglasses, wide-brimmed hats, and umbrellas make more of an appearance to protect them from the strong midday sun.

Our go-to spot for spotting Chinatown street fashion in L.A. is at the informal farmers' market on Broadway and Ord Streets. Every morning, seniors lay out blankets with homegrown vegetables and fruits, the products of SoCal sunshine. "Very beautiful," we overheard one man say while showcasing his squash. "One dollar, one dollar," hawked a woman selling avocados.

The original L.A. Chinatown, known as Old Chinatown, first came to be in the 1860s with two hundred settlers, many of whom had migrated to Los Angeles after the Gold Rush. By the 1880s, it had expanded to where Los Angeles Union Station, the city's main railway station, stands today. The end of Old Chinatown began with talks of building a station on that land. Since none of the tenants owned the land beneath their buildings, there was little motivation to maintain them. Eventually, the neighborhood was condemned and torn down in the mid-1930s. The residents and business owners were forced to find a new Chinatown, a search that took several years and iterations.

Some people moved to City Market, on Ninth and Pedro Streets, to be near the wholesale produce hub. At the same time, two Chinatowns were developing in proximity to each other: New Chinatown and China City. In 1938, during Old Chinatown's decline, some businesses relocated to China City, a tourist destination founded by socialite Christine Sterling. China City was made up of movie sets from the 1937 film *The Good Earth* and featured a miniature Great Wall. It catered to tourists and has been critiqued for playing into stereotypes. After two fires, China City eventually closed by 1950.

New Chinatown, which is current-day Chinatown, was completed in 1938 and is made up of commercial streets and plazas hosting Chinese restaurants, bakeries, home goods and clothing stores. Engineer Peter Soo Hoo Sr., who was born in Old Chinatown, worked with twenty-seven other Chinese American partners to buy and develop the vacant railroad lot that is now New Chinatown. It was the first Chinatown planned, developed, and owned by Chinese Americans.

It has a movie-set feel, with the neon-lined East Gate that welcomes visitors to Central Plaza. Inside, technicolor buildings in orange, green, and aqua house gift shops and family associations. The pagoda structure that used to be Hop Louie, a now defunct restaurant and dive bar, stands tall as one of L.A. Chinatown's iconic structures.

Though L.A. Chinatown does not have the same population density as San Francisco or New York, there are approximately ten thousand people who live here, half of them of

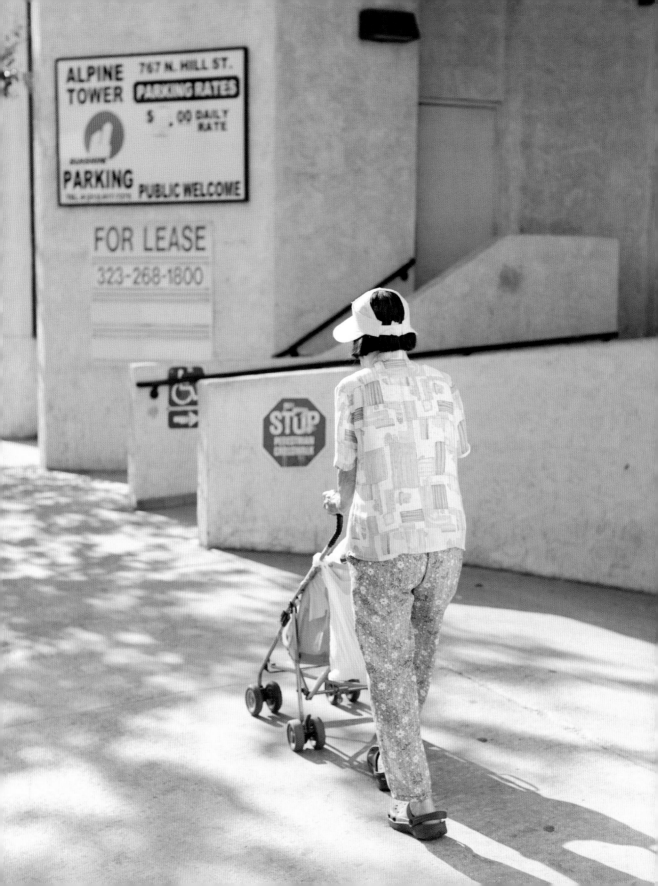

Asian descent. In the mornings, seniors in yellow sweat-suits gather at the Alpine Recreation Center to practice Luk Tung Kuen, a type of aerobics, or dance routines. Some attend adult day centers where they share meals and participate in activities like Chinese calligraphy, opera, and arts and crafts.

Seniors relax on benches in Central Plaza, which now, in addition to typical Chinatown shops and restaurants, also includes spots like Burgerlords, a take-out hamburger window, and General Lee's, a cocktail bar with Green Tea Gimlets on the menu. Though New Chinatown was developed to cater to the Chinese community, businesses are now starting to skew more toward the younger millennial set, much more than in any other Chinatown we've seen. Landlords and business improvement districts are courting famous chefs; some of their restaurants, like Howlin' Rays, a Nashville hot chicken joint, draw hour-long lines out the door. As trendy shops grow in number and developers build market-rate condos, we wonder if there will be a balance between old and new.

We are partial to some of the new establishments at Far East Plaza, a '70s-style strip mall, which used to have more Chinese businesses. We often stop by Endorffeine for pandan lattes before our morning scouting; we've also picked up a pair of Chinatown pants (a nickname we created for the elastic waist, pull-on pants favored by seniors) at East/West Shop, a vintage store where Chinese seniors will sometimes rummage through the five-dollar bin looking for styles that they've been wearing for years and that have now made their orbit to become trendy again.

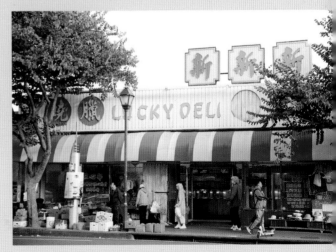

THE JUNGS

ALPINE RECREATION CENTER, 2016

We met the Jungs at the Alpine Recreation Center, where Mrs. Jung, eighty-six, teaches Luk Tung Kuen at eight o'clock every morning. She's been practicing for forty years and teaching for the last twenty-plus years.

They both wore bright yellow sweatsuits, custom-made in Hong Kong, printed with "Luk Tung Kuen," an exercise program consisiting of thirty-six movements that promote blood circulation and muscle strength.

The Jungs have owned their sweatsuits for decades, but it looks like they just got them yesterday. The bright blue lettering and a small mock turtleneck collar gave them some flair (as if they didn't have enough!).

"When it's a happy day or party, I'll wear it," said Mrs. Jung.

Mrs. Jung told me that her husband suffered a stroke a few years ago, so while she teaches, he'll sit and read or walk around the park—"very slowly," she added. Looking at Mr. Jung makes you go "aw": the "STAFF" baseball cap, the cane and rainbow umbrella walking sticks, the '50s-style glasses that sit slightly cocked to one side.

Mr. Jung said he met his wife through his cousin. We asked how long they dated before they got married. "There was no dating back then," he said. "You just get married." He left Hong Kong to come to the United States first, and she joined him two years later in New York.

We asked him about his sixty-nine years of marriage to Mrs. Jung. "How often do you guys celebrate?" we asked. He laughed: "Every ten years."

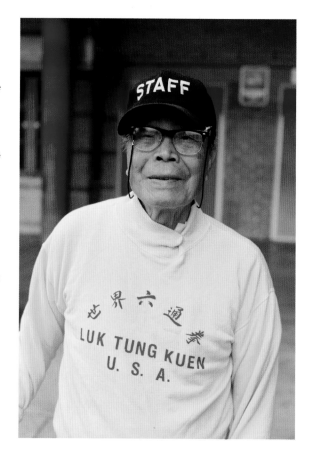

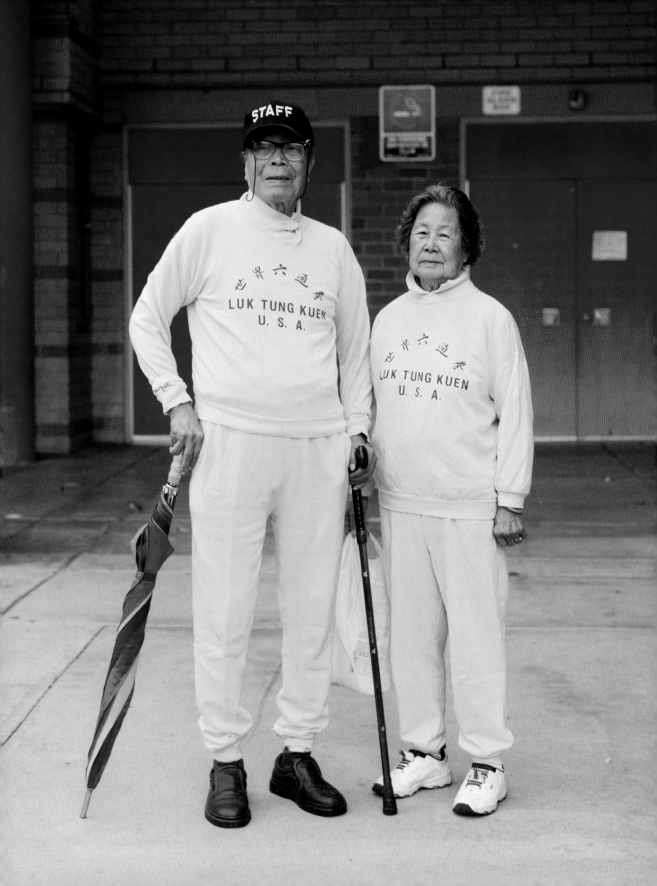

DAILY RITUAL

We met Sow Ling Wong, eighty-seven, while she was out getting her daily newspaper. Her pattern mixing created a balance that was so pleasing to the eye—a bold busy purple with a more neutral knit vest, both with floral decorative patterns. Ms. Wong was another example of "I-would-never-think-of-that-how-did-you-put-this-together?"—one of the simplest yet most memorable looks we've come across.

Ms. Wong worked as a dressmaker in Chinatown for twenty-five years and is now retired. Her daily routine consists of grocery shopping, cooking, and laundry. In the afternoon, she treats herself to a newspaper.

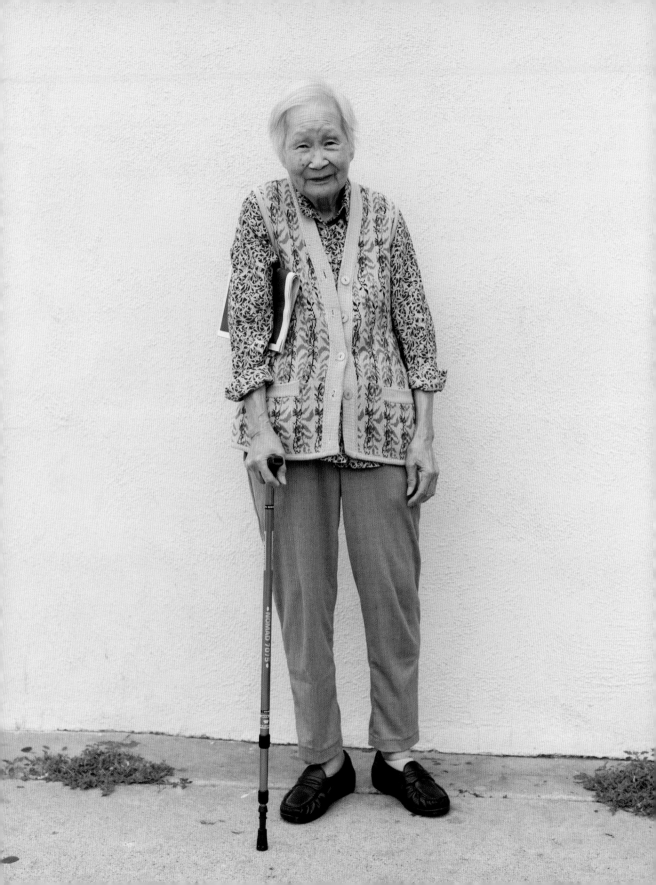

QUILTED JACKET

BROADWAY, 2016

We met this woman on our way to dim sum. She had made the quilted jacket herself with delicate details: ornate burgundy buttons, well-worn flannel lining, and a purple drawstring around her waist. Her look exemplifies a Chinatown Pretty outfit. The jacket is fitting of someone her age; meanwhile, the Cleveland Indians baseball cap gives it a twist, making it ever-so-hip. Her best accessory, though, was her infectious smile.

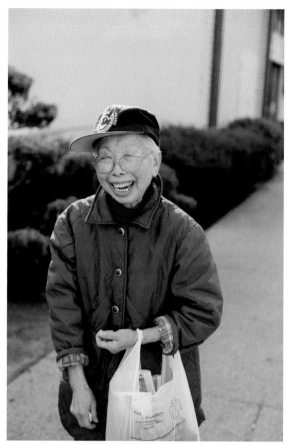

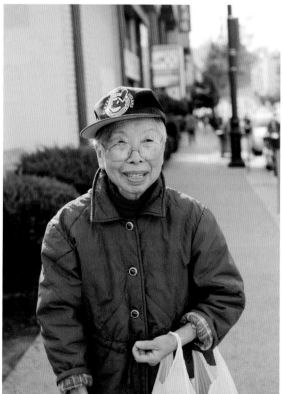

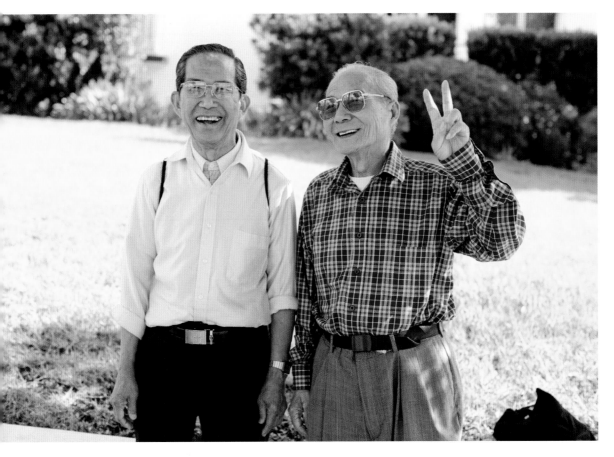

BUS STOP BUDDIES

COLLEGE STREET, 2016

Johnmen Wong (left) and Zhuang Xue Hui (right) have been neighbors and friends for thirty years. We met them while they were waiting for the bus to take them to their homes up the hill.

Mr. Wong had on two collared shirts. "I'm afraid of being cold," he said. He also wore a USC Trojans drawstring bag and new Birkenstock sandals that his son purchased for him online. His friend Mr. Hui wore gold-rimmed glasses he bought in Hong Kong twenty-five years ago. There's nothing we love more than seeing old friends out and about together.

PINK LEMONADE

ALPINE RECREATION CENTER, 2016

We met Hui Fung Dang, eighty-five, after she'd just finished her seven a.m. dance class—a casual but consistent meet-up of seniors who bring a stereo and choreography to the park.

Ms. Dang worked as a seamstress for fifty years. She made her yellow zip-up and red-piped velvet pants with leftover fabric from sewing jobs.

"I don't have money to buy clothes so I make it," she said.

Pink and yellow made for a youthful outfit. We liked how she layered clothes and jewelry—especially the red jade and gold ring combo.

She was witty and snappy and answered most questions with "How can I remember stuff like that?"

What she could tell us was that she came to the United States from China with her brothers thirty years ago. She retired at sixty-five and rents a one-bedroom apartment for eight hundred dollars a month, which she adamantly declared that she paid for herself.

She has two sons and four daughters, whom she was about to meet up with for dim sum. She left us with one piece of advice: "Don't have six kids. Just have one!"

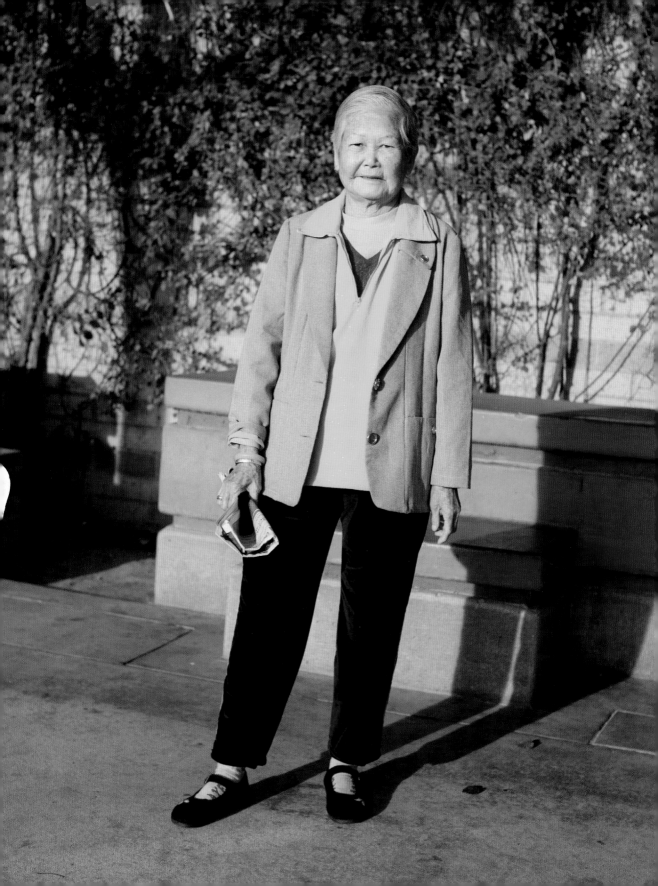

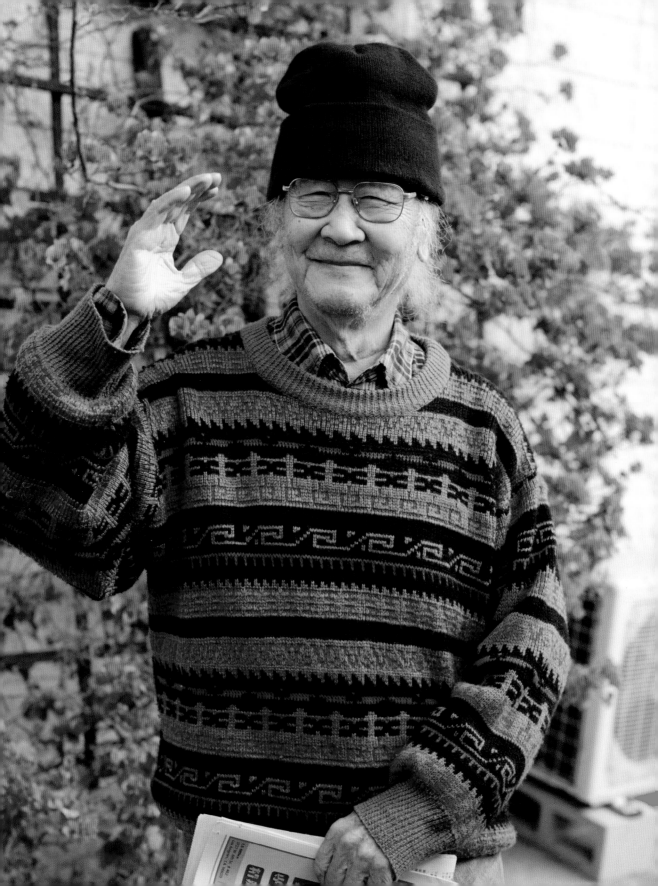

A LONG STORY SHORT

ALPINE STREET, 2016

When we met Kuochiang Fung, eighty-eight, he was at a senior day center sitting at a plastic folding table with Chinese newspapers spread around him. He looked hip with his square rimmed glasses, Fair Isle sweater, and beanie.

With his sweet smile, we would've never guessed his tough backstory. Our interaction took an unexpected turn when he told us that he was a prisoner in China for twenty years.

"I say a very short story now, but it's very long," he began.

Born in 1928 in Indonesia, he became influenced by Communist ideology. "They said China was progressive— no exploitation, suppression, or beggars—that it was heaven," he said. "Everyone's equal. I believed it."

When he was twenty-one, he moved to China to follow the party and to study architecture at Tsinghua University, which he described as "the Harvard of China." But he quickly became disillusioned—he said "propaganda, killings, oppression" were all around him. After three years, he decided to leave but said it was "impossible."

"I was forced to stay," he said.

The Anti-Rightist Campaign in 1957 was a purge of intellectuals in the Communist Party who were accused of being pro-capitalist—they were removed from jobs, jailed, or even sentenced to death. In 1959, Mr. Fung was sentenced to life in prison without parole, where he remained for twenty years.

"I moved to twenty prisons over twenty years—wherever they needed labor. They used you like a slave. At one of the labor camps, only three people survived. I was one of them," he said. "They starved people. We worked twelve hours a day. They called it a farm, but it was really a concentration camp."

There was one time he got out. At two a.m. on June 6, 1960, he escaped prison, but was arrested in Burma ten days later.

The entire time he was imprisoned, he wasn't able to communicate with his family. "I had to praise the government in my letters to them in order for them to mail it. I refused for twenty years," he said. "[My family] had no idea where I was for twenty years."

After Chairman Mao Zedong died in 1976, Mr. Fung sought political asylum in America.

Now he plans to write his autobiography. "If I told you the whole story, it would take three days," he said.

His parting words were a passionate plea against propaganda. "Now in China, there is freedom in the economy but not politics," he said.

SHINING IN
SILVER

ALPINE STREET, 2016

Ruey Ling Chang, eighty-three, was on her way to
pick up a prescription when we met her. We loved the
layers of her all-gray outfit: a silk paisley shirt from
Taiwan, thick ribbed pants, and a barrette that pulled
back her silver bob. On Mrs. Chang, this dark mono-
chrome was vibrant.

She also had the blogger pose down.

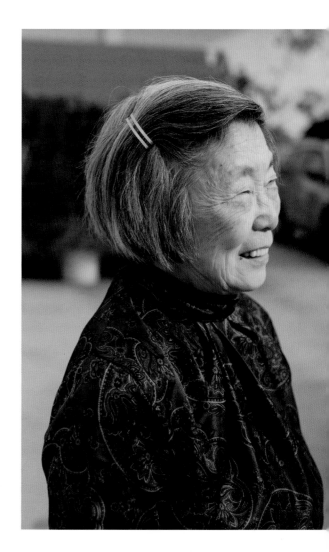

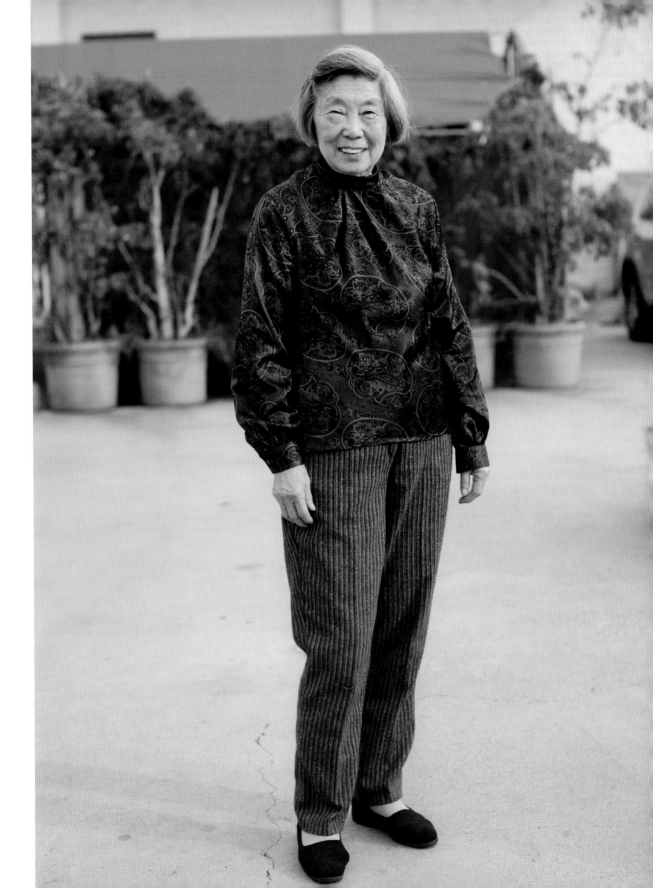

THE YEES

We ran across the street to get a closer look at Mr. Yee, seventy-three, and Mrs. Yee, seventy-two, whose colors caught our eyes: she in her bright orange cap and madras blazer (that her daughter gave her when she moved away for college), he in his bright red plaid fleece and blue windbreaker pants. Their synchronicity was heartwarming. It felt unintentionally intentional: the plaid, layering, and bold colors.

"Do you guys match on purpose?" we asked.

"We don't talk about what we wear," they said. "We just put it on."

They met forty-something years ago through a match-maker. When we pressed for more details about how they met, they declined to share. Some things don't need to be explained, we suppose. Their outfits gave us a hint of how their souls match, of how their fashion sense and hearts work in sync.

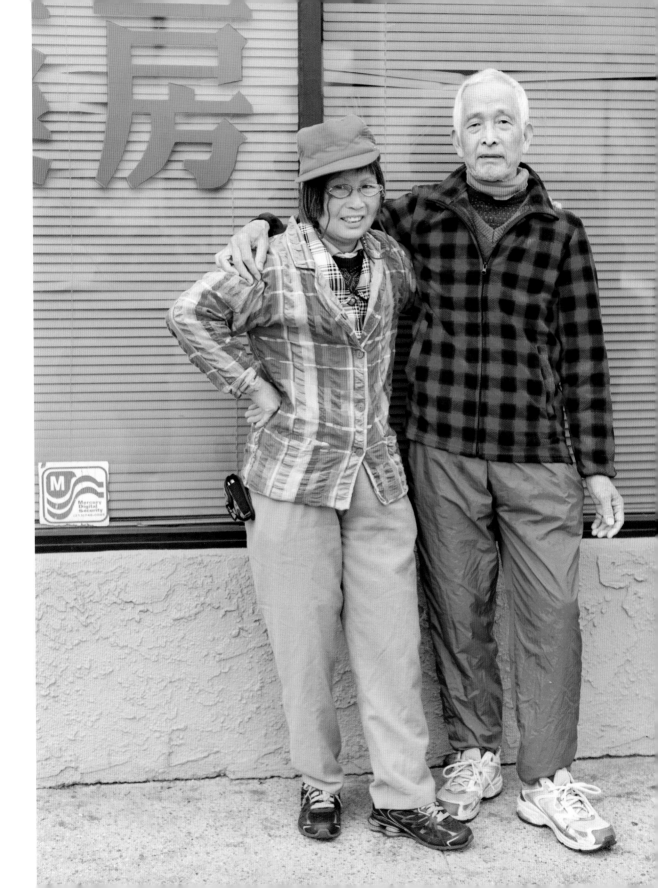

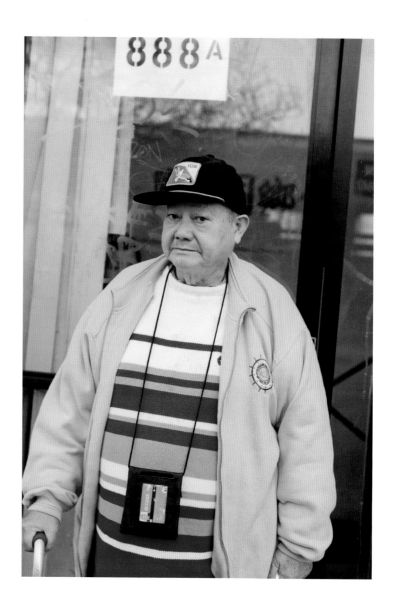

COAL HAT

HILL STREET, 2016

Mr. Leung, eighty-three, stepped outside his door right as we walked by, wearing a cool coal hat, San Francisco fleece sweater from Fisherman's Wharf (beloved by both tourists and Chinatown seniors), and a striped knit sweater. It was an auspicious meeting since his apartment building number was 888. Eight is considered to be a lucky number in Chinese culture, since eight or *ba* sounds like *fa,* which means fortune. We were lucky to have this chance encounter.

AARP

FAR EAST PLAZA, 2016

We met Ming Liang, eighty-four, while we were waiting for coffee at Endorffeine in Far East Plaza. We were drawn to her blue AARP bucket cap and waited for her to finish her sticky rice to ask her questions.

She told us about her hangout spot: the ABC Day Health Center, a recreation and care center for Chinatown seniors. They offer health services, exercise classes, food, and arts and crafts. She especially enjoys Chinese calligraphy and singing songs from Hong Kong in the 1930s. (She even sang for us!)

Ms. Liang has been in the States for sixty years. One of her jobs in the United States was selling souvenirs on Melrose Avenue. "I made a dollar an hour but also sold jam and bread sandwiches on the side," she said.

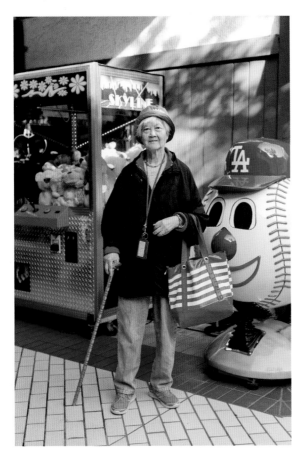

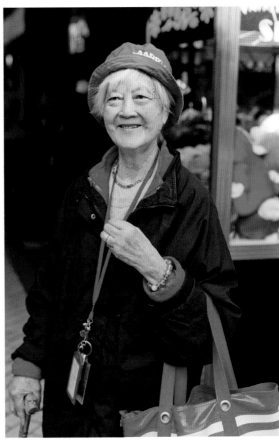

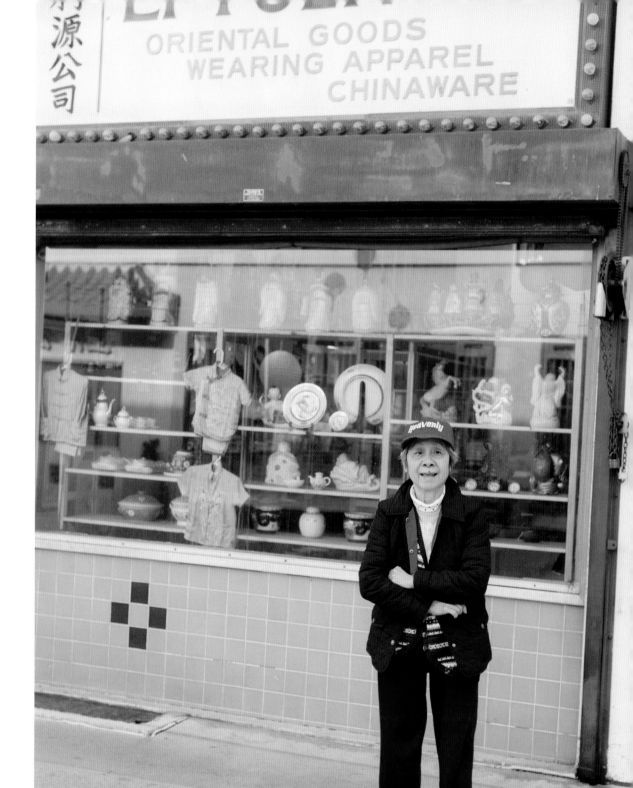

THE
SHOPKEEPER

CHINATOWN CENTRAL PLAZA, 2016

We met Jeannie Fong as she stared at an empty wall space on Chung King Road, a quiet lantern-lined street where older Chinese-owned stores are now neighbors to newer art galleries.

She was wearing a red baseball cap from a ski resort, given to her by one of her kids. "They didn't want it anymore, so I took it," she said, still staring quizzically at the wall.

In addition to her hat, she had on a puffy jacket, Fair Isle vest, floral sweater, and polka dot turtleneck poking out on top—the icing on the outfit.

Back to the empty space: "What's going on?" we asked.

"Someone took the air conditioner out of the wall. I don't know why they would do that," she said.

Turns out she is the landlord, just happening to be walking by early that Saturday morning to open up her store. Fong, eighty-eight, owns the Li Yuen Import Company, a gift shop that sells home goods and apparel. It didn't have much inventory, and whatever's there looks like it's been there for a long time.

But she doesn't do it for the money, it seems.

"It's better than staying home by myself," she said. "When I go to my kids' house, it's boring. I just stay at home and wait for them to come home."

They want her to stay close, but she says it's lonely. At her shop, she gets to keep busy and interact with customers and neighbors.

Originally from Taichung, Taiwan, Jeannie moved to the San Francisco Bay Area when she was a teenager. She attended San Jose High School and had "a lot of Italian friends." In 1960, she moved to Los Angeles with her husband, whom she repeatedly described as "a very good man."

She said he would always remind her of the perks of being a business owner. "He would tell me, 'You are the owner—you can close whenever you want. You can shut down the store and go shopping, eat, and buy some clothes,'" she said.

He's gone now and she sounds wistful whenever she speaks of him. So every morning, she opens the doors to her shop—seemingly to keep up her spirit, but also to honor her husband's as well.

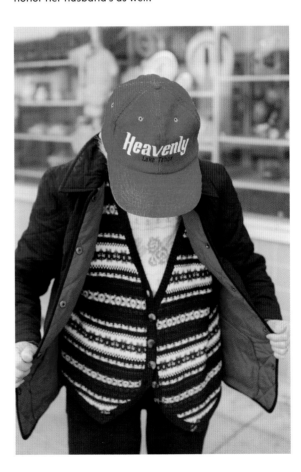

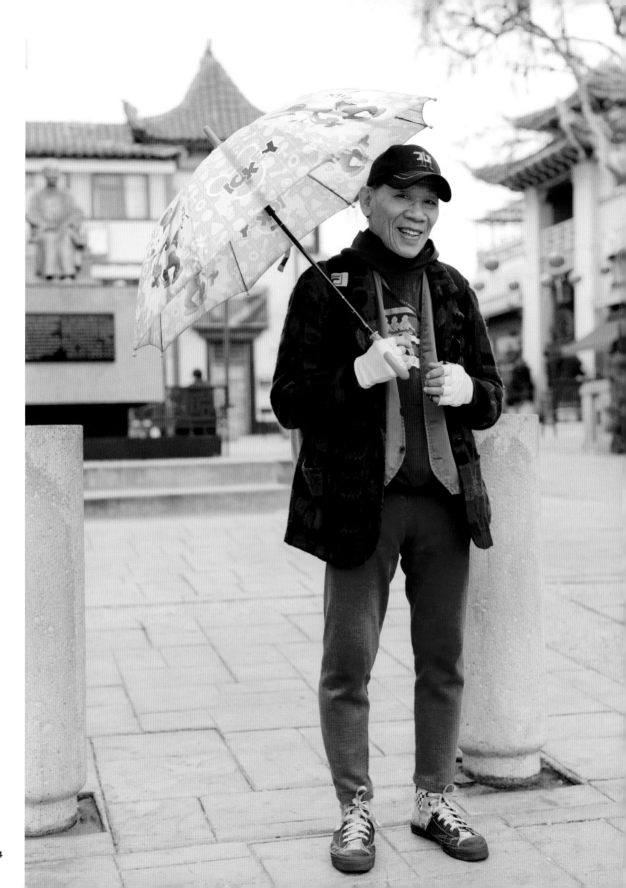

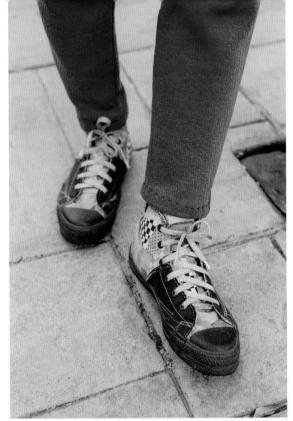

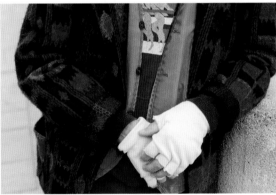

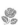

CHARLIE

CHINATOWN CENTRAL PLAZA, 2016

We first noticed Charlie's shoes: patterned high-tops he bought from Goodwill.

Charlie immigrated from Vietnam after the war. "I wanted to find Charlie Chaplin," he said, an obsession that began after seeing him in a short movie. "His face makes you laugh, so I remembered him."

Committing Chaplin to memory, he described the actor to his boss in the United States, who then told him Chaplin's name, which Charlie adopted as his American name. To be more like Charlie, he joined a tap-dancing troupe.

He also found inspiration in another performer, Gene Kelly, which is why he has an umbrella strapped to his backpack so he can also dance in the rain on a moment's whim. "I imitate him," he said.

A few other fun facts: Charlie's a card-carrying member of the Democratic Party. He keeps his membership card around his neck.

We commented on his youthfulness. "What's the secret?" we asked.

"I know how to live so I live long," he said. He imparted some wisdom: "Don't smoke. Don't drink whiskey. And don't have too many wives."

CHICAGO CHINATOWN

The sleeper hit

Chicago is *the* under-the-radar Chinatown, that charming neighborhood that feels like a local's secret.

When talking about Chinatowns, Chicago is not the first that comes to mind. People were surprised we were going to Chicago. Even our friends who were born and raised in Chicago weren't really familiar with it.

But Chicago came up in our research into U.S. cities with the highest Chinese populations. There were the expected

hitters: San Francisco Bay Area, New York, Los Angeles, Boston. Then there was Chicago.

Chinatown Chicago was established in 1878, after Chinese workers finished up the Transcontinental Railroad and looked for new places to settle as anti-Chinese sentiment grew along the West Coast. Early settlers in Chinatown Chicago settled in the Loop area. Among them was Dong Chow Moy, considered one of the first Chinese in Chicago. He and his two brothers convinced sixty of their friends to join them in the area around Clark and Van Buren Streets. At its height, six hundred Chinese people lived in the area, until white landlords raised their rents because of the prevalent anti-Chinese sentiment at that time.

The Chinese relocated in 1910 to the South Side, where Chinatown is today. Before, Chinese residents didn't own the buildings they were operating out of in the downtown area. To ensure their longevity in the new neighborhood, they knew they had to buy real estate or secure long-term leases. A group of Chinese business people also secured fifty ten-year leases in the area through an intermediary company.

This resulted in today's Chinatown, with big developments like Chinatown Square, a two-story outdoor mall. From the Chinatown Gate on Cermak and Wentworth Avenues, Chicago Chinatown is a self-contained enclave where people live, work, and shop. Most seniors don't have to leave the area and refer to the rest of Chicago as "downtown."

We asked the seniors why they chose Chicago; most said that's where their relatives or children immigrated to, and they followed along after they retired in China. Some had more specific reasons: It's flat, not like San Francisco. It's clean, unlike New York!

Chicago Chinatown does not fit the narrative of what's happening in other Chinatowns. The usual story is this: Chinese population and seniors have moved out to the suburbs. Business is declining and vacancies are aplenty. Third-wave coffee shops and art galleries are gentrifying the neighborhood, with condos making their way in.

That's not the case here. Between 2000 and 2010, the Asian population in Chinatown increased by 30 percent. During the day, bakeries and restaurants are busy serving dim sum and Chinese pastries (we liked Frieda's) to the senior set, and the streets seem even more vibrant at nighttime, with younger folks frequenting new businesses serving Szechuan food and rolled ice cream. Almost all storefronts are filled. On Sundays, the Chinese Christian Union Church has three services in the morning, two in Cantonese and one in Mandarin.

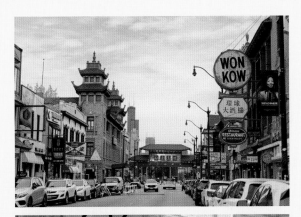

The shiny new jewel is the Chinatown Branch of the Chicago Public Library, a modern, LEED-certified building, which sits a few feet away from the train stop. Because of the wind, snow, and cold, the library is robust with programming for locals. There's live Cantonese opera (twice a week), ESL and tai chi classes, and a game room upstairs where *gùng gungs* gather to play Chinese chess. It's a warm refuge on the coldest days.

We came in the spring, just missing Chicago's first succession of sunny days. Instead, it was gray and rainy, with scattered thunderstorms, which meant that there were not as many seniors in the streets and parks as we would've hoped. But we came across wonderful people hanging out at the library and senior centers, and in a magical nook on Wentworth Street, where we met Chicago's most fashionable seniors, waiting for the 24 bus in front of a worn door with cracked paint and molding and an aged patina.

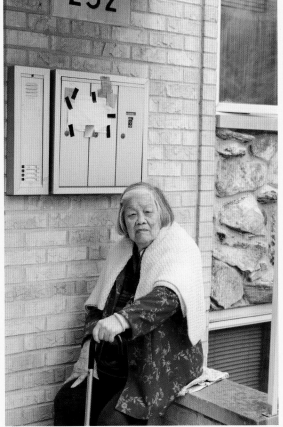

As we made our rounds, we saw the same groups of people bouncing between the library, free senior lunch at the Chinese Benevolent Association, and Chinese American Service League, a community center that serves the Chinatown community with everything from daycare for two-year-olds to health services for people as old as 102!

Chicago was a refreshing, albeit rainy trip, where we experienced a buzzy Chinatown with friendly seniors and plenty of good outfits.

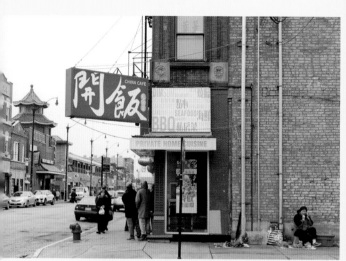
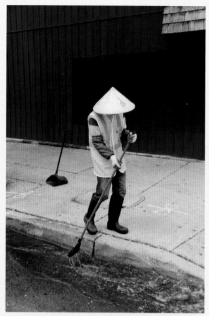

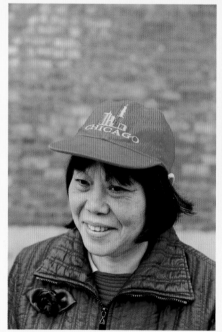

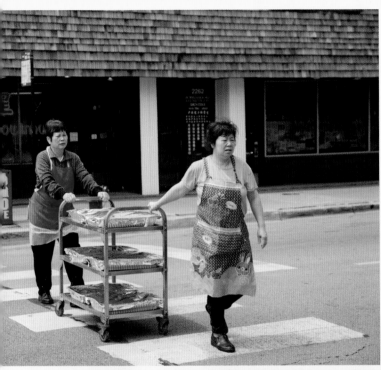

WINDY CITY WEAR

WENTWORTH STREET, 2018

We found Qui Zhen Mei, sixty-seven, hiding from the wind in a doorway while she and her husband waited for the bus. She popped out against the aged maroon door, an entrance to a toy shop. We couldn't believe what we were seeing. She was a vision in a Burberry print bucket hat (to which she added a long string so it wouldn't blow away—we were in the Windy City, after all), a teal bomber jacket with oversize pear blossoms, a purple polyester shirt, and a yellow '70s striped ringer tee underneath. Probably one of the most powerful pattern-mixing combinations we've ever come across.

"I have many colors in my wardrobe," she said. "I don't have too much money so I don't have a philosophy on fashion."

Ms. Mei's lived in Chicago for more than ten years. Almost the entire time she worked at a *chow fun* factory, where they steamed long sheets of rice noodles. She's one year into her retirement. Her job now: taking care of her six grandchildren—picking them up from daycare, getting them clean and fed.

"Do you make them *chow fun*?" we asked.

"No, I buy it for them," she laughed.

And as if the outfit wasn't mind-blowing enough, we made the last move to scope out her socks, which revealed a smiling puppy with a soccer ball. Good thing we checked.

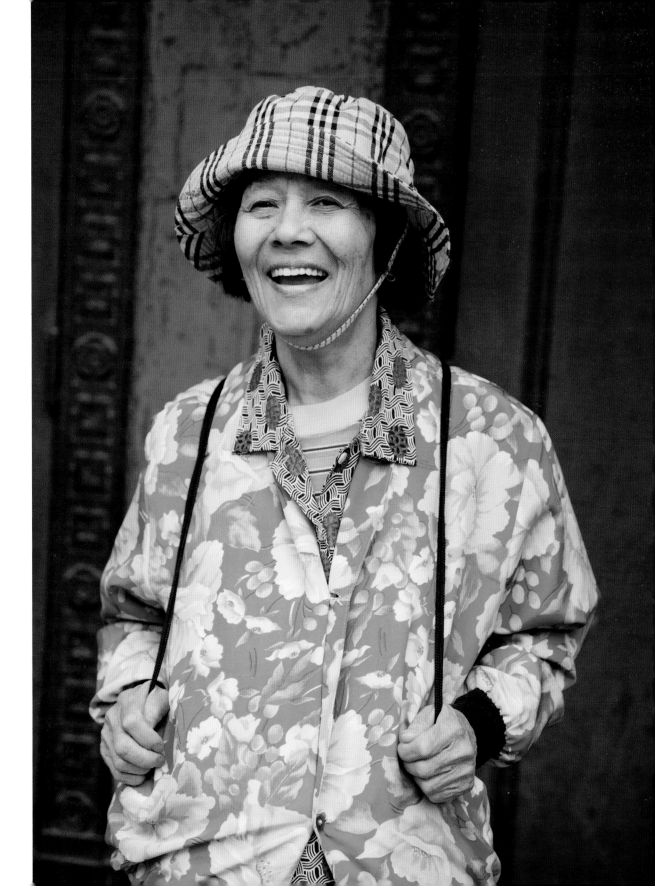

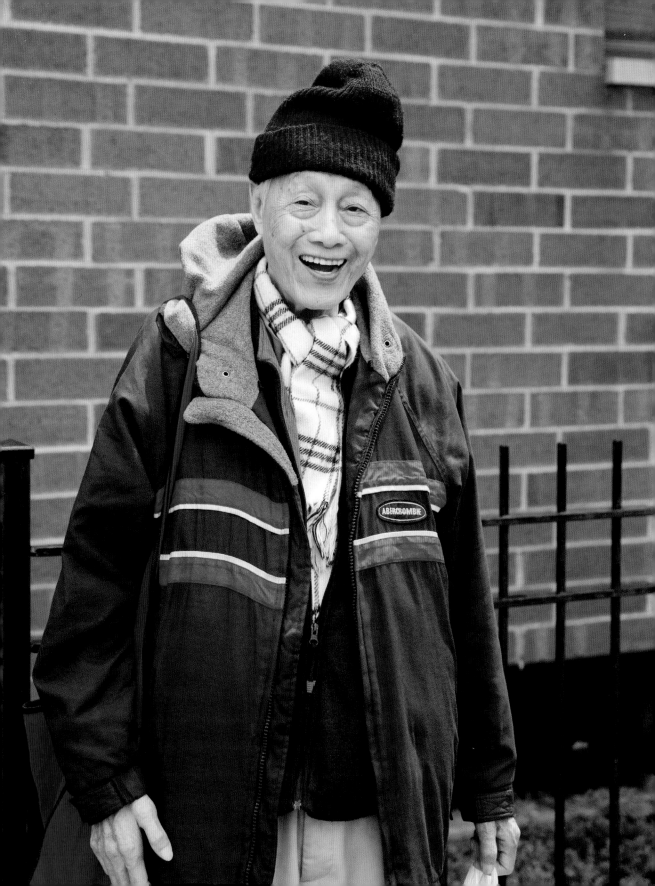

THE OPERA SINGER

CHICAGO PUBLIC LIBRARY, CHINATOWN BRANCH, 2018

Eddie Jeung, eighty-eight, stands tall at five-foot-ten, with smooth skin and a friendly smile. He was dressed so gentlemanly: a navy blue beanie, plaid scarf, two layers of fleece.

Mr. Jeung has been in Chicago for forty-eight years, after moving from Hong Kong because of the 1967 leftist riots, a violent clash between pro-communists and the Hong Kong government. He did stints in San Francisco and New York before settling in Chicago. "I like Chicago's landscape because it's flat. SF is up and down," he said. And New York was too dirty and expensive for his taste: "Restaurants throw trash in the front. And the rent is too high."

He was at the Chinese library to sing at the twice weekly Cantonese opera. It's a hobby he started when he was twenty-one with his roommates in Macau. "We didn't go out after work," he said. "We would just stay in the apartment and sing Chinese opera."

We asked him what Cantonese opera was all about. "Cantonese opera lyrics are about romance," he said. "Love stories."

"What's your love story?" we asked.

"When I was twenty-three, there were seven girls chasing me," he said.

"OK, and then what happened?" we asked.

"But I just liked my first love," he said. "After that we were married. We've been married for over sixty years."

"Where is she today?" we asked.

He answered: "I don't know. She might be at the casino."

THE KEYHOLDER

TWENTY-FOURTH STREET, 2018

We waited patiently to meet Ai Shao Wu, seventy, who had entered the Good Ming Food Market in a red sweater that just popped against the gray Chicago day.

The red knit jacket had a black-and-white checkered trim and was layered on top of an argyle knit vest and a patterned polyester shirt of the sort favored by Chinese seniors. She has had this sweater for as long as she's been in Chicago after moving from China— thirty years.

Around her neck was a lanyard with at least thirteen keys. "I have so many keys because the house has a lot of rooms," she said.

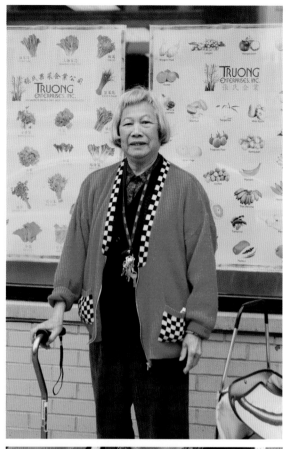

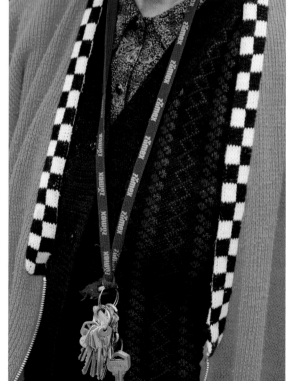

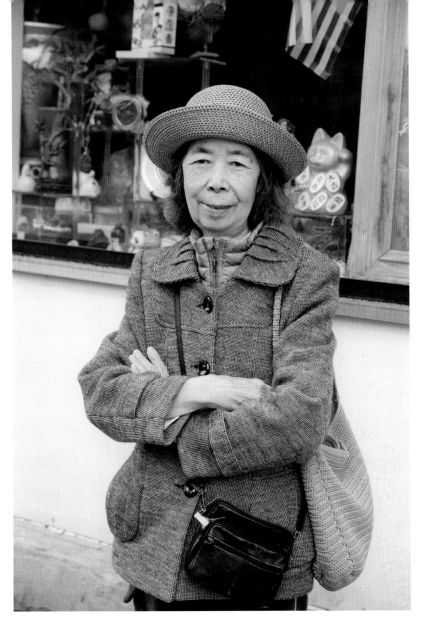

WOVEN IN GRAY

WENTWORTH STREET, 2018

We met Man Li Wu near the Chinatown Gate. Puffy jackets are a Chinatown staple since they're warm but lightweight. We liked how Ms. Wu dressed hers up by layering it with a pleated-collar coat and woven bowler hat (and matching bag).

RED
BASEBALL CAP

CHICAGO PUBLIC LIBRARY, CHINATOWN
BRANCH, 2018

We met Li Ting Lan Li, eighty-five, at the library. She
had come for Chinese opera—musicians and singers
perform two to three times a week in one of their
event spaces.

She wore a quilted jacket with Chinese symbols. The
fuzzy collar coordinated with her mauve two-piece
wool set, slightly fuzzy in a similar color. "Someone
gave me the clothes," she said. "I don't have any-
thing." Over the course of our stay in Chicago, we
saw her walking around Wentworth Street in different
patterned sweatshirts. Most of the time she wore her
red baseball cap. When she wasn't, you could see her
silver bob, which had a frosty white strip that framed
her face.

Ms. Li told us about growing up in Toisan during war-
time. Her whole town was burned down during the
second Sino-Japanese war, when Japanese imperialist
forces wanted to take control of China, especially the
port towns in Guangdong province.

"When I was younger, the Japanese invaded Toisan and
killed everyone," she said. "When they invaded, I was
at home. I saw people killed and leave. It's a miracle I
didn't starve." As a result of the war, she never went to
school and never learned how to read. She worked as a
rice farmer and later washed dishes at restaurants.

After a while, the talk must've brought back too many
painful memories. When we tried to ask her more
details of her past, she turned away and said, "I don't
remember." Our translator said, "I'm not sure if she
remembers or doesn't want to talk about it."

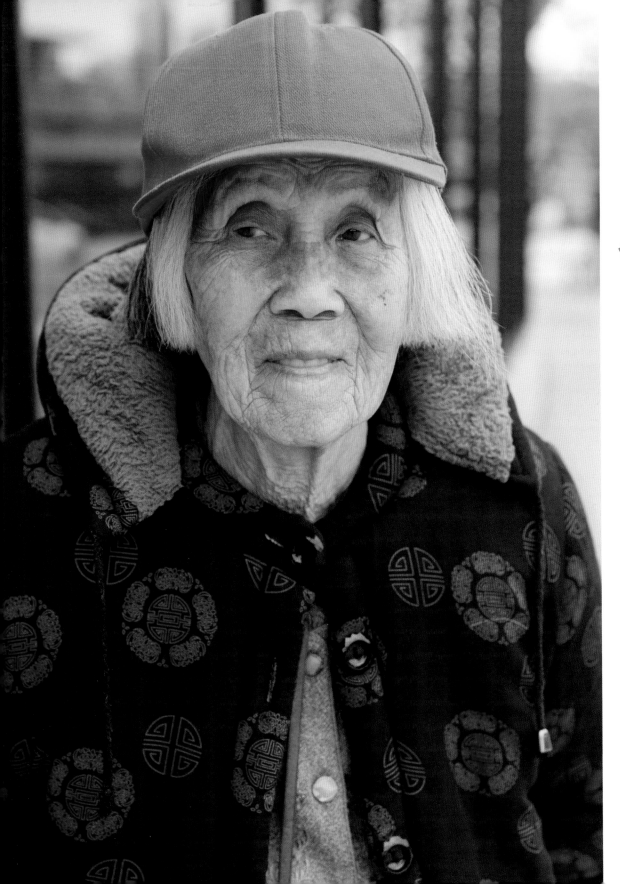

PEACH TONES

Pun So Wong, ninety-two, had on a jacket with groovy waves in mauve, black, and peach, fastened by yellow and green enamel buttons. She bought this piece in Hong Kong over thirty years ago. It complemented the peach sweater she had knit herself.

"I don't knit anymore because my hands hurt," she said.

She also had on our favorite type of trouser: the China-town pant. (We often tug on our elastic pants to show our solidarity—which usually gets a laugh.) Her shoes: embroidered floral slip-on flats that blended in with her whole outfit.

Ms. Wong moved to Chicago when she was sixty years old and became a citizen four years later. She then sponsored her sons and daughters to come to the United States. History was repeating itself: Ms. Wong's own mother lived in the United States for fifty years and had sponsored her over. "I was two years old when she left," Ms. Wong said, noting that her grandfather had immigrated to the United States as well.

Her outfit, like those of many of the seniors we see, seems understated at first but so sophisticated upon closer inspection.

And a heartbreaking detail: the buttonholes rein-forced by tender stitches that revealed thoughtful, long-term care.

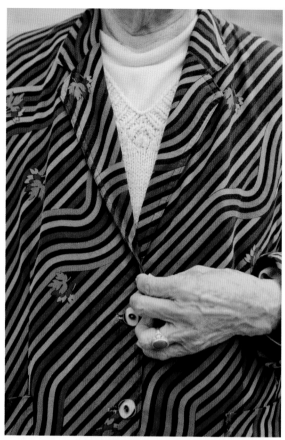

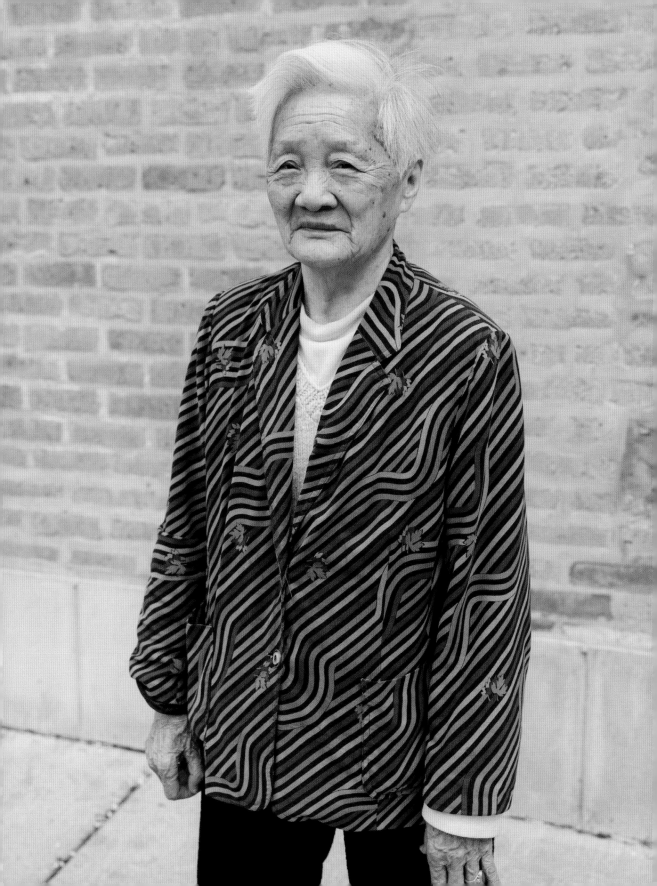

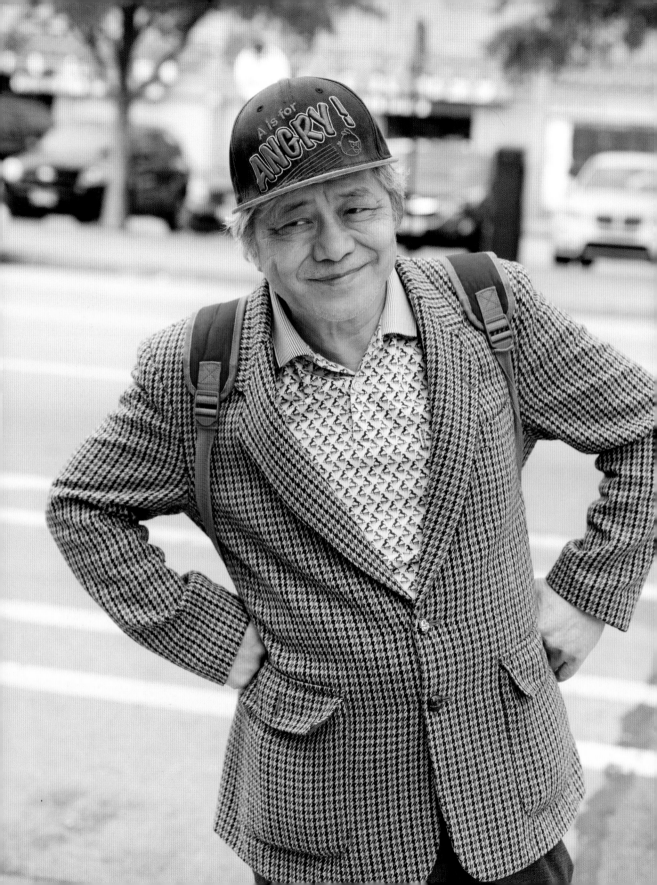

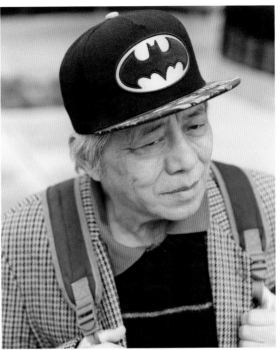

ANGRY BIRDS

CHICAGO PUBLIC LIBRARY, CHINATOWN
BRANCH, 2018

Jah Wei Ying, seventy-seven, was perusing the stacks
for art books to use for inspiration for his paintings.
"I like to paint at home so I look out for painting
books," he said. His favorites are books of Chinese
landscapes. "When you draw, you should make it real,
not abstract," he said. "I believe when people draw
abstractly they don't really know how to draw."

Although he was serious when it came to art, every-
thing else about him was very youthful—from his
demeanor to the details in his outfit. There's the
Angry Birds hat, and then the backpack with "Alex"
written on it, a hand-me-down from his friend's
young daughter.

Mr. Ying is economical. About the Angry Birds hat:
"I didn't like this hat, but it was cheaper," he said.
"I like cheaper." When the original stitching on his
hat got dirty he painted over the word "angry" from
yellow to blue using watercolors. The next day he
switched it up with a Batman hat, paired with a
houndstooth blazer his sister-in-law bought him from
Taiwan thirty years ago.

We asked him about his work. It's simple work, he
said—he worked as a crossing guard and in a factory.
But what he focuses on is language: "I study English
every day," he said.

SILK SCARF

CHICAGO PUBLIC LIBRARY, CHINATOWN
BRANCH, 2018

Mee Lee, eighty-three, was the first person we sat down with at our Senior Portrait Day at the Chinatown Library. Her English was great so we didn't need a translator. Ms. Lee has been taking English classes for decades, ever since she lived in Hong Kong.

She wore a long teal jacket, with a silk scarf from Shanghai gracefully knotted around her neck. It's amazing how a little detail like the silk scarf can take an everyday outfit into something spectacular.

Ms. Lee has been a Chicago resident for forty-five years, after moving from Hong Kong to work at the Tootsie Roll factory as a machine operator. Her friend referred her to the job and she stayed there for more than thirty years, working in a multiethnic factory with "every kind of person."

"When you come to the U.S. everyone has to work," she said. "I worked because I needed to put food on the table," she said. She arrived in her thirties and had to support her child.

In order to work, she said, you have to be healthy. And the secret to that, we asked? "Eat good things. Don't smoke cigarettes and marijuana."

After she retired, she started to travel: L.A., Seattle, New York, Mexico, and Minnesota. Nowadays, she alternates among the library, English classes, and church.

Lastly, we asked her about her thoughts on Chicago.

"Here you have hot and cold," she said of Chicago's weather. "In San Francisco, you only have one season."

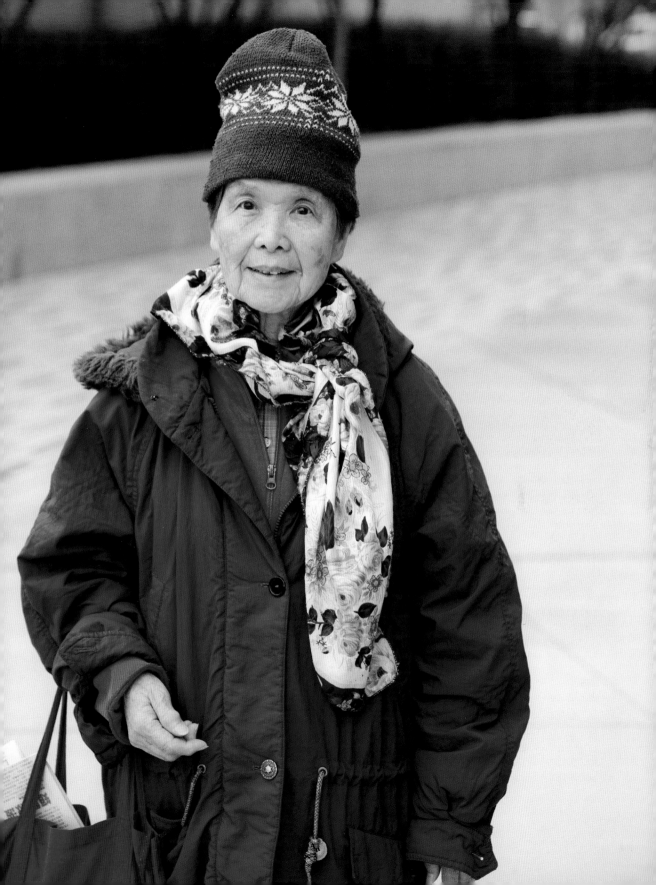

PENGUIN SOCKS

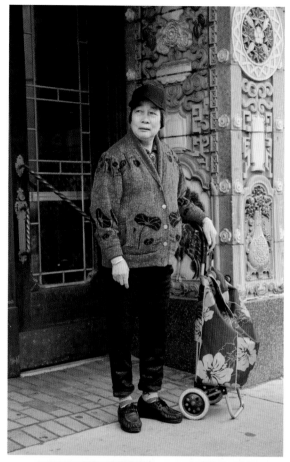

WENTWORTH STREET, 2018

Jin Qing Zhong, seventy-five, is another reminder of why we should Always Check the Socks.

We met Mrs. Zhong in the magical nook on Wentworth, a doorway right past the Chinatown gate where people gather to get away from the wind.

Her urban outfit was punctuated with purple accessories—penguin socks, hibiscus rolling back-pack, a floral sweater from Hong Kong. The black cap, leather wallabies, and pants with a barely-there patterned sheen (and fleece lined, no less) gave the outfit a sleekness that balanced the tropical purple elements.

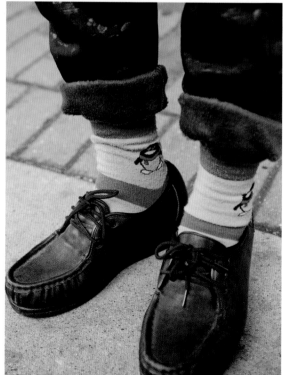

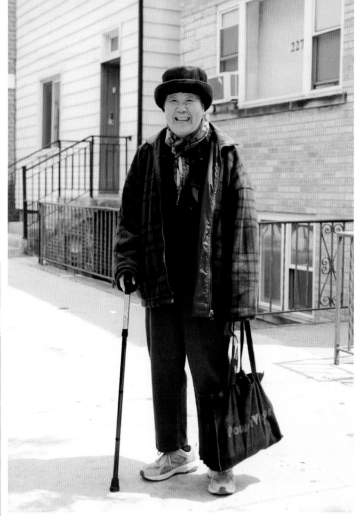

PLAID ON PLAID

WENTWORTH STREET, 2018

Hang Chu Moy, eighty-five, was grabbing Chinese bar-
becue at Starlight Market. She had on a combination
of fleece and plaid items in similar colorways: a fleece
plaid jacket, a flannel plaid shirt, and lastly, a poofy
fleece hat her kids had given her. We liked how her hat
and silk scarf gave a special touch to an otherwise
utilitarian outfit.

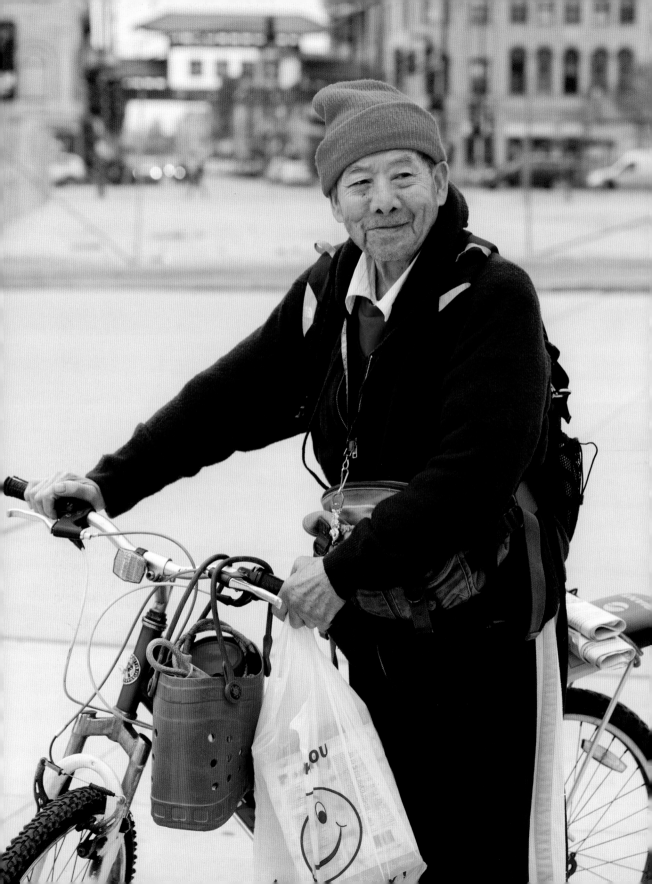

COWBOY BOOTS

CHICAGO PUBLIC LIBRARY, CHINATOWN
BRANCH, 2018

Hang Ching Yip, eighty-eight, was parking his bike
in front of the Chinatown branch when we met him.
It was the accessories that made this outfit: the red
beanie cocked just so, a purple basket with "Olivia"
written on it, and cowboy boots with athletic pants
tucked into them. "They were a present from a
friend," he said.

TEN-GALLON
BUCKET HAT

WENTWORTH STREET, 2018

We met Lau Wai Kwong Cho, eighty-four, around the corner from a bus stop. She had on a next-level bucket hat, reminiscent of Yosemite Sam's ten-gallon cowboy hat. A basic Chinatown bucket hat staple on steroids. Mrs. Cho purchased it from Costco for two dollars, a bargain for such a statement piece.

Paired with her white bucket hat was a white mock turtleneck patterned with Santa Claus mice and mistletoe. Mind you, it was in May when we met her.

For her bottoms, she had on brown velour baseball striped pants underneath black sweatpants along with chunky black sneakers.

When she pulled out her ID to show us her address, she unveiled a pattern mixing surprise: a sleeveless plaid shirt with giant gingham apron pockets that her sister-in-law made for her. That's where she keeps her valuables: her wallet and phone, which her grandson gave her. The secret pockets at work again.

Mrs. Cho has been in Chicago for twenty-seven years and has worked as a cook at a senior center. What did you make? we asked. "Sometime eggs, sometime egg foo yong," she said, referring to a Chinese-American omelet with minced ham, bean sprouts, and bamboo shoots.

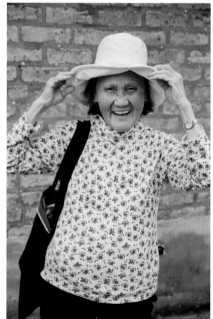

"For some seniors, they didn't have teeth to chew, so I would cut them into smaller pieces," she said.

At home, she cooks a simple meal of fish and vegetables for herself and her husband.

Before we parted ways, she tried to offer us money, but we politely refused. Her parting words were a reward in and of themselves: "When I look at you guys, you are so beautiful and good," she said, holding our hands. "When I see you are happy, then I am happy."

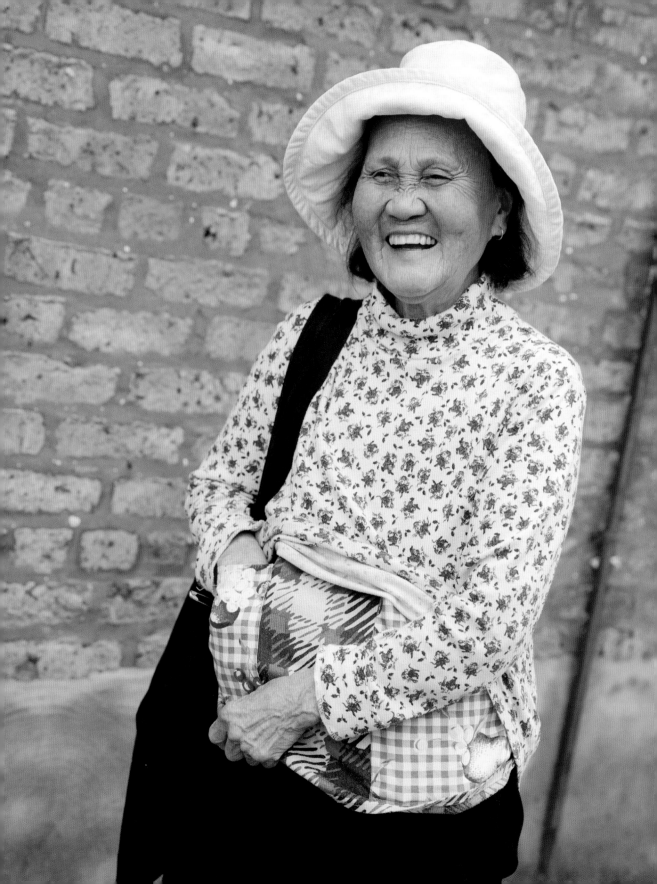

MANHATTAN CHINATOWN

Attitude and grit abound

Manhattan Chinatown is the largest Chinatown in North America, with around two square miles on the Lower East Side. Its history runs along the curves of Doyers Street; the city's grit and attitude are woven into the clothing of its inhabitants. The colors aren't quite as bright here. The urban uniform of black extends to Chinatown—in their puffy jackets, baseball caps, and bags. There's New York in their voices, sometimes gravely and more to-the-point. New York is the toughest city we've worked in. Most people give us the hand—"Thank you," they'll say, as they push out their palms and promptly walk away. Sometimes they just walk away.

There's a new urban vocabulary for New York, which we tried to get the seniors to explain to us. As an eighty-year-old, how do you get up and down a "walk-up," a multistory building accessible only by stairs? And how do you dress for a New York winter when you already wear three layers in sixty-degree weather?

In the late 1800s, Manhattan Chinatown's population grew when people moved from West Coast cities as jobs became scarce and discrimination increased. Chinese laundries, restaurants, and textile factories became the main sources of work on the East Coast. Between the 1960s and 1980s, Chinese-owned garment factories ballooned from employing 8,000 to 20,000 workers as older garment factories in New York closed due to unionization and overseas production. Most of these places employed recent female immigrants who didn't speak English.

There are nine Chinese neighborhoods in New York, though the more sizable ones are in Sunset Park, Brooklyn, and Flushing, Queens. The last is dubbed "Little Taipei" because of the large numbers of Mandarin-speaking immigrants who moved from Taiwan in the 1980s. Manhattan Chinatown's demographics have changed too, as it's become a new hub of nightlife for the younger set, with bars and restaurants taking over some of the storefronts on Mott Street.

Despite these changes, Manhattan Chinatown is still visibly going strong. Columbus Park is the living room where seniors play Chinese chess and *dà lǎo èr* (or Big Two, a card game similar to President). Women in the most epic bucket hats will reposition their bills and umbrellas to block out the moving sun—and photographers. It's almost a fact: Anyone playing a card game will not talk to you. This is a bummer because they're usually the most fabulous-looking.

Canal Street takes us to Sara D. Roosevelt Park, another popular hangout with grassy areas, playgrounds, and athletic areas. Men and women sit on benches, soaking in the afternoon sun and people-watching. Walking past the basketball courts farther down Chrystie Street one morning, we saw a Chinese woman in her sixties shooting hoops, landing her shots one-handed. "I play five-on-five at nine a.m. every morning," she said. "I'm the only female. Sometimes I play with sixteen-year-olds. I beat them most times." A New York moment.

Speaking of age, we heard a good adage while we were in a New York senior center. Someone said: "Sixty is young, seventy is in the middle, and eighty is old."

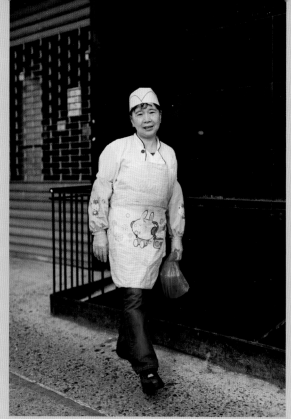

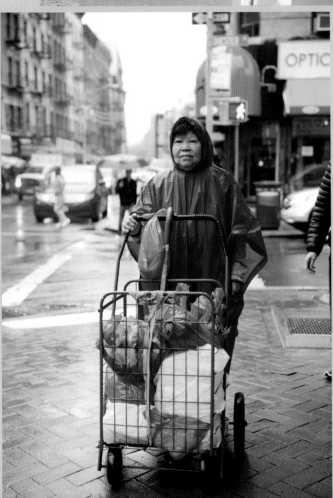

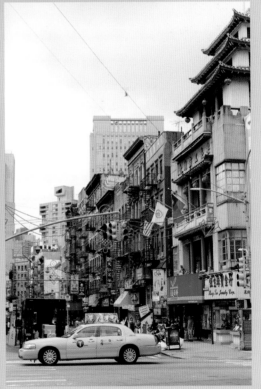

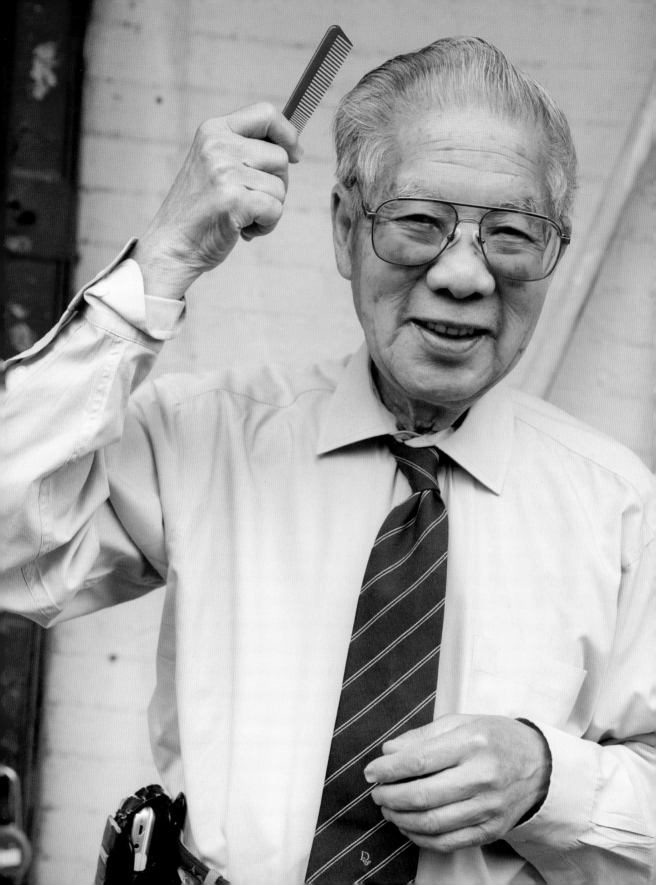

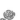

CURRY PUFF

COLUMBUS PARK, 2018

We met up with Farn S. Lee, ninety-three, and his daughter Mel Young in Manhattan Chinatown, where she gave us the lowdown on his life story, since Mr. Lee is hard of hearing. Her father was born in a tiny village in Toisan nicknamed "Dog Head Ridge."

"He was fourteen years old and a scrawny sixty-nine pounds when he came here in 1939," Mel said. His parents had bought him passage by ship and train. "He was never to see his mother again." A ninety-five dollar "special third class" ticket took him from Hong Kong to Canada, then to Ellis Island—a journey that took almost a month.

"He was never afraid," she said. "It was all one big adventure for him."

His father and two older brothers were already in New York City, and they all worked at the Lee Fong Laundry at 200 East Fiftieth Street in Manhattan.

Mr. Lee was the first in his extended family to go to college. He studied structural technology at New York State Institute of Applied Arts and Sciences, now known as the New York City College of Technology. The school was established for World War II veterans to receive technical education after the war. He later taught a course there once a week for additional income, as well as delivering mail during the holidays, co-owning a Chinese restaurant in Rockefeller Center, and selling life insurance and World Book Encyclopedias to get his kids a discounted copy.

Mr. Lee was drafted into the Korean War, where he worked as a draftsman, creating technical drawings for using dynamite. Afterward, he worked as a civil engineer for the New York City Transit Authority, where he became the first Chinese person to hold the position of project coordinator, and retired at fifty-seven. He keeps a lifetime bus and subway pass in his wallet, a never-expiring MetroCard—a retirement perk for all his years of service. He uses it to take the subway from his house near Coney Island to his son-in-law's eye surgery practice in Manhattan, where he helps with office work. "We tell him to take it easy at home, but he hates being cooped up," Mel said. Post-retirement, he's taken fishing trips to adventurous places including Cuba, Venezuela, the Yukon, England, and Belize.

As for his style, we liked his pink aviators and his petite pompadour, which his daughter refers to as his "curry puff." She thinks he wears it this way that way to add a few inches to his five-foot-six frame. "The Malaysian waitresses in Chinatown used to tease him for sporting a *gaa lei gok* (curry puff)," she said.

He still favors that look today. "He always keeps a comb in his pocket," she said.

CARDIGAN
COMPANIONS

MADISON STREET, 2018

Ci Juan Lin, seventy-four, and her friend Chun Xia Li, seventy-eight, were accidentally twinning when we met them at the Smith Senior Center, a community center run by Hamilton-Madison Center that provides meals and activities for the people in the area.

Both were wearing cardigans with only the top button buttoned and floral shirts underneath, pointy collars exposed up top. "I had no idea that we were going to match," Ms. Lin said. "This is my everyday clothes."

During the shoot, we liked how they joked with each other and playfully hit each other on the legs.

They matched from top to bottom, down to their checkered socks.

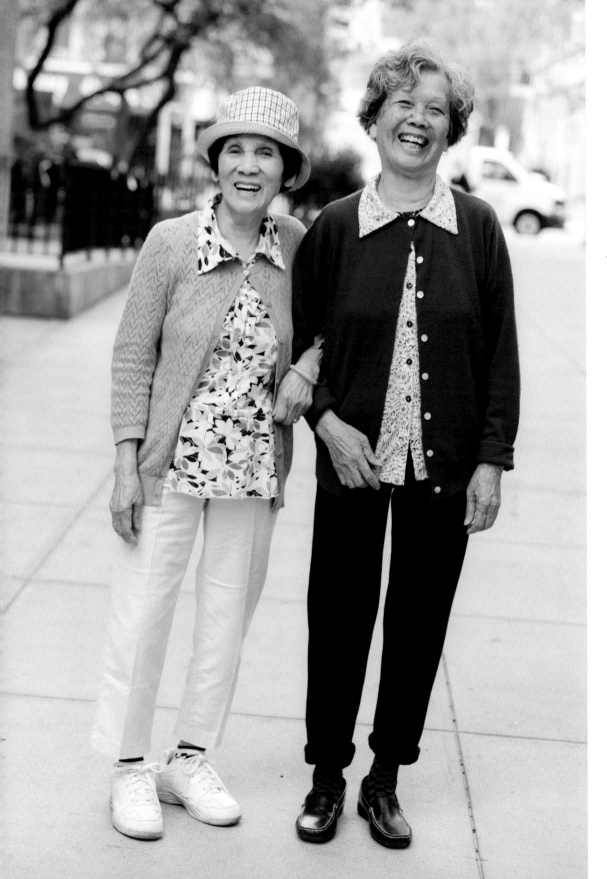

PINK
PATTERNS

MOTT STREET, 2016

We headed straight for Helen Lo, eighty, when we
saw her multipatterned outfit halfway down the
street. When asked about how she assembled her
outfit, she replied: "I like beautiful things and I
just put them together."

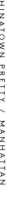

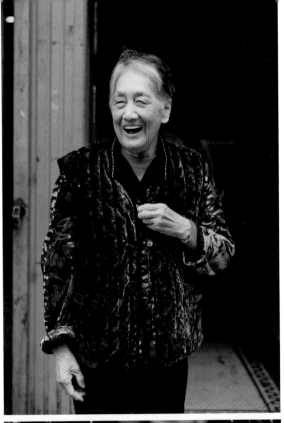

VELVET CRUSH

MOTT STREET, 2018

We took a minute to admire the velvet look sported by Song Mui, seventy-eight. Her outfit sparkles: the radiant sheen of her velvet vest and collared shirt, along with diamond-like buttons and bedazzled crystals on her collar.

"I've lived here for twenty-something years," she said. "I like flowers."

THE GARDENER

Gui Zhi Li, seventy-three, was waiting outside the Chinese Community Center on Mott Street. She had on a bright purple orchid vest paired with a NY baseball cap—part grandma, part urbanite.

We asked her where she got her clothes. "I got everything from Chinatown," she said. "Do you think I would go all the way to Guangzhou to get my clothes? Of course I would get it here!"

Prior to immigrating to the United States, Ms. Li worked as a park gardener in Hong Kong. "Trees and plants, big and small," she said.

She's been in the United States for about five years, but wants to go back to Guangzhou. "The weather here is cold. It snows. Guangzhou doesn't snow," she said. "I don't want to be in a cold environment."

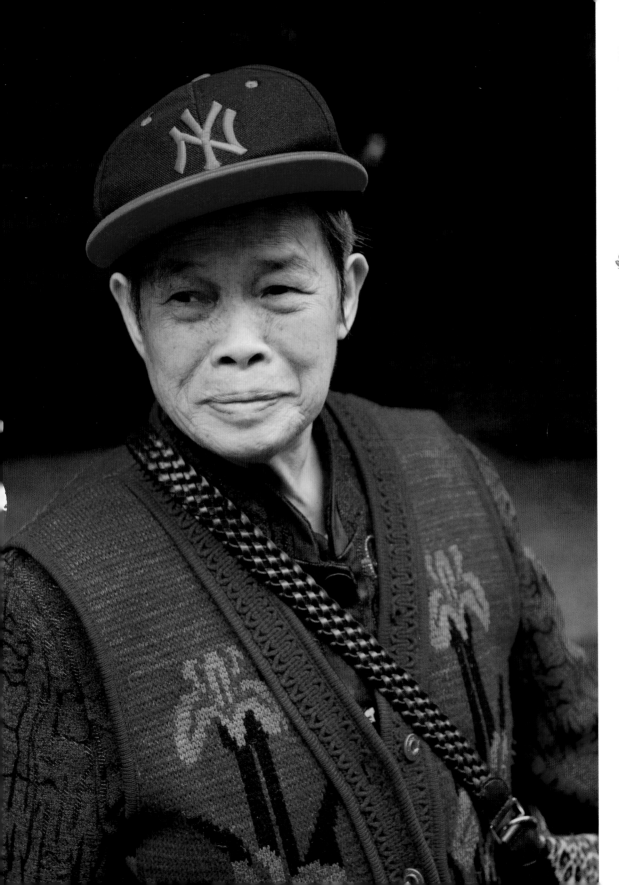

SPACE
CULTURE

We spotted Victor Lee from across Columbus Park, a popular hangout spot for seniors to play Chinese chess, chill on park benches, and exercise. Lee, fifty-eight, stood out among all the black parkas with his green knit cardigan.

A closer look revealed the delightful details: an orange polo shirt with a matching mesh jersey layered on top; a golden sphinx necklace that he adorned with an orange polka dot bow.

"It's now in style," he laughed, when we asked about his fashion sense. "Normally I wear a down jacket, but I wanted to be more fashionable."

We looked down at his jeans and saw Chinese characters written in Sharpie on his pant leg. "What does that say?" we asked.

"Space culture," he replied. "You know—the sky, airplanes, UFOs."

His catchphrases and quirkiness were all over his outfits—and we saw many variations of this over the course of our week in Manhattan.

Lee's been in Chinatown since he was ten and he's a regular fixture around the neighborhood—during the day he moves from corner to corner, chasing the sun, smoking cigarettes.

One day he wore a hat with the American flag and bald eagles. There were a few of his signature Sharpie scribbles on them, one of which was the phrase "Golden Times," a warming thought. When we complimented him on his hat, he immediately offered it to us. He also gave us White Rabbit candies and metal bracelets.

Earlier, during our walks around Chinatown, we had seen a Sharpie drawing on a wooden wall—two turtles with Chinese characters written on the side. Our translator said it read, "It is worth an entire city." Did the author mean that turtles were literally worth the value of an entire metropolis? Was it a random phrase or an ancient Chinese proverb?

Either way, we figured out who the author was the next time we saw Victor, who had the same two turtles drawn on the America-themed hat he tried to give us—a gesture worth an entire city.

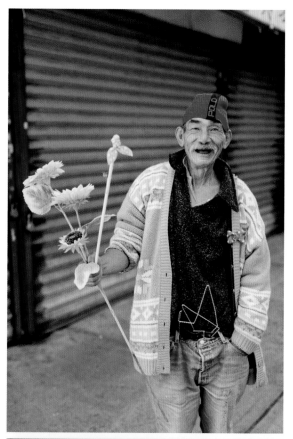

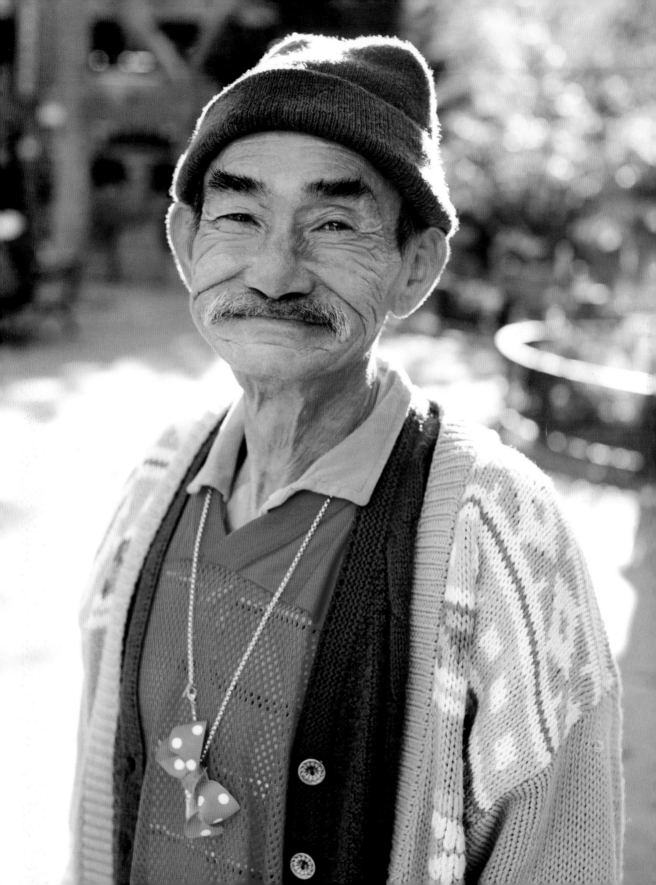

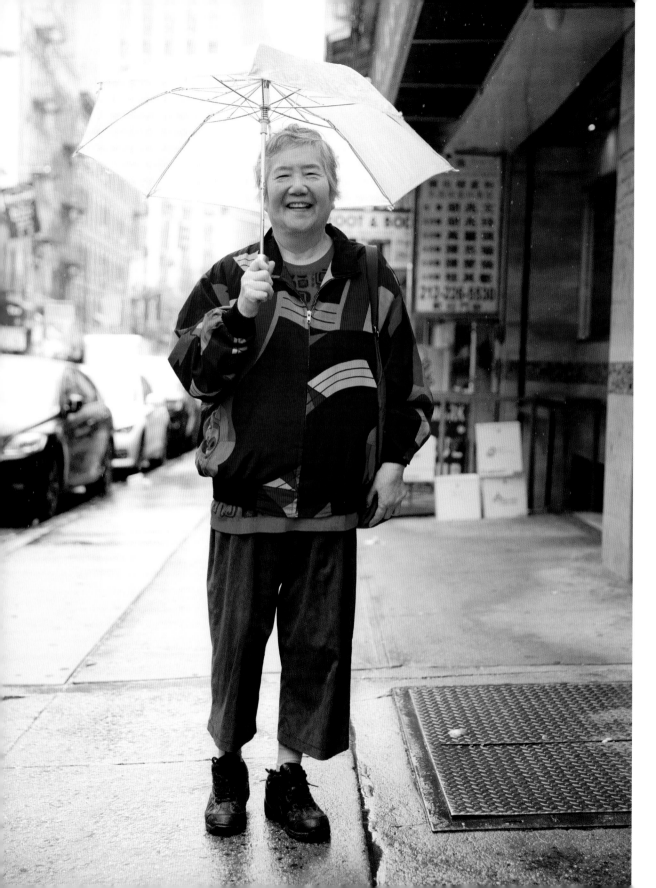

THE CHURCHGOER

BAYARD STREET, 2018

Yin Qin Cai, seventy-eight, was sporting a lavender umbrella and patterned windbreaker when we met her on a rainy morning. She moved to New York from Shanghai forty years ago because the pollution in Shanghai was giving her health problems. "I came here for the good air," she said.

We liked the ease of her outfit, especially her gray culottes, and the fun shapes featured on her jacket and shirt. "My clothes are very comfortable," she said. "I wear whatever's comfortable."

It was a Thursday, which meant she was headed to church. "I like to have a lot of people around me, it's a happier feeling—being able to share happiness with people," she said, "I like my community."

However, our conversation bled into the church service time. "I skipped church to talk to you. I'll just go buy some stuff instead," she said before heading toward the grocery stores.

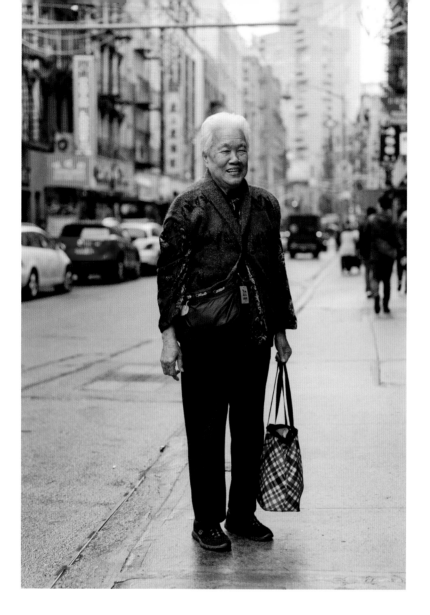

LESPORTSAC

MOTT STREET, 2018

If you're ever wondering what present to buy a grandma, we'd recommend a LeSportsac bag. It's beloved by elders—it's lightweight, comes in many colors and patterns, and features pockets for days. Wan Kau Eng, seventy-eight, was sporting a minimal black one with reflector tags to increase her visibility while she's out and about. Originally from Toisan, she worked as a seamstress for fifteen years.

"I don't come out in the winter," she said.

PONCHO PORTRAIT

MOTT STREET, 2018

The Chinatown rainy-day gear of choice seemed to be ponchos. Lin Xiang Yee, the woman in the blue poncho, bought hers from a ninety-nine cent store, and smartly pinned the hood to her baseball cap to secure it.

"I'm going to dim sum," she said. "I'm going to get duck noodles."

When this woman in a yellow poncho passed by, Ms. Yee pulled her in for a poncho portrait.

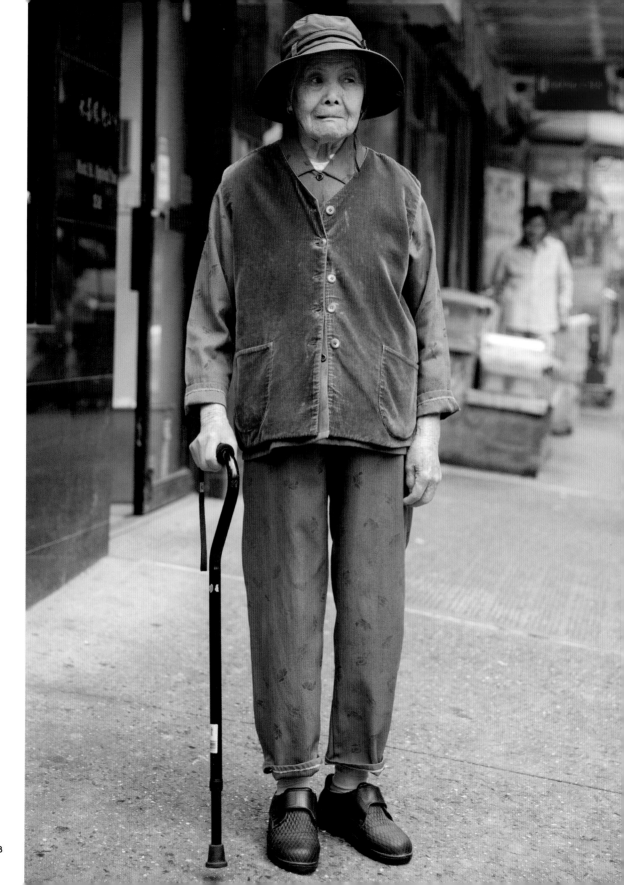

PURPLE PAJAMAS

MOTT STREET, 2018

Qun Si Yuan, eighty-nine, was shuffling around a corner when we ran into her, wearing an outdoor purple pajama set topped with a brown corduroy vest. There was a gang of us by this point and we were ogling her color combination and the way she mixed her comfortable "pajamas" with more sporty accessories for her urban outing.

She stood there as we asked questions (revealing only that she worked as a farmer and sometimes makes her own breakfast), gently switching her gaze from one to another of us with a soft smile. No doubt we were overwhelming but she took it in sweet stride. It melted our hearts then, and it still melts our hearts now.

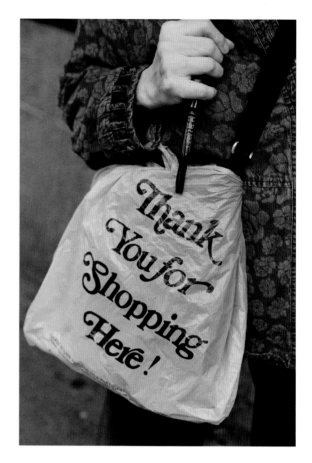

THANK YOU
FOR SHOPPING

CANAL STREET, 2018

C.P., sixty-seven, was walking in front of Golden Jade Jewelry wearing a floral denim jacket over a floral shirt, both of which she purchased in Chinatown. "I'm going grocery shopping for me and my husband," she said. We liked how she used a plastic Thank You bag (a very nice one, in fact) to protect her purse.

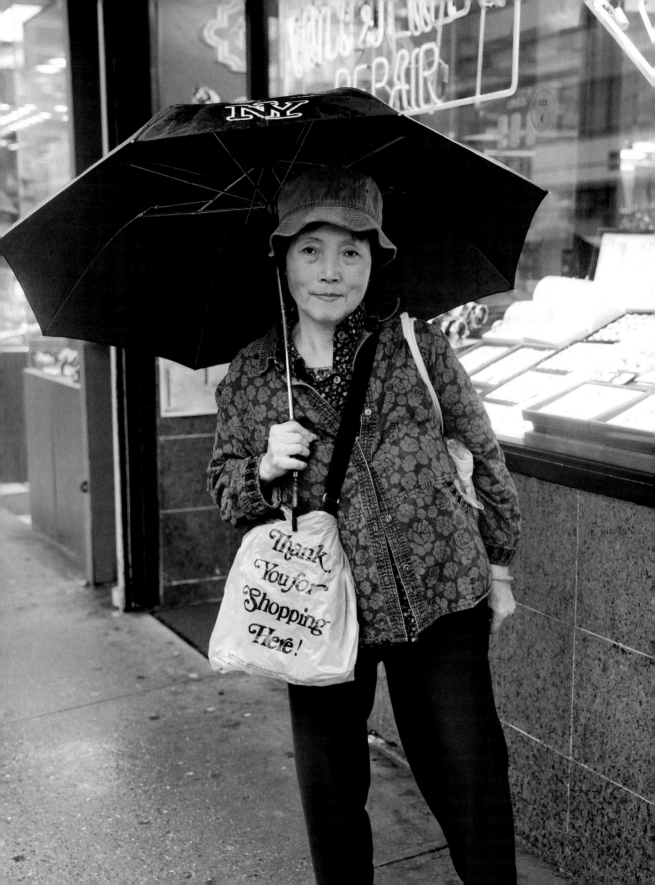

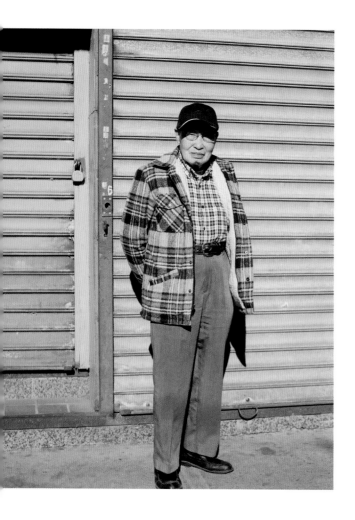

YOURS SHEARLING

MOTT STREET, 2016

Wing Chun, eighty-five, had on fall gear when we met him: a shearling coat he purchased twenty years ago on top of a plaid shirt paired with high-waisted pants. A black monochrome embroidered New York cap topped off the look.

Mr. Chun immigrated here with his grandma and father and worked in the restaurant industry, though not in New York City. "It was easier to find work in other states," he said. He did everything from waiting tables to delivering food to being a host. When he was younger, he and a few friends opened up a Cantonese restaurant together. But they started to disagree on things and he decided to close up shop. "I preferred to lose the restaurant than lose my friendships," he said.

GOLDEN SMILE

HAMILTON-MADISON CENTER, 2018

Lian Yun Chen, eighty-six, had on a variety of accessories: a Louis Vuitton scarf and Burberry hat. We liked how she worked contemporary patterns into her outfit. And her golden smile.

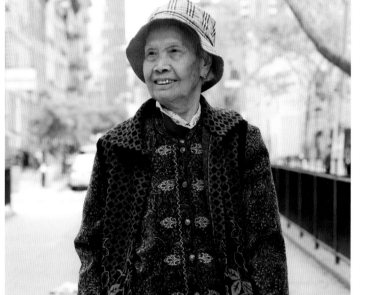

EXTRA STITCH

COLUMBUS PARK, 2016

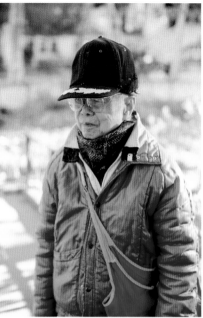

We saw the hat first. It had been visibly hand-stitched—in the front and in the back, where he had covered a hole with nylon fabric.

"*Jóu sàhn,*" (good morning) we greeted him. He looked at us skeptically from behind his newspaper. "What do you want?"

"We're writers," we explained. "We want to know more about your hat."

With that, he quickly opened up.

Our friend, who declined to give his name, said he customized his hat by sewing a few of them together. When he lifted it off his head, a plastic bag fell out. "For extra warmth," he said.

"If you had money, you would get a knit hat," he said. "But when you're out of funds, you have to make stuff yourself."

Upon closer inspection, we saw he had modified all the elements of his outfit. He attached an extra piece of fabric around the collar to protect his neck from the wind. His sleeves had a small (but perhaps significant) half inch of extra fabric. The scarf around his neck had been trimmed and hemmed. He even customized his bag, repurposing a lanyard to transform a regular nylon bag into a cross-body bag.

Our friend, ninety-five, moved from Hong Kong in 1979. He's worked as a tailor, a hairstylist, and for a while, a cobbler. During our conversation, he expressed frustration that younger people seldom talk to seniors, and was happy that we took the time to chat with him.

He left us with a proverb to simmer on: "The sunset is infinitely beautiful, but it signals the end of the day," he said. "One day you'll be old as well."

VANCOUVER CHINATOWN

Hot and noisy

Vancouver's Chinatown is the largest one in Canada. Chinese have been in Canada since the mid-1800s—coming first to mine gold and then to build the Canadian Pacific Railway. The story is similar to that of other Chinatowns. White locals resented the Chinese labor force. The Canadian government imposed ever-increasing "head taxes" on Chinese trying to immigrate. This made it cost-prohibitive for men to bring their families over. Eventually, the government passed its own Chinese Exclusion Act in 1923, which banned all Chinese immigration. It was the only time Canada ever singled out one nationality.

Despite this discrimination, when World War II erupted, hundreds of Chinese Canadians enlisted to fight for the Allies. Their loyalty to Canada contributed to their being granted full citizenship in 1947 and the repeal of the Exclusion Act.

Starting in the 1950s, new waves of Chinese arrived and families were finally reunited. Later, between the 1980s and 1997, another wave of Chinese came, fleeing Hong Kong before the handover, when Britain's ninety-nine-year lease expired and the territory became part of China again. Fearful of political and economic uncertainty, many moved to Vancouver, while others settled in neighboring cities such as Richmond and Burnaby.

Modern-day Chinatown borders the Gastown district, a trendy neighborhood, and Downtown Eastside, where homelessness and the opioid epidemic are very visible. Tracing the outlines of Chinatown, we were able to see how Vancouver Chinatown teeters between new and old. Shops selling third-wave coffee, açaí bowls, and cashew ice cream are interspersed between older Chinese businesses—tea shops, bakeries, and grocery stores with red plastic pendant lights hanging over outdoor fruit stands, which made us feel for a second like we were in Hong Kong. In a few years, a modest one-story super-market on Keefer Street will be transformed into a new condo development, six stories tall.

The tension between new and old has given Vancouver Chinatown an energetic sense of advocacy. Heading up this effort were our hosts Doris and June Chow, the two founders of the Youth Collaborative for Chinatown (YCC), "a network of youth doing awesome things in, for, and with Vancouver's Chinatown." The Chow sisters are the unofficial ambassadors of Chinatown. They know everyone from the grannies playing mahjong on the second floor of association buildings to the shopkeepers inside Sun Wah Centre, an '80s mall, to various young Chinese Canadians who are trying to preserve the Chinatown of their childhood.

YCC's cornerstone event is the "Hot and Noisy" Mahjong Social, where they set up mahjong tables in an outdoor plaza for young and old to play. We hosted a Senior Portrait Day in collaboration with them on a warm June afternoon. People we had met in various senior homes showed up to Chinatown Memorial Plaza, on the corner of Keefer and Columbia, hiding their mahjong faces behind polarized glasses and super sun hats. Meanwhile, twenty-something tattooed and blue-haired Chinese Canadians had their phones out to Instagram the game. It was special to witness an event where age and language were not factors, where people only needed a willingness to play.

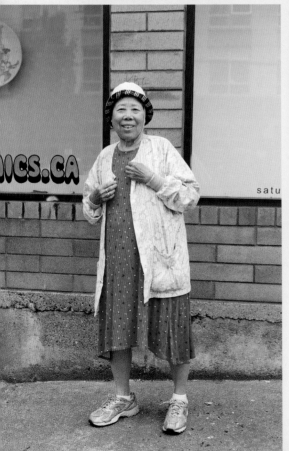

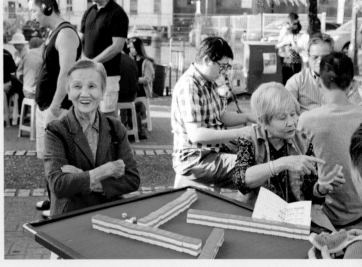

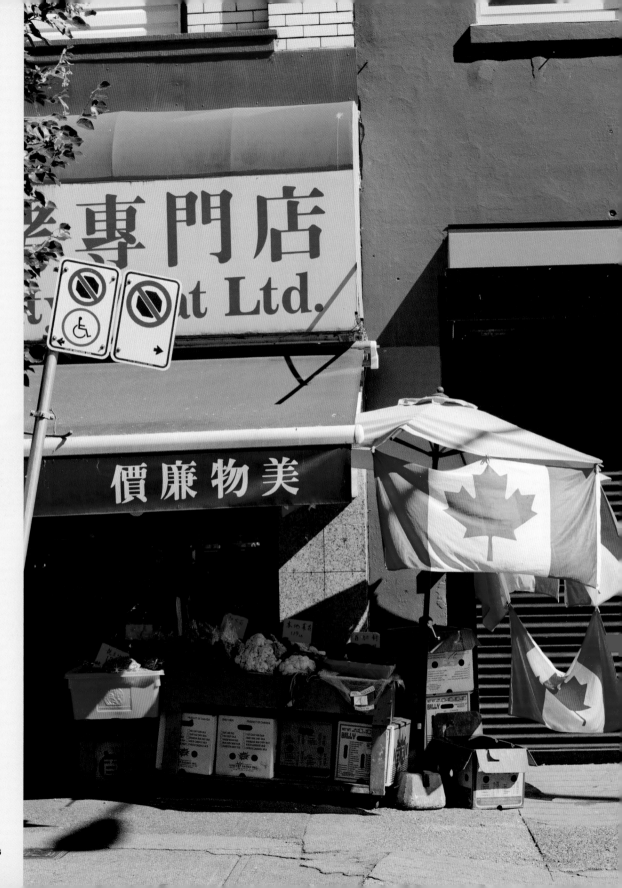

We were surprised to run into Chan Sum Qui, whom we'd approached unsuccessfully and tried to photograph earlier in the morning. She apologized for turning us away before. "Sorry, you came over to me when I was selling vegetables!" she said when she recognized us. She had thought the event started at eleven a.m. (when it was four p.m.), so she had rushed to come over. "I sold all my veggies cheap so I could come here at eleven a.m.," she said. "No one was here. So I went home and had leftovers."

Ms. Qui had heard about our event through the Senior Concern Group, a coalition of *pòh poh*s and *gùng gung*s who lobby for affordable housing. What a turn of events! Little did either of us know of each other's intentions. We were touched that this event was something that she was looking forward to, so much so that she was willing to take a loss.

There's a determination in Vancouver Chinatown. We see it in seniors like Ms. Qui. It's evident in the way she rises early to sell vegetables she's grown on her rooftop garden, meets with Senior Concern Group at the Roosevelt Center in the afternoon, and plays mahjong in a public plaza, determined to outsmart her opponents.

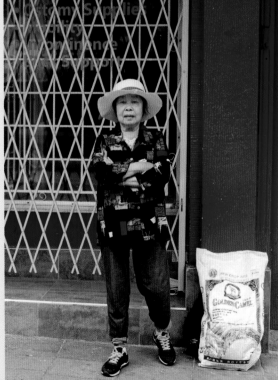

THE SWIMMER

GEORGIA STREET, 2018

Show Chun Chang was the first person we met in Vancouver Chinatown. June Chow introduced this Chinatown resident of thirty-seven years as an avid swimmer.

We had just gotten our day started, but Ms. Chang had already gone swimming, changed clothes, and was now shopping—all before nine a.m. "I've been swimming for thirty years, Monday to Friday, even when it's snowing," she said, standing in perfect posture that made us straighten our spines.

We admired her long hair, which is uncommon among seniors, who usually prefer short bobs or perms.

"My long hair is not for beauty, it's to make it look like I'm attentive," she said. "At this age, we don't need to be pretty." Though she noted that she was pretty back in the day. "I was voted the beauty queen of my elementary school," she said.

But nowadays, practicality trumps everything else. "At my age, we don't care about fashion," she said. "We just wear what's comfortable." We've heard this same sentence echoed by countless other seniors, but their outfits speak to a uniqueness that extends beyond functionality.

Ms. Chang had on fun plaid pants with a pop of pink Mary Janes. We'd never considered pink Mary Janes before.

But Ms. Chang was more matter-of-fact about the outfit inspiration. "I inherited these pants from a dead person," she said. "She was a good friend."

Then an employee from the grocery store rushed out to share some intel on Ms. Chang. "Do you know how old she is?" the grocery worker exclaimed. "She's older than a hundred!"

We bowed down to her, as we tend to do with other centenarians. Ms. Chang was still matter-of-fact: "I eat everything," she said. "I go everywhere."

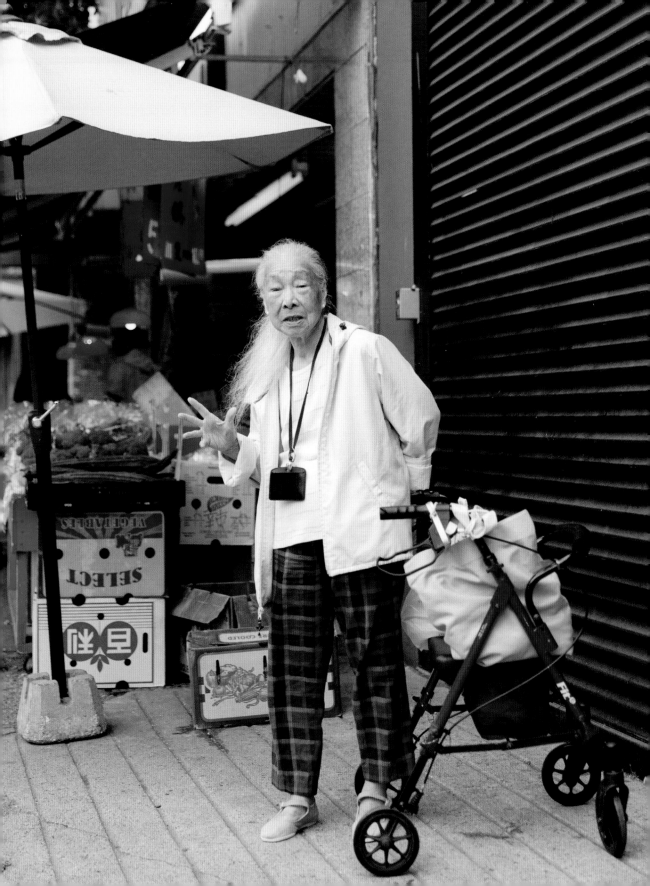

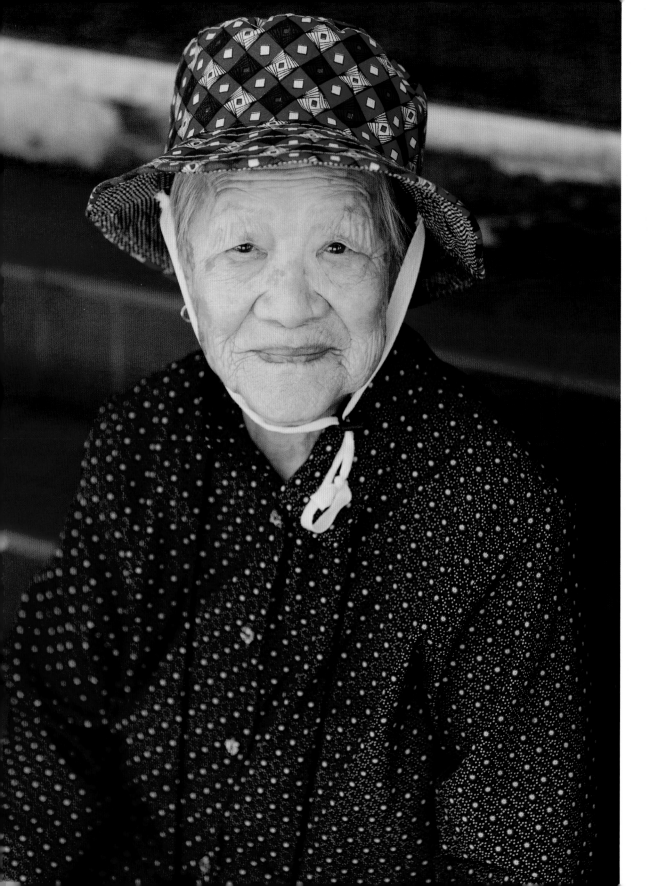

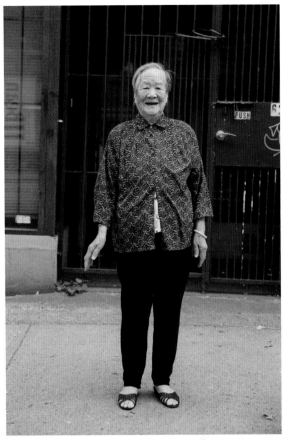

PURPLE-PATTERNED PÒH POH

GORE STREET, 2018

Shi Gong is a fan of purple. When we ran into her over the course of three days, she had on four different purple-patterned items. We admired her diamond bucket hat as well as her bright gold hoop earrings.

We first met her at Shon Yee Place, a residential center where we hosted a Senior Portrait Day, then at Zhao Mah Bakery, where she was buying a whole bag of day-old pastries, and lastly, one day when she was sitting on a set of stairs waiting for the bus. Ms. Gong—a purple-patterned lady about town.

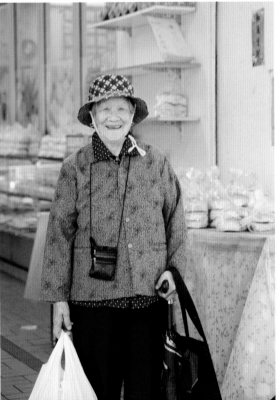

IN CANADIAN TUXES WE TRUST

MAIN STREET, 2018

We couldn't have dreamed up a more Canadian Canadian Tuxedo until we bumped into this gentleman outside of a bank on Main Street.

"Do you like to bowl?" we asked him, eyeing the "Most Improved Bowler" and "Triples" patches.

"The patches were only two dollars each!" he replied.

We tried again. "Why is the 'N' backward?" we asked.

And again, he repeated that the patches were only two dollars.

We couldn't get much insight into why he chose those patches. We did, however, learn that the Chinese patch meant "blessing." We'll just take our encounter as a serendipitous moment and his jacket as an inexplicably delightful DIY garment.

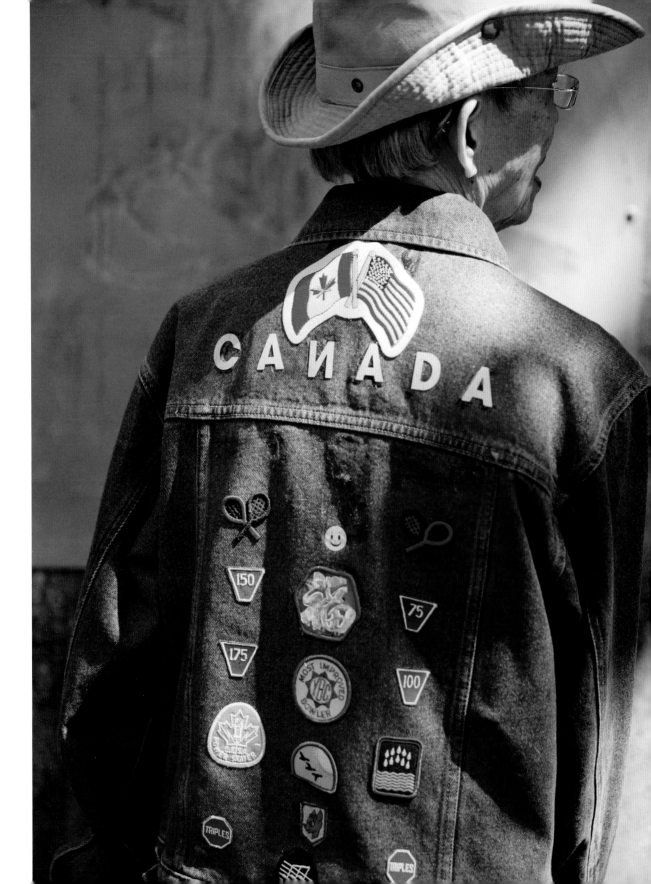

GREEN GLOW

STRATHCONA PARK, 2018

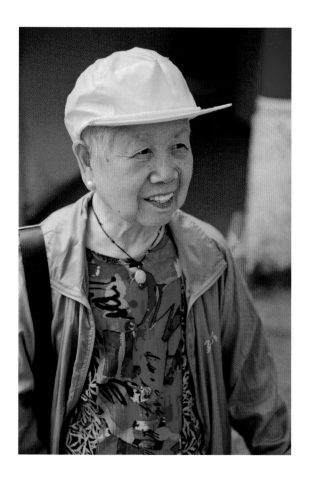

Sui Chen Shen, eighty-six, was glowing in her neon cap after visiting her husband at Villa Cathay, a senior care home.

When she came to Vancouver at fifty-five, Mrs. Shen got a job working at a clothing factory. The shirt was made by a friend, utilizing leftover fabric. At first we only saw the fun '80s print on the bib of her shirt. When she unzipped her jacket, we saw the darker leaf resist print that delightfully contrasted with the front fabric. Oh, how Chinatown Pretty outfits keep revealing themselves.

For seven years, Mrs. Shen steamed clothes to support her four daughters, three of whom lived in the United States. "I was really tired and sweat a lot," she said. "It was really hot—no air-conditioning." Eventually, the physically demanding job took its toll. "I had to stand a lot," she said. "Later my body wasn't feeling good, so I retired."

Mrs. Shen's outfit taught us a lesson on how to balance boldness. We liked the way she mixed patterns, and how the apple green jacket and olive pants harmonized with the brighter elements. She claims there isn't much to it. "I don't really have a thought process," she said. "I wear whatever I feel like."

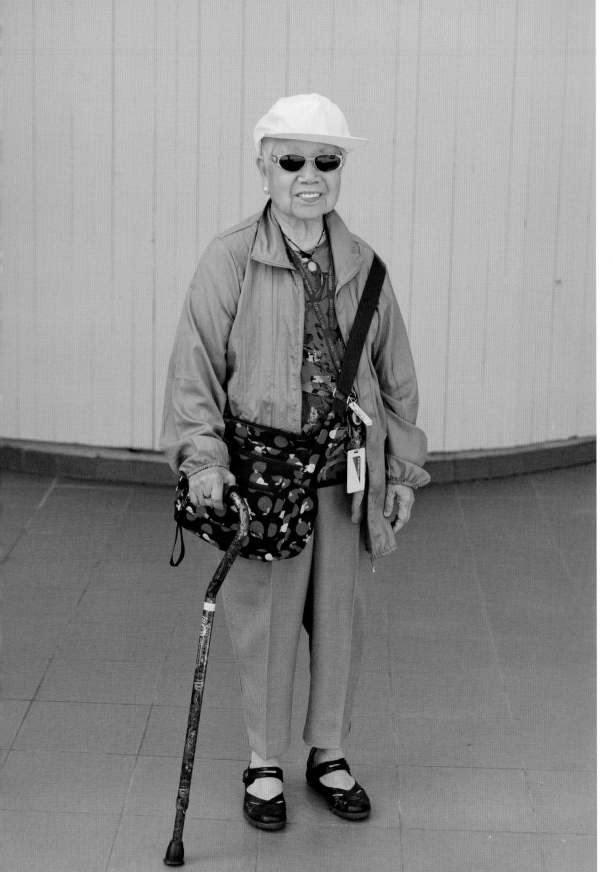

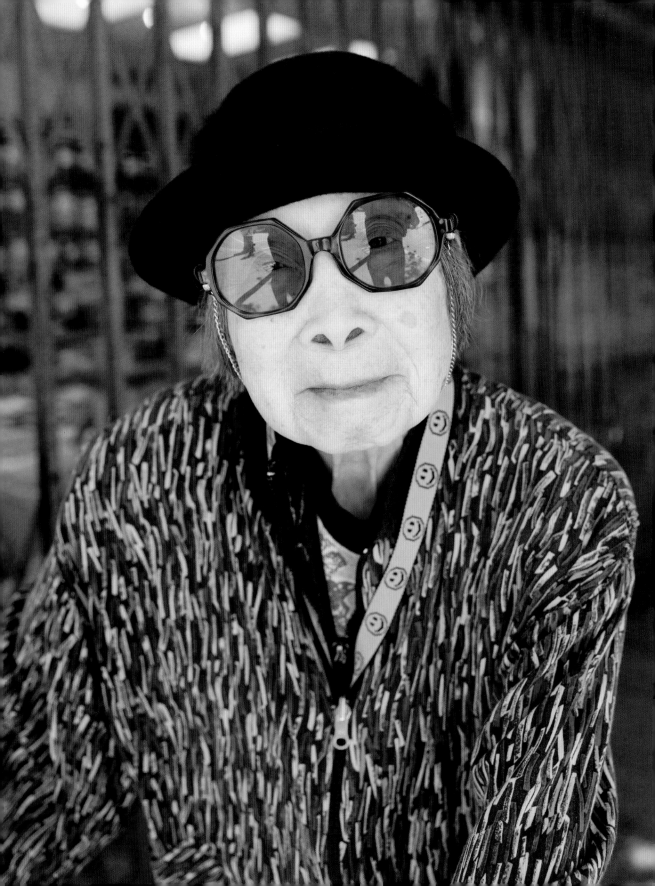

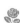

HELEN

KEEFER STREET, 2018

Andria and I were off absorbing Vancouver Chinatown separately—she to shoot some B-roll, while I soaked in sensory details—when she called me on the phone. "Meet me on Keefer and Gore! Be quick!"

I hurried over and saw Andria speaking to Helen Lok. She was making her way down Keefer Street using her walker. "Today is a beautiful day for a walk," she said. At ninety-five, she said, it's harder to find the energy to go outside. "My doctor said not to stay in the house," she said. "They said I must come out for a walk, at least once a week." We felt lucky to have caught her in the small window that she was outside.

Her demeanor gave her the Upper West Side vibe, as well as her accessories: the wool bowler hat, perfectly tailored cashmere pants, embroidered slip-ons, and tortoise eyeglasses with a metal chain. And it wasn't just any pair of spectacles: hers was a hexagonal pair with blue lenses.

Her outfit was elegant, but not in a traditional way. Instead of a tweed blazer, it was an '80s bomber jacket and printed T-shirt. Instead of pearls, it was a lanyard lined with smiley faces.

Originally from Hong Kong, Ms. Lok came to Canada forty-six years ago. Prior to retirement, she worked as a secretary for the British government. She also volunteered by driving non-English speakers to meet with translators. She's now living in Vancouver by herself. Her daughter is in Hong Kong, her son in Toronto.

"Nobody can help me," she said. "I can only help myself." After letting us take a few last shots, she persisted down the street—slowly but surely.

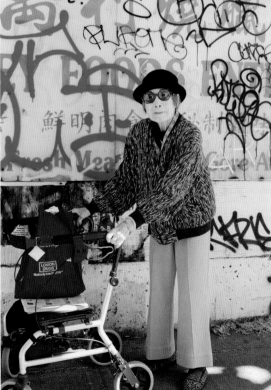

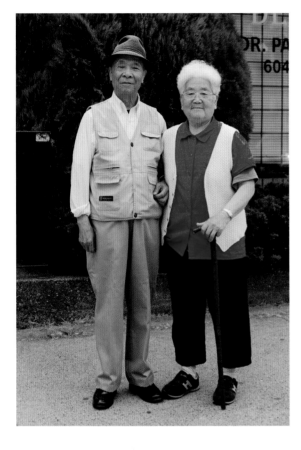

WATERMELON COUPLE

CHINATOWN MEMORIAL PLAZA, 2018

At the Mahjong Social, we watched Ling Ying Zhing, eighty-three, and her husband, Ming Chu Wu, eighty-one, happily socializing with another married couple. They sat on a park bench enjoying slices of watermelon that matched their bright red shirts.

Mrs. Zhing said they've been married for more than fifty years. "Our friend introduced me to him," she said. "I noticed how handsome he was." The sentiment went both ways: "She was very beautiful when she was young," Mr. Wu said.

She cites the different skills they brought to their partnership as the key to their long-lasting marriage. "We help each other," she said. She praised his intelligence ("He's very smart—he studied science"), and noted that she took care of all the house affairs by caring for the kids and cooking for the family.

Sweet, just like the watermelon.

MAHJONG MATES

CHINATOWN MEMORIAL PLAZA, 2018

It took a few rounds until we could get a photo of these mahjong players, who waved us off as they were too busy washing tiles and contemplating their next moves to stop for a photo. These three women, who all live at Shon Yee Place, a senior residential building run by the Shon Yee Benevolent Association, are seriously devoted to the game.

"We play every day," one of them said. *"Every day."*

Even though she's a mahjong aficionado, her husband has never learned how to play. At the Mahjong Social, she was teaching him for the very first time, which goes to show it's never too late to learn.

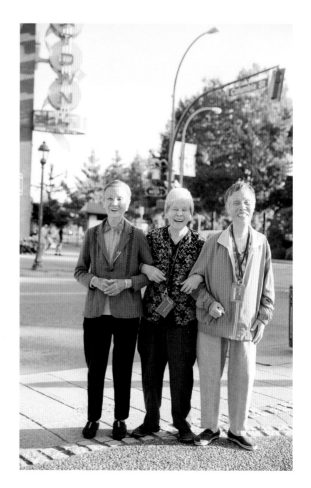

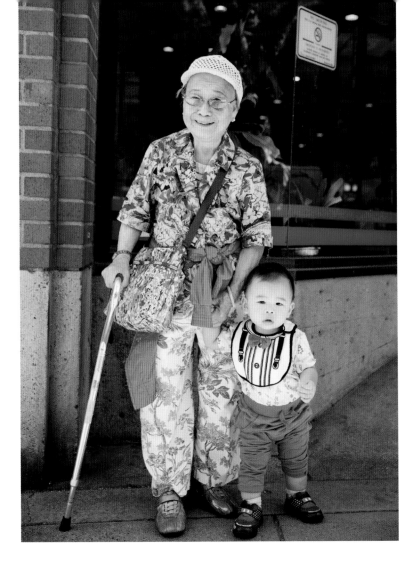

FLORAL FAMILY

KEEFER STREET, 2018

Sundays in Chinatowns means dim sum outings with the family. Peeking into a sit-down restaurant, we see dining halls made up of ten-person tables, filled with multiple generations. Sui Ngan Sung, ninety-three, was heading into Goldstone Bakery and Restaurant for the Sunday ritual with her family, which included her grandson, looking handsome in his tuxedo bib. They both had on Velcro shoes and featured foliage in their outfits—little pine trees on his shirt, a blend of bold colors and florals bursting on hers.

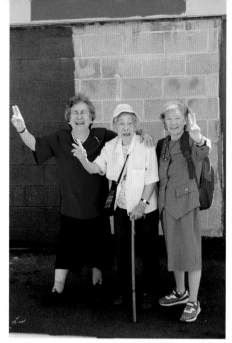

DORA THE EXPLORER

SUN WAH CENTRE, 2018

Young and old is the theme of Xing Jun Ma's look. Ms. Ma, eighty-six, wore a robin's-egg-blue skirt suit she had custom made in China, after seeing a similar design that she liked. We liked how she accessorized her mature two-piece with a bright pink Dora the Explorer backpack inherited from her great-grandchildren. "They grew out of it so they gave it to me," she said. "They're eighteen now."

Her bright pink orthopedic shoes from China (with "Warrior" written in neon) matched her youthful backpack. "My feet aren't the best," she said. "These shoes soothe the pain."

Then, to our surprise, Ms. Ma demonstrated her tai chi skills for us. She's been practicing Yang-style tai chi for seven years and has competed in Canada, China, and San Francisco. She leads a group of ten tai chi practitioners who meet at MacLean Park every day from eight a.m. to nine-thirty a.m. "I own a radio with the music, so if I don't go there won't be any music," she said.

The daily ritual keeps her body healthy. "I don't feel accomplished when I don't do tai chi," she says. It's most noticeable when she walks among her peers; she notes that she's often the fastest walker.

In addition to tai chi, she also enjoys swimming, kung fu, mahjong, group vacations, and political activism. She's an active member of the Chinatown Concern Group, a group of senior citizens who advocate for affordable housing by holding rallies, lobbying, and issuing statements about new development and city planning policies that affect Chinatown.

"Developers are trying to get rid of old architecture to build high-rises," she said. "We don't want that. We want affordable housing."

She notes that the new housing complexes and third-wave coffee shops don't serve the low-income population in Chinatown and have changed the feeling of the neighborhood. Ms. Ma is doing something about it. "Now our Chinatown doesn't look the same as before, so I want to help," she said.

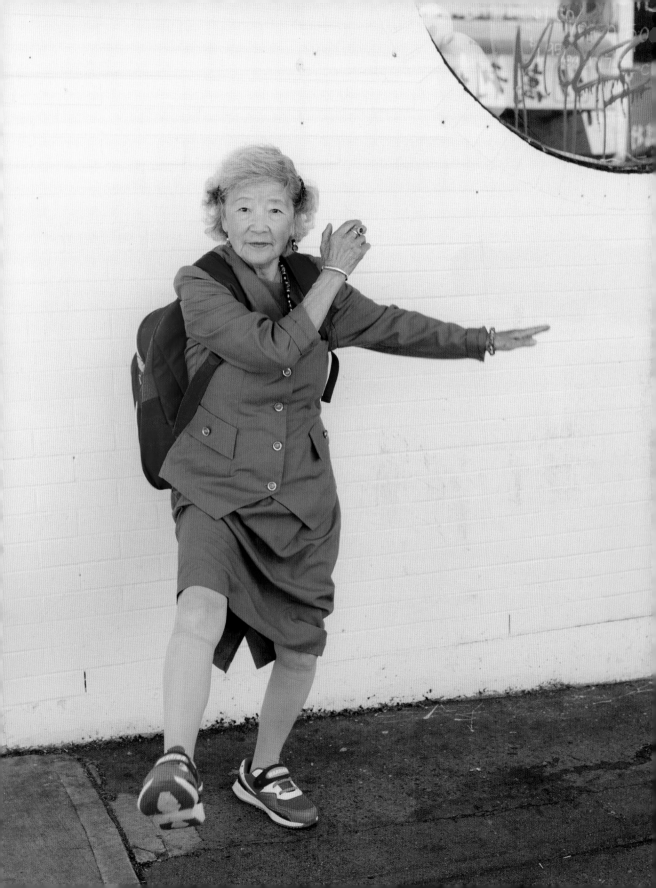

THE QUEEN

Meet Anna Lee, my step-grandmother.

Anna Lee lives in Burnaby, a town thirty minutes east of Vancouver. She reminds us of Queen Elizabeth with her regal air. She smiles, asks questions, and is undoubtedly engaged. Not to mention, she is always well-dressed, usually in high-waisted pants, a silk blouse, and necklaces she's made herself. She stands with impeccable posture and her hearty laugh reveals all her teeth, while her eyes squint and press up against her glasses.

She's ninety-four, but you would barely believe it. She lives a socially and physically active life. She starts her day with an hour of yoga, Bible reading, and meditation. In recent years, she and my stepdad, Andrew, enjoy dim sum at Jade Restaurant in Richmond, where she holds court and socializes with other regulars nearly every day. Afterward, he drops her off at the Metrotown mall, where she walks for two hours for exercise. One of the most impressive facts about her is that at ninety-four, she could still drive herself there.

I asked her about her clothes during one of her daily walks at the mall. She wore a handmade dress from Hong Kong, where she's originally from. "This fabric is from France," she said. That's what makes some of her pieces very interesting—Hong Kong tailoring with Western fabrics.

She moved to Canada in 1989 after she retired at age fifty-five because "China was going to take Hong Kong."

"I have many friends in Vancouver," she said. Every month, she has lunch with friends from middle school and colleagues from her days in social work in Hong Kong. However, they are all getting older. "Everyone is over ninety," she said. "Some of them are in a care home, some of them are not here."

On another visit, she showed Andria and me her collection of cheongsams, or traditional Chinese dresses. She pulled them out from a white cardboard box underneath her bed. Our hearts melted over her custom-made

dresses: royal blue embossed lace with pearl buttons; a modern floral print with zigzags reminiscent of Missoni; a blue batik print, perfect for a tropical getaway.

She told us a story as she pulled out her dresses. At the age of thirty-five, she decided to get out of accounting and into social services. It was a courageous and unexpected thing to change careers in her late thirties. "I was a little overage," she admitted. "They usually hired people under thirty."

As part of her career transition, she went to London to complete a master's degree in residential childcare. She worked as a senior social work officer for the Hong Kong Social Work department for twenty-two years until her retirement in 1980. I asked her why she chose social work. "I followed my mother's will," she said, citing that her mother often volunteered her time at organizations like the Red Cross.

While she worked as a social worker, Ms. Lee's British supervisors would come visit the children's home she ran in Hong Kong, which housed a hundred foster children. She recalled the one time Princess Anne (Prince Charles's sister) came to visit. "It was a big event in Hong Kong," she recalled. "I wore my cheongsam so I wouldn't have to bow like the English," she said, as if it gave her some sort of immunity. "I'm Chinese."

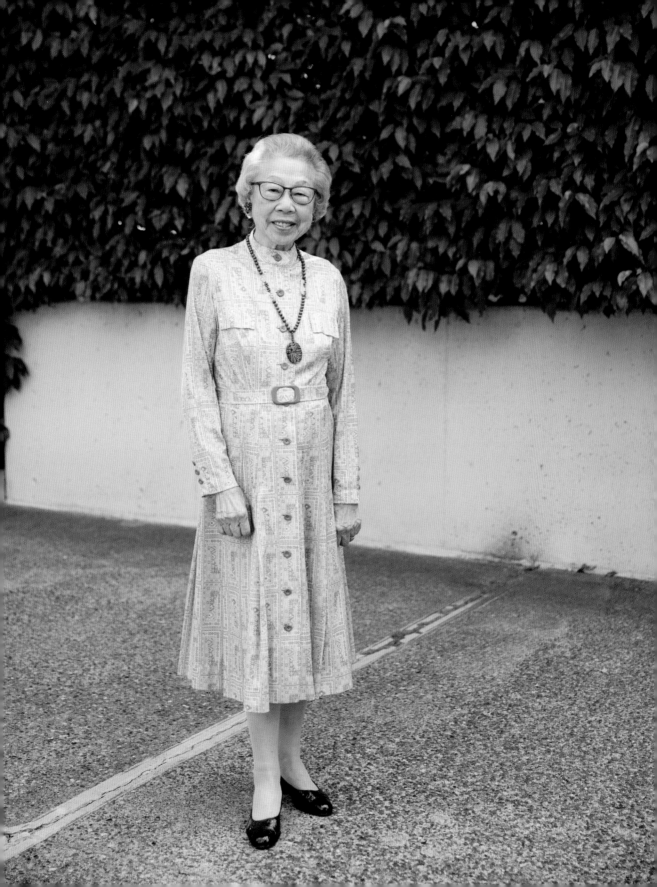

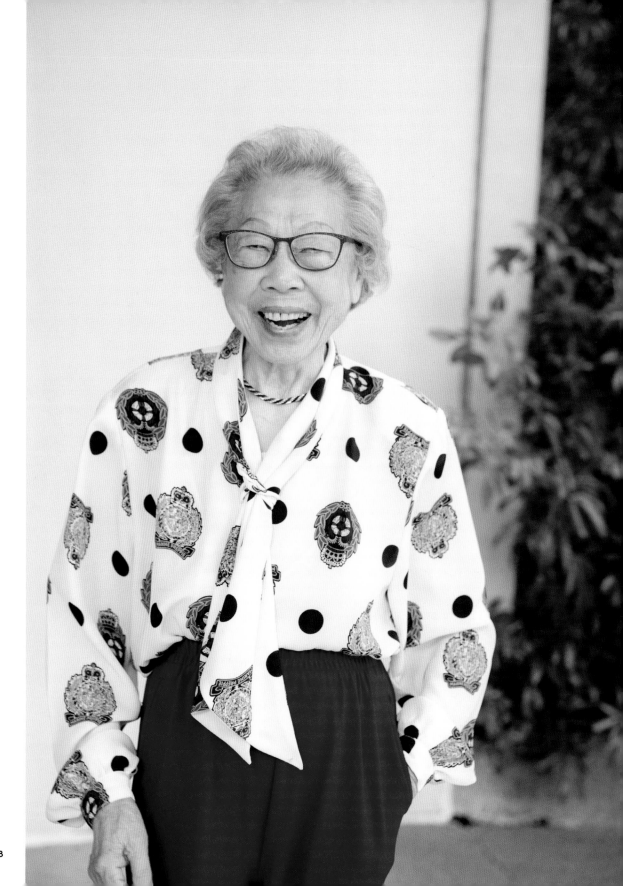

199

MATCHING
HALVES

EAST HASTINGS STREET, 2018

Friends Shi Rong Liu, eighty, and Su Wing Chow, eighty-two, wore matching denim chore coats, a garment that originates from French work wear. Chore coats are usually made from durable fabric like denim, twill, and canvas and feature buttons, big pockets, and a pointed collar.

Playful stitching appeared on their coats: embroidered dragonflies fluttered around Ms. Chow's jacket; rainbow thread traced Ms. Xi's. Their synchronized look was complete with trousers and sensible slip-on sneakers.

EIGHTIES DOROTHY

EAST PENDER STREET, 2018

Dorothy Chu Yeung, eighty-three, has been in long-term relationships with her husband—and her hat.

She's owned her acid-wash cap for over twenty years. Acid wash's popularity peaked in the 1980s, which coincided with the rise in windbreaker suits, rounding out her throwback outfit.

As for her other relationship—Mrs. Yeung met her husband, Jerome Yeung, in a scouting organization in Hong Kong. The youth service group (similar to Boy and Girl Scouts in the United States) was introduced to Hong Kong in 1909 by the British.

"We were both twenty-something when we met," she said. "Now we're over eighty."

"What's the secret to sixty years of marriage?" we asked.

She paused to look at him, then turned back to us and replied: "We tolerate each other."

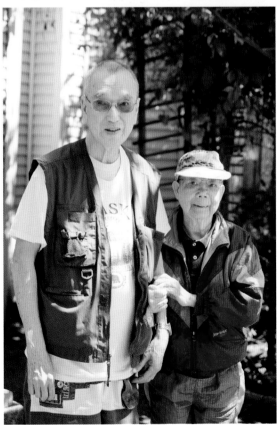

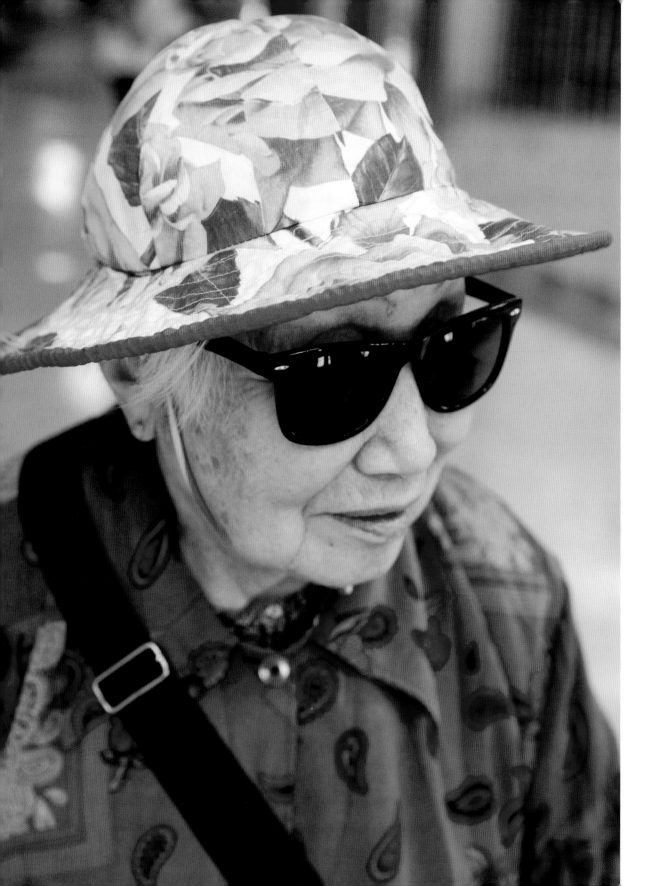

THE MALL HAT

INTERNATIONAL VILLAGE MALL, 2018

Mei Zhou, ninety, was getting relief from the midday sun with a few of her friends at the International Village Mall, a Chinatown shopping center with a food court, clothing stores, and air-conditioning. They were sitting on a bench, all looking fly.

We squatted down as she gave us her life story.

"I used to work as a seamstress," she said. "I would make pants, clothes—anything."

In the case of her outfit, she made her rose hat and purple windbreaker sling bag—both expertly well-constructed.

"Other people are wearing the same thing," she said, discussing the monotony of mainstream fashion. With Zhou's style, that is far from the case.

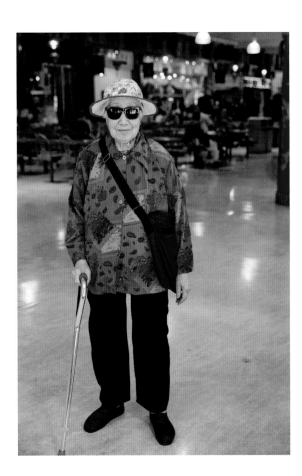

NAVY NOTES

EAST HASTINGS STREET, 2018

Navy notes were prominent in Zhen Xu Cui's outfit. Ms. Cui, ninety-four, wore a scarf tie blouse with navy blue polka dots peppered throughout the nautical pattern. "I've had it for more than thirty years," she said. "I sewed this shirt myself."

A sweet addition were the blue buttons, which looked like hard peppermint candies.

She worked as an interior designer, which explains her great sensibility. "I worked everywhere in China," she said. "Mostly residential."

Her outfit finished with a tote bag that pokes fun at Britain's rainy reputation.

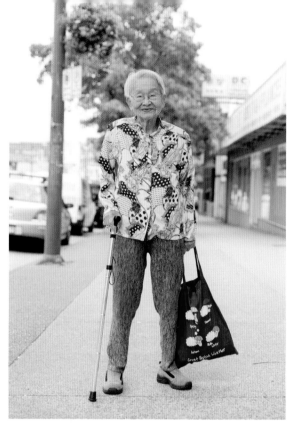

THE COW HERDER

CHINATOWN MEMORIAL PLAZA, 2018

Chan Sum Qui, eighty-eight, had shooed us away earlier in the day, when she was running her renegade farmers' market stand on Gore Street.

We were surprised to see her later at our Senior Portrait Day at the Mahjong Social. She apologized for refusing us earlier—she hadn't realized we were the same people who were going to be shooting portraits later that day.

Mrs. Qui has been in Canada since 1977. Prior to that, she worked as a cow herder in China. She'd been doing it since she was a child. "I learned how to walk by chasing cows," she said.

She's been busy working her whole life—from when she was five until she got married. On the farm, she chopped wood, grew potatoes, herded cows, and harvested vegetables. "The only time we go to sit was eating dinner and then we go back to work," she said.

At eighteen years old, she got married to a train operator in Hong Kong, someone her aunt's husband worked with, as part of an arranged marriage. "I didn't want to get married with someone so far away," she said. "My parents said, 'What, you want to marry a farmer?'"

She herded cows, even up till the day before her wedding. At thirty years old, her husband passed away and she had to go back to farming. She said that if he hadn't passed away, she would've had ten kids. "There was no birth control back then," she said. "We keep popping them out. I can have two kids in every three to four years. Nowadays, kids don't want to have kids."

When she first came to Canada, she opened a restaurant in Winnipeg. She could only bring one son at the time, because the rest were too old to qualify for immigrating over with her. There weren't many Chinese people in her area back then. "I cried every day," she said. "I missed my house, my farm, my chickens."

She was so homesick that whenever she saw a Chinese person at her restaurant, she would treat them to a free meal.

Eventually more Chinese people immigrated over. "I'm so much happier because there's so many Chinese people in Chinatown," she said.

Nowadays, she's busy advocating for affordable housing in Chinatown. All of her six kids are now in Canada. "That's why it's so important for me with housing here, to stay in Vancouver with my kids," she said. "Even my youngest son is old. He's retired. I want him to have affordable senior housing."

FATEFUL ENCOUNTER

CHINATOWN LIONS MANOR, 2018

We met Suzhu Liang, ninety, early one morning at a bus stop on Gore Street. She had just gotten off the bus wearing a bright knit hat and maroon vest. We ran into her again a few hours later, when she was on her way to the Buddhist temple on Pender Street. She was headed there to fold gold coins out of joss paper, a thin tissue paper used in ceremonial burning. "I fold them for my ancestors to use in the afterlife," she said.

She was busy, so we asked if we could meet up later to take a photo. "OK!" she cheerily responded.

When we went to the Lions Manor for a portrait day, we ran into her again at her apartment and recognized her closely cropped hair and sweet smile. Inside her apartment, we saw a pair of Wayfarer sunglasses sitting next to an altar and had her show us all her patterned clothes neatly folded in the drawers underneath her bed and hung up in her closet.

She put on a maroon bowler hat, given to her by a friend in Guangzhou. It was too large, so she sewed in a liner to make it more snug. Most of her clothes came from Guangzhou, where she lived before she moved to Canada thirty years ago.

Growing up, she wasn't able to go to school. Not just because she was poor, but because girls were not allowed to. "As a daughter, you were expected to do

the house chores," she said. "You just marry someone instead of going to school."

Combined with a war and food shortage, this made for a rough childhood.

But she had a life philosophy. "You can choose happiness or not," she said. "I've been living independently for sixty years and I learned to choose happiness."

Before she retired, Ms. Liang worked in an electronics and clothing factory. She had five kids, two of whom were girls. She told us that one of her daughters had just passed away, which is why she was at the temple when we met her a few days prior. "I burn them for my husband, mom, and dad," she said. "And for my daughter. I have my daughter's photo there."

She started crying as she said this. Our translator started crying as she translated. I started crying. We reached out and grabbed her hand, adorned in a bright jade ring and bracelet.

She said, "People talk about fate. Meeting you guys was fate."

The feeling was mutual.

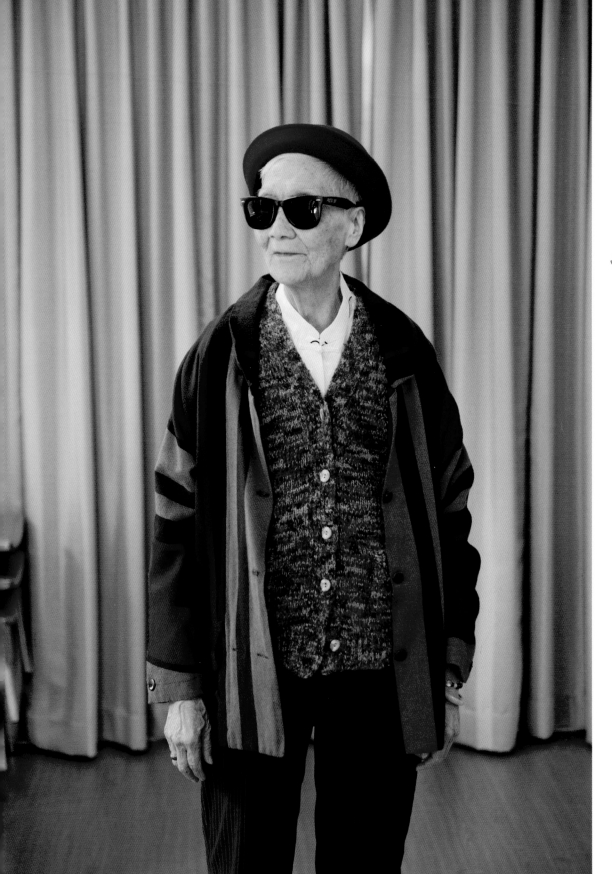

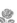

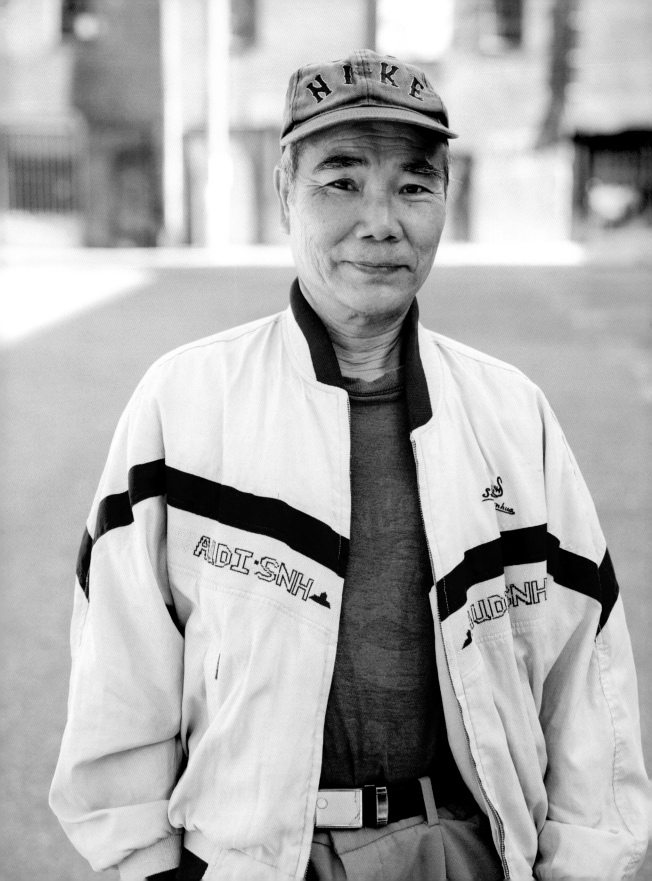

RAABOK

CHINATOWN MEMORIAL PLAZA, 2018

We met Wan Song Liu, ninety-six, casually sitting on a park bench in the plaza where we had held the "Hot and Noisy" Mahjong Social photo shoot the day before. There was a vintage patina to his look, with the high waisted belted pants and lettering on his cap, that reminded us of a 1950s baseball uniform. Though the track jacket and silhouette suggested early '90s streetwear, and there were so many subtle hints to other eras.

Our favorite part of his outfit were the bootleg Reebok slip-ons. "These shoes are light and easy," he said. We also liked his model sensibility—the ease that radiated from him, the way his face rested when we took his photo.

Mr. Liu immigrated from Guangzhou seventeen years ago. He often attends some of the events around Chinatown, like the Chinatown Night Market, which was hosted for three years by local Chinatown community groups until it was canceled in 2018 in protest of Vancouver's lack of support of Chinatown merchants. He now attends the new incarnation, the "Hot and Noisy" Mahjong Social, though only as an observer. "I don't know how to play mahjong, so I don't have anything to do sometimes," he said.

He also spends his time reading the newspaper or watching people play soccer. Before he retired, he worked as a farmer, and he got a little nostalgic when he talked to us: "I was happy working on the farm, even though it was hard work."

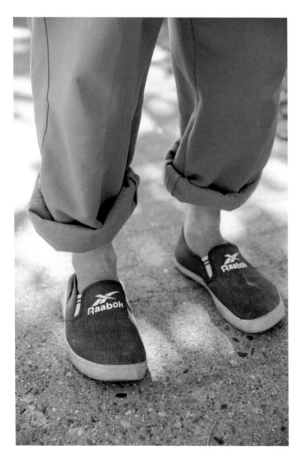

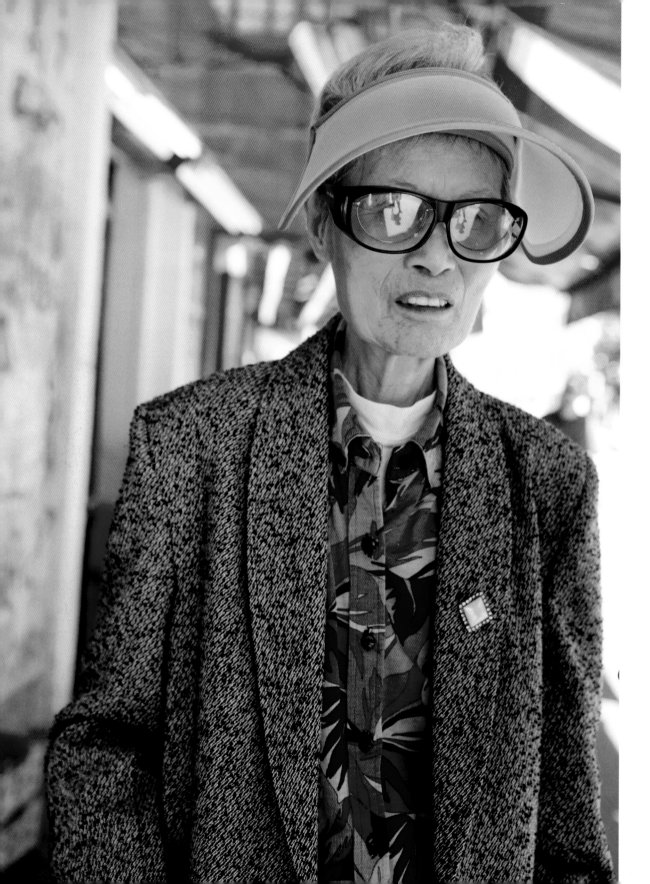

VISOR VISION

PENDER STREET, 2018

We met Man Gei Yuen while she was grocery shopping on Pender Street, the awning casting a red glow on her extra-wide brim visor.

"Everything is from Hong Kong ten years ago," she said.

Her outfit was feminine and refined—the buckled penny loafers and blazer, with a pearl brooch delightfully placed on her lapel.

It's the details that provide additional satisfaction. Like how the royal blue in her tropical shirt is picked up by her metal shopping cart. The yellow lenses layered on top of her glasses and the black leather fanny pack give a captivating tweak to the outfit's tone. Even the bright white stitches exposed by her extra-large pant cuffs add to the feeling. It's not just practical. It's edgy.

And lastly, the extra-wide visor, which she had customized. "I can't really see so I cut up all the ends," she said.

She made this outfit work for her. And as a result, it works.

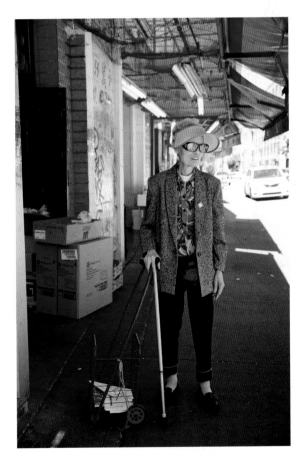

THE CAN COLLECTOR

DOWNTOWN EASTSIDE, 2018

Can collecting, or bottle picking, is a very visible part of Chinatown culture. Chinese seniors rummage through public garbage cans and residential recycling bins in search of empty glass bottles and aluminum cans, which they take to recycling centers to collect the five- or ten-cent deposit. The haul is stored in ingenious ways while they're out on the hunt: rolling metal carts or backpacks, large plastic tarp bags, see-through garbage bags tied to the end of a wooden pole and balanced on their shoulders. Not to mention the interesting outfits, which usually involve bright rubber gloves and patterned sleeve protectors.

We don't know much about what motivates the seniors. Money is an obvious draw. But we've heard several people comment that it's a way for seniors to feel useful. Some might be living a comfortable life with their kids in the suburbs, but they want a purpose, a mission—so they walk all over town, foraging from bars and restaurants and picking discarded bottles off the street. The exercise and pocket money is a bonus—even if it comes in nickels and dimes.

We met Yin Zhi Su, seventy-six, as she was heading down an alleyway in Downtown Eastside to pick up a few loose cans on the ground. Her setup was more casual—she wasn't going for a shopping cart's worth of cans. Instead, she had a small plastic shopping bag that she deposited her cans into.

She was wearing a floral bucket hat her daughter's friend had made. It was too thin so she sewed in an additional liner. We liked the rich colors of her teal shirt and maroon vest.

She moved to Canada in 2001. Before that, she worked on her own farm, growing peanuts and potatoes. Her daily routine now involves going to the Downtown Eastside Women's Centre, which provides social services, free breakfast and lunch, and clothes and toiletries for low-income people in the area. "I go to the DEWC," she said. "Then I go home and cook."

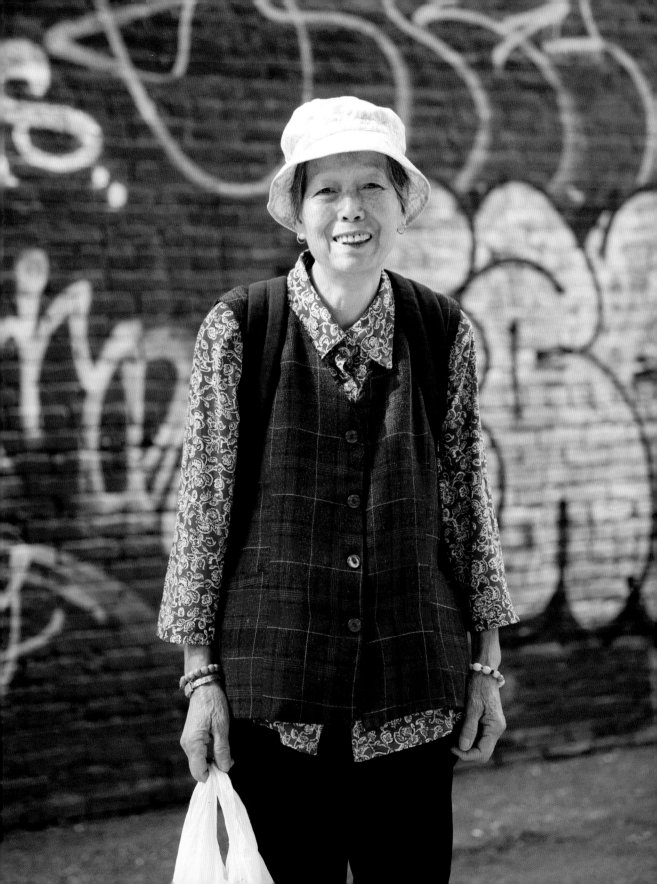

WINKY

There's so much that can be communicated without words. Neither of us speak Cantonese, but sometimes there's a connection that can be gained through eye contact, smiles, and holding hands.

When we met Pui Fong Shum, ninety-six, it was through her winks and playful demeanor that we felt a kinship. When we first said hello to her, she kept winking at us, alternating between her left and right eye. We nicknamed her Winky.

She was sitting with a family friend ("Her daughter-in-law is my sister-in-law," he said) who visits her every few weeks at Villa Cathay Senior Home. Since Ms. Shum is deaf, he writes on an electric notepad (kind of like an advanced Etch-a-Sketch) to her in Chinese. She responds verbally.

According to her friend, Ms. Shum's parents only sent the boys to school while the girls stayed at home—a common practice in China back in those days. "She always claimed she's not well-educated, but she's proficient in writing and understands poetry," he said. And even though she has Alzheimer's, she can still recite famous poems.

Then he pulled out a napkin with a poem she had written in Chinese. "She'd always say, 'Remember I wrote that poem?'" he said. "I keep the napkin so I can show her that I know the poem." He's had it with him for two years.

The poem was about how it took a lot of effort to develop Hong Kong. He read it out loud to us:

> Lingering during a visit to this beautiful garden,
>
> Harmony, matching the spirit of a master's painting,
>
> Grass germinated subtly; nurtured by morning dew,
>
> Flower bulbs prepared to blossom, next to the pavilion,
>
> Soothing melodies, flowed by the trickling creek,
>
> Shimmering reflections of mountaintops, casted upon the waterside,
>
> Once a deserted island, became now a paradise,
>
> All the efforts and dedications, created this piece of heaven.

We sat there in silence, absorbing the poem. Afterward, we told her how special it was to hear it, and I turned away a bit misty-eyed, feeling moved by her poem and how her vibrant personality transcended language.

She broke the silence by saying something in Cantonese, then covered her eyes and ears, and flipped her pocket inside out.

"I'm blind, I'm deaf, and have not a penny in my pocket," her friend translated, which got us cracking up.

She smiled and left us with her last punchline. "No matter how long you talk, I can't hear you," she said with a laugh.

We all laughed.

It's OK. So much more was communicated with a series of winks and a few lines of poetry.

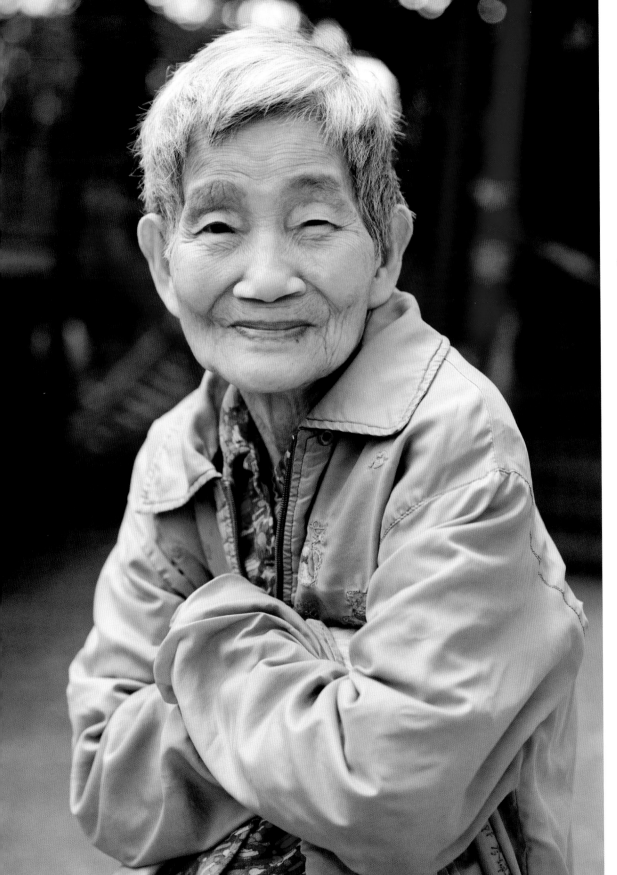

THE LIBRARIAN

CHINESE COMMUNITY LIBRARY, 2018

We spotted Sau Wah Hui on the street. She was a subject of "In Chinatown," a documentary on Vancouver Chinatown residents we had seen prior to our arrival. Through community organizations, we were able to secure a photo shoot scheduled for a few days later. We stopped her and her caretaker to say hello.

"How do we know you?" she said, looking at us curiously. "We have an appointment on Sunday," we reminded her. "Sorry, I don't know English," she said in perfect English.

We don't even know how to say "I don't know Chinese" in Chinese.

Mrs. Hui, ninety, was wearing a cool mint windbreaker layered over a pink geometric sweater; the combo was delightfully hip. Her white hair was neatly combed. "I do not even look in the mirror," she later told us, as we rummaged through her closet in her Chinatown apartment. "I've never worn makeup. The only thing I do is comb my hair and put in a bobby pin."

Mrs. Hui is one of the most active seniors we've met. She volunteers at the Chinese Community Library Services Association, a nonprofit that has provided a place for seniors to read and borrow Chinese-language books for the last forty-seven years. She's been a volunteer for the past two years and has a designated desk and business card. She helps with fundraising and facilitating book donations (their collection consists of 40,000 donated books).

"I never learned English, so this is the only thing I can do," she said. "I'm continually trying to learn English but it's hard to retain."

Prior to volunteering at the library, she was at S.U.C.C.E.S.S. (also known as the United Chinese Community Enrichment Services Society), a social service agency that helps the Chinese community, for eleven years, where she worked in the mailroom, organizing mail, donations, and paperwork.

She left S.U.C.C.E.S.S. to volunteer at the Chinese Community Library because she wanted to find affordable computer classes. "The first day I sat down and haven't left," she said. Herman Yan, another volunteer and coordinator for Shon Yee Place (a senior residential home), bought her a tablet and helped set it up. "I'm still a beginner," she said. "It's a lifelong endeavor to learn English and computers."

We asked her about her philosophy on social service. "If I receive pension without giving back, it feels like I'm freeloading," she said.

Her commitment to service stems from her teaching career. Growing up, she was third in her class and her father encouraged her to pursue an education. She views knowledge as an invaluable asset. "In a fire, things will burn, but you won't lose things in your brain," she said.

Prior to immigrating from Hong Kong, she taught at a Chinese government school for twenty-four years—educating students from preschool to grade six. She taught Chinese, dancing, and music—and sewed her own costumes. Since her husband imported Japanese fabric, she got first dibs on any fabric she liked.

"I made 100 percent of my own dresses," she said. "I donated it when I moved here from Hong Kong."

At the library, she showed us a chart her mother kept of her sixteen children in the order of their birth. Her mother's document of the family tree was found under her mattress. "I didn't know about it until 2015," Mrs. Hui said. The years spanned from 1924 to 1948, with an average of two years between each child; some did not make it.

One of our favorite things about Mrs. Hui was a comment she made during the documentary. She was cooking in her kitchen, wearing the same geometric sweater she had on when we first saw her on the street. She lives independently in Chinatown. Her five kids live far away—most are in Toronto, one is in Taipei. "My husband died of cancer in Hong Kong in 1994," she said in the documentary. She didn't like living alone in Hong Kong, so she settled in Vancouver. "There's no way I'm going to move. I'll live alone until I'm old," she said. We like that at ninety, she doesn't feel quite old yet.

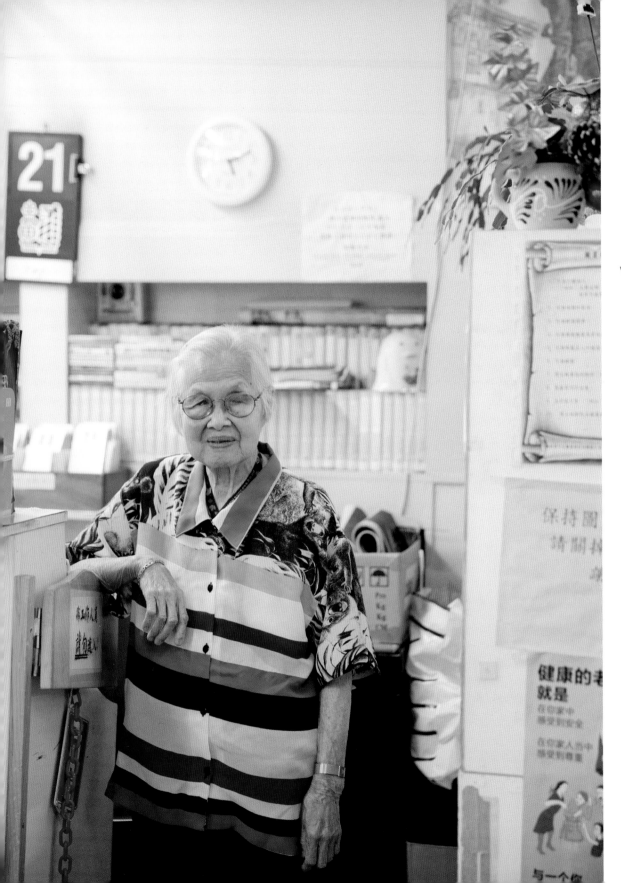

We asked her how she maintains such an active lifestyle. "As a senior, you cannot sit and eat," she said. She insists on walking everywhere, never leaving home without her thermos of hot water, glasses, and some cash in her pocket. "My legs have to keep going," she said. Mrs. Hui has a free bus pass from the government but rarely uses it. She says it's easy to get accustomed to taking a car or bus and as a result, miss out on much-needed exercise. Her doctor has given her a clean bill of health. "The only health issue I had was when I slipped on ice," she said. "I was laid up for a few days."

When we were chatting, she was standing, leaned up against her office door. We asked if she wanted to sit. She said no.

"Are you tired?" June Chow, a community organizer, asked.

"I'm not tired," she said.

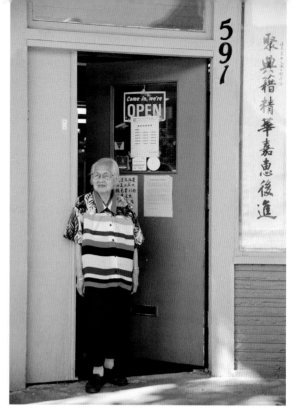

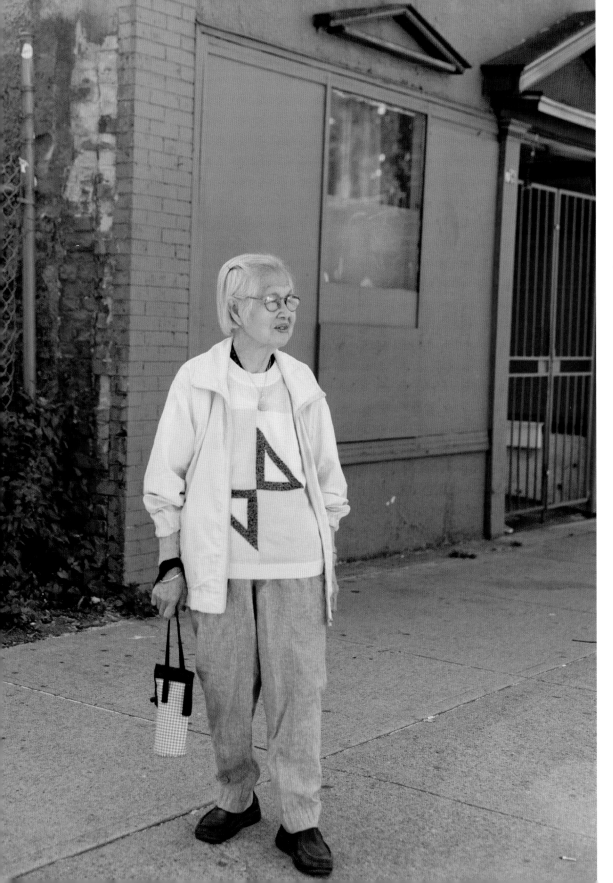

CLOSING

After spending five years chasing seniors around in the Bay Area, then traveling to another four cities for this book, we feel a deep appreciation for the lives of the people in Chinatown. Their stories encompass so much history, pain, joy, and resilience. Their clothes demonstrate beauty that transcends age, class, and location.

Along the way we learned more about Chinatown histories—and how they resonate today. In 2017, President Trump instituted a ban to restrict travelers from several Muslim-majority countries. It was the first time people from specific nationalities have been banned from entering the United States since the Chinese Exclusion Acts. Our heads looked both ways, toward both present and past.

A vital part of this project was connecting with nonprofits that supply housing and resources to seniors. We saw how they are actively giving seniors support and companionship in ways that are respectful and culturally mindful, meanwhile pushing against the seeming inevitably of gentrification. We met artists and store owners from newer generations, who pay homage to the past while trying to create the new Chinatown: at 41 Ross, an art and community space in San Francisco; Wing on Wo & Co. in Manhattan, a hundred-year-old gift shop that now hosts artist residencies; and Youth Collaborative for Chinatown (YCC) and Yarrow Intergenerational Society for Justice in Vancouver, which both work alongside seniors to shape the Chinatown they want to see.

At YCC's Mahjong Social in Vancouver Chinatown, it gave us so much excitement to see seniors and Chinese Canadians in their twenties and thirties coming together one warm summer afternoon. Faye Leung, a woman in her eighties who started developing commercial real estate in Chinatown in the 1950s, was chatting with the younger community organizer Doris Chow:

"Chinatown is gone forever," Faye said.

"Your Chinatown," Doris said, then corrected herself: "Our Chinatown."

"It's your Chinatown now," Mrs. Leung said. "I've already done my part."

We hope this book gives you more insight into Chinatown. That it inspires you to say hello to seniors. To ask your grandparents about their histories. And lastly, to think about your participation in protecting and honoring the culture around us.

Chinatown Pretty is a celebration of street style, but it's also a celebration of Chinatown history, and the hard work that goes toward preserving it. We hope our book plays a part in that.

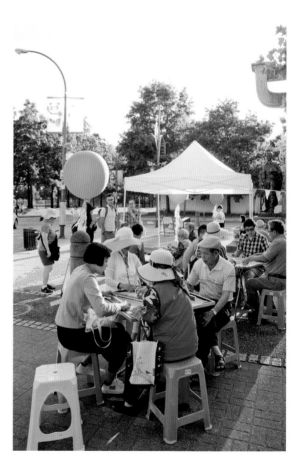

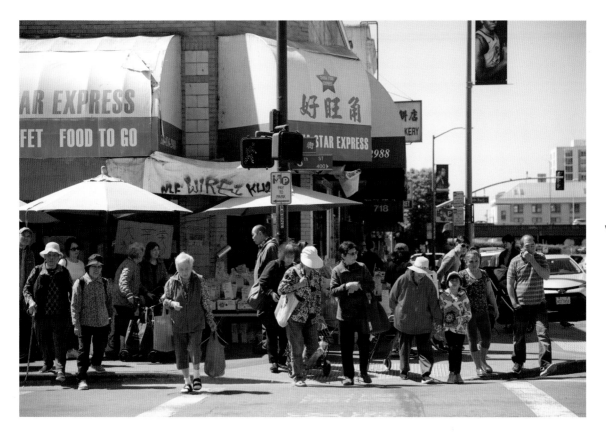

AUTHORS' NOTE

It was important to us to have the seniors know and understand why their stories are important to document and celebrate. All the featured portraits and interviews were conducted with the seniors' consent (and with the help of Cantonese and Toisanese interpreters). Many people declined to participate (about 90 percent!), because they were private individuals or were simply too busy grocery shopping. Despite our success rate, all the hard work was worthwhile since the ones that did stop to chat gave us so many heart-warming moments that make up this book.

The names in this book are written in Westernized style, with first, middle, and last names. Since Chinese names are written with the surname first, we have tried our best to make sure each one is translated accurately to the Western format. Some names, ages, and biographical information are not included because of the subject's request for privacy and the fast and ephemeral nature of street photography.

All stories have been written by Valerie Luu except for Niners Fan (page 28), The Fox (page 40), Random Acts of Kindness (page 44), Elephant Hat (page 76), Mustard Blazer (page 83), Elegant Earth Tones (page 85), Merlot Man (page 89), and Red, White, and Blue (page 93), which were written by Andria Lo.

ACKNOWLEDGMENTS

Chinatown Pretty exists because of the people who inhabit and care about Chinatown.

To all the seniors who shared their inspirational stories and interesting outfits. To our readers and followers, whose shared admiration for seniors kept us at this ambitious project.

Cathy Lam from Chinatown Community Development Center, who reached out to us about collaborating. Roy Chan and Erika Gee at CCDC, who invited us to show our work at 41 Ross: first, a self-titled photo exhibition, followed by *Eat Chinatown*, a show about the neighborhood's food institutions. Our relationship with CCDC was the catalyst for transforming *Chinatown Pretty* into an ongoing photo and storytelling project. Their deep-rooted connections with the community gave us an understanding of Chinatown that grounds this project.

To all our friends who shared their enthusiasm and expertise: Valerie Shagday, who designed our logo and art show collateral. Sarah Han, who supported our idea and edited the first iteration of this project, an article called "Chinatown Sartorialist" for *The Bold Italic,* an online magazine. Zaneta Jung for getting this project started at Chronicle Books and for her enthusiasm and early edits. To the historians who reviewed our manuscript and shared their knowledge, who act as keepers of the complicated and important history of Chinese in America: Mark Chiang, Jenny Cho, Catherine Clement, Harvey Dong, Huping Ling, Eugene Moy, and Susan Moy.

Our interpreters (many of whom volunteered their time) for building the bridge between us and the Cantonese- and Toisan-speaking *pòh pohs* and *gùng gungs*:

San Francisco Bay Area: Crystal Chan, Phoebe Chan, Rosa Chen, Tricia Choi, Virginia Dam, Meifeng Deng, Jerri Diep, Nora Feng, Judy Fong, Tim Ho, Cathy Lam, Christine Lau, Madelyn Lee, Diana Liu, Kevin and Mary Lo, Thomas Lo, Wilson Tsang, Alison Wong, Phoebe Wong, Kat Wong, Michelle Yeung, Anastasia Yip.

Los Angeles: Tiffany Chan, Judy Lee, Connie Vuong.

Chicago: Shengfun Li, Grace Chan McKibben, Eunice Tse.

New York: Yixin Cen, Yayun Chang, Vivian Kong, Shirley Lew, Michelle Lee, Kent Li, Ming Lok, Terilyn Ma, Jinting Ye, Mel and Richard Young, Iris Zhang.

Vancouver: June and Doris Chow, Andrew Lee, Dawn Lo, Wendy Lui, Jodie Mak, Wynn Siu, Forever Young.

Being an interpreter for this project requires a certain tenacity, a unique combination of persistence, humor, and curiosity that fosters openness when approaching seniors on the street. Getting rejected nine times out of ten wasn't easy, so *doh jeh* many times over.

Making a book is scary, so many thanks to our agent, Danielle Svetcov, and editor at Chronicle Books, Mirabelle Korn. Their energy and feedback made this daunting project less so.

To the community organizers and service organizations that helped profile Chinatown residents in San Francisco and beyond. Their work helps keep Chinatown a place for seniors to live and thrive, and their connections allowed us to meet the many people featured in this book.

San Francisco Bay Area: Chinatown Community Development Center, 41 Ross; YWCA San Francisco and Marin.

Chicago: Si Chen at Chicago Public Library for giving us a home base on those rainy days. Sharyne Moy Tu for her local knowledge.

New York: Hamilton-Madison House for hosting us at the City Hall and Madison Street Senior Center.

Vancouver: Doris and June Chow of Youth Collaborative for Vancouver Chinatown, whose creative work and deep-rooted connections to Chinatown give us so much hope and energy. To these organizations and senior centers who helped us organize Senior Portrait Days: Yarrow Intergenerational Society for Justice, Herman Yan at Shon Yee Place, Chinatown Lions Manor, Villa Cathay Senior Home, Downtown Eastside Women's Centre.

From the authors:

Andria: Thank you to my family for all your support and consultation on all things Toisan and Cantonese; my *pòh poh,* who sewed all of her own clothes—I see and hear you in so many of the grandmas we meet; and my *ng nai,* who showed me a flair for fashion; Sean for your love and encouragement; Valerie for being the best wingwoman around Chinatown I could ask for.

Valerie: *Cảm ơn* to Monica Bui; my mother, Hoa Nguyen; my maternal grandmother and Anna Lee, my Vancouver grandma who showed me beauty in resilience. My dads Andrew Lee and Andrew Luu: the former for constantly reminding me how this project opened his eyes to the beauty he hadn't noticed before, and the latter from whom I've inherited my love for stories. To my friends in San Francisco who are still creating and seeing the magic in this city. Thank you to Matching Half Cafe, where most of these words were written. To Andria for being a friend first and collaborator on many fronts. To anyone who's ever had to start over.

SOURCES

CHINATOWN HISTORY

Kwong, Peter. *The New Chinatown*. New York: Hill and Wang, 1996.

Kwan, Choi Wah. *English-Cantonese Dictionary: Cantonese in Yale Romanization or Ying Yue Zi Dian*. Hong Kong: New Asia-Yale-in-China Chinese Language Center, 2004.

Tsui, Bonnie. *American Chinatown: A People's History of Five Neighborhoods*. New York: Free Press, 2010.

SAN FRANCISCO

Yung, Judy. *San Francisco's Chinatown*. Mount Pleasant, South Carolina: Arcadia, 2016.

OAKLAND

Wong, William. *Images of America: Oakland Chinatown*. Mount Pleasant, South Carolina: Arcadia, 2004.

LOS ANGELES

Cho, Jenny. *Chinatown and China City in Los Angeles*. Mount Pleasant, South Carolina: Arcadia, 2011.

Mai, Randy, and Bonnie Chen. "The State of Chinatown." UCLA Asian American Studies Center Research, Luskin School of Public Affairs, University of California, Los Angeles: 2013. aasc.ucla.edu/research/pdfs/StateCT.pdf.

CHICAGO

Kiang, Harry. *Chicago's Chinatown*. Lincolnwood, Illinois: Institute of China Studies, 1992.

Ling, Huping. *Chinese Chicago: Race, Transnational Migration, and Community since 1870*. Redwood City, California: Stanford University Press, 2012.

NEW YORK

Kwong, Peter. *Chinatown, New York: Labor and Politics, 1930–1950*. New York: New Press, 2001.

VANCOUVER

Con, Harry, and Edgar Wickberg. *From China to Canada: A History of the Chinese Communities in Canada*. Toronto: McClelland and Stewart, in association with the Multiculturalism Directorate, Department of the Secretary of State and the Canadian Government Publishing Centre, Supply and Services Canada, 1982.

THE AUTHORS

Andria Lo is a freelance photographer living in Berkeley, California. Raised in Alaska and Texas, she moved to the Bay Area to study art at University of California, Berkeley. You can find her photos in the *San Francisco Chronicle*, the *New York Times*, and *Wired* magazine.

Valerie Luu is a writer living in San Francisco. Born and raised in Sunnyvale, California, she studied journalism in high school and later at University of California, Santa Cruz. She moved to San Francisco in the summer of 2008 and has been there ever since. She is also one half of Rice Paper Scissors, a Vietnamese pop-up restaurant.